52 PHOTOGRAPHIC
PROJECTS

Art direction: Tony Seddon
Cover design: Lisa Båtsvik-Miller
Design and layout: Lisa Båtsvik-Miller
Editor: Lindy Dunlop
Typeset in: DIN, DINOT, Helserif, and Soho

Reprographics in Singapore by ProVision Pte.
Tel: +65 6334 7720
Fax: +65 6334 7721

Printed in China by 1010 Printing International Ltd.

Acknowledgments

This book is dedicated to my new little girl Matilda Meredith and her mum Sarah Meredith.

Thanks to Lisa Båtsvik-Miller and Lindy Dunlop at RotoVision; without you I am sure this book would not be the standard it is.

Thanks to Lee Bushy for the use of his photo of Alex Bamford, for helping me out with my color splash photos, and for the use of his ultra-wide-angle lens. Thanks to Anna Carlson and Steve McNicholas for lending me their photographic kit.

Thanks to all the people who appear in the book:
Abi Coles, Adam Bronkhorst, Alex Kershaw, Alexis Scherl, Alfie Bronkhorst, Alison Bronkhorst, Amber Traven , Amy Ng, Andy Clymer, Anita Goralnick, Anna, Anna Carlson, Benjamin Rosenblum, Bob Phipps, Boris Kossmehl, Chad Allen, Chad Nicholson, Chris Coles, Chris Frewin, Chris Uduezue, Clive Flint, Corrina Greenberg, Cousin Caely, Damian McIver, Danny Fontaine, Darcy, Dave Sawyers, Eeva Doherty, Elin Johansson, Elsa Nobel, Emelye Leffler, Emmeline Cook, Heather Champ, Henry Law, Hsing Wei, Ian Goralnick, James Kendall, James Prest, Jamie Cambler, Jennie Zhu, Joanne Skinner, John Cherry, Jotham, Julia Walter, Juliet Gabrielle, Justine Linn, Katherine Reid, Laura Brunow Miner, Leah Grammar, Lee Albrow,Lee Grist, Leo Santos-Shaw, Lindy Dunlop, Malcolm O'Connor, Marco Scagnelli, Marek Machlowski, Maria Murray, Mark Capalbo, Mark Goralnick, Marty Yoo, Mary Goldthwaite, Matt Krueger, Meg Shoemaker, Mike Wrobel, Mimi Pearlson, Mona Brooks, Neil Fowler, Oliver Cook, Poppy, Potato Potato, Priya, Rachel Fowler, Ruby Campbell, Sally Finnigan, Sangita Morgan, Scarlett Fowler, Simon Cooke, Steph Goralnick, Steph Hope, Suzette Subance, Tom Pillips, Wendy Laurel, William Oberlin, Yvo Luna, Zali, Zen, and whoever I may have forgotten to put on the list.

I would like to thank the flickr community for its continued interest in my work, and for clearing up photo queries when I have them.

Trevor Williams would like to thank Naoya Hirayama and Phill Parry for helping to make the light-painting pictures, and Noriaki Nagao for venturing out into the night with him to shoot stars. "Without these three people, night shooting would be impossible."

Ricardo Mendonça would like to thank Ette (Henriette Monteiro Cordeiro de Azeredo) for being encouraging and assisting him with his many projects, now and always.

52 PHOTOGRAPHIC PROJECTS

Kevin Meredith

Creative workshops for the adventurous image-maker

APPLE

Contents

Contributor index

Ruby May Allcock

(aka ruby-may)

Ruby May is currently concluding A-level photography in Brighton and plans to study fashion photography at university. Ruby has shot headline acts at major venues and festivals in the UK, including Glastonbury. She also works as a photographer for a Brighton listings magazine.

www.flickr.com/ruby_may; www.myspace.com/ruby1992

Alex Bamford

Working as an art director in some of London's foremost advertising agencies, Alex Bamford has spent the last 25 years creating images for major brands. More recently he's been heading into the night to create images for his own amusement.

www.alexbamford.com; www.flickr.com/photos/bambooly

Hailey Bartholomew

(aka poppy smiles)

Hailey Bartholomew's endearing visual style is influenced by her genuine desire to communicate and delight with color, positivity, and hope. An award-winning stills photographer, Hailey has also written, directed, and filmed several award-winning short films.

www.youcantbeserious.com.au

www.flickr.com/photos/poppysmiles/

Adam Bronkhorst

(aka the brownhorse)

Adam's photography has been published in books, magazines, and newspapers around the world, and has featured in solo and group exhibitions. In 2008 Adam Bronkhorst set up Garage Studios with two other professional photographers. He runs workshops in flash photography, wedding photography, and film cameras. Adam has a love for film cameras and never leaves the house without at least two on him.

http://adambronkhorst.com

www.flickr.com/photos/garage_studios/

Mona T. Brooks

(aka macaby)

In 2003 Mona married her soulmate, quit her corporate job, moved to San Francisco, and started photography school at the Academy of Art University. Her photography resume reads off the who's who in US progressive politics, from President Barack Obama and former President Bill Clinton to Speaker of the House Nancy Pelosi. Mona's work can be seen in *San Francisco Magazine*, *Augenzeuge Magazine*, *Le Monde*, and Rome's *Europa* newspaper.

www.monabrooks.com

www.facebook.com/monabrooks

Darren Constantino

For Darren Constantino, photography is a hobby. He likes to photograph the landscapes around his home in northeastern Ohio, USA, using pinhole and digital cameras. He is indebted to his wife for her patience with his photography during their travels.

www.flickr.com/photos/dcsnaps

dcsnaps@yahoo.com

Gianluca Fabrizio

(aka Shotbart)

Self-taught photographer Gianluca Fabrizio began his serious digging into photography in late 2006. He explored the stunning world of macro photography with his Lilliput series, and has since concentrated more on portraits. Whatever he shoots, he loves the result to be evocative.

www.flickr.com/shotbart

Ricardo Mendonça Ferreira

Ricardo Mendonça Ferreira is a Brazilian software engineer and photographer with a passion for taking aerial pictures, especially using kites. He has published his work and participated in aerial photography events in Brazil, the USA, and the UK.

www.altoretrato.com.br/; www.flickr.com/photos/ricardo_ferreira/

Lisa Garner

(aka lissyloola)

Lisa Garner is a self-employed graphic designer and co-director of Itonic Design. She finds inspiration in the unusual things and people around her and finds photography a great way of recording it. She enjoys the freedom that digital photography gives her, but can't help loving film and her film cameras that little bit more.
www.flickr.com/photos/lissyloola
www.flickr.com/gloriousfreaks
www.itonicdesign.com

Alexis Gerard

Alexis Gerard founded imaging technology think tank Future Image in 1991. He subsequently founded, and chairs, the 6Sight® Future of Imaging executive conference (www.6Sight.com). He coauthored the book *Going Visual* and is a member of the International Advisory Council of the George Eastman House. A passionate photographer since the 1970s, he started shooting digitally in the early 1990s. He prefers small cameras that he can carry with him at all times.
www.jpgmag.com/people/AGFuture
www.aamora.com/?cat=49
www.redbubble.com/people/AGFuture

Steph Goralnick

(aka sgoralnick)

A photographer and graphic designer living in Brooklyn, New York, Steph enjoys documenting wacky New York events, throwing ridiculous theme parties, and traveling to faraway lands. Her work has been published in *Adbusters Magazine*, *The Village Voice*, and *Imbibe Magazine*; and featured in the We Are All Photographers Now exhibition at the Musée de l'Elysée in Lausanne, Switzerland.
www.sgoralnick.com
www.flickr.com/sgoralnick

Kevin Mason

Photography ruined Kevin's life. He has been shooting full time since 2002, but has been obsessed with taking photos for much longer. Published many times, with work ranging from fashion to documentary-portrait work, he is most interested in photographing the people he meets in his ordinary day. Kevin shoots because he likes to make fictional narratives and present them as truth.
http://kevinmason.garage-studios.co.uk/
gallery work: www.darkdaze.org

Kevin Meredith

(aka Lomokev)

Kevin Meredith is an evangelist for the use of simple compact film cameras, although he is not a stranger to digital. His obsessions with food, shoes, and swimming have won him commissions with Dr. Martens, the Victoria & Albert Museum, London, *The Times* newspaper (UK), and The National Gallery, London. He became well known in Internet circles when he joined flickr as an early adopter in 2004. His first book, *Hot Shots*, was published by RotoVision in 2008, and has since been translated into Spanish, Polish, Estonian, and Chinese. Kevin now teaches photography privately all over the world.
http://lomokev.com; http://www.flickr.com/lomokev

Russ Morris

Russ Morris has been shooting through the viewfinder (TtV) since May 2006. Inspired by the work of the earliest members of the flickr Through the Viewfinder group, he spent six months experimenting with the medium, discovering ways to apply his personal touch to these unique photos taken using two cameras. His online tutorial www.russmorris.com/ttv is regarded as *the* resource for learning how TtV is done.
www.russmorris.com

Michael O'Neal

(aka moneal)

Michael O'Neal lives in San Francisco, but commutes to Cupertino for his job as an Associate Creative Director at Apple. Michael brings the perspective of having art directed famous photographers, but is himself a photographer and lover of all things Polaroid.
michaeloneal.net
www.flickr.com/moneal/

Tracy Packer

(aka Trapac)

Tracy has a great variety of mostly cheap—and often old—film cameras, many held together with Blu-tack and electrical tape. She carries several with her at all times, even to university where she is currently (2009) undertaking a BA (Hons) in photography to help launch her second career.
www.flickr.com/people/teepee1/

Meg Pickard

Meg Pickard is an inveterate photographer who carries at least one image-capturing tool with her wherever she goes (four if you count her eyes and brain). Though self-taught, her photos have appeared in print and ad campaigns, as well as online. Her favorite camera is whichever she happens to be holding at the time, but she particularly loves squeezing interesting shots out of lo-fi devices, including phones and toy cameras.
www.flickr.com/meg; www.meish.org

Dan Smith

(aka shoegazer)

Dan Smith has been shooting with a Lomo LC-A since 1999. He is residing in northern California while he photographs the Golden State from border to border with a collection of toy cameras ranging from plastic medium-format to panoramic swing-lens cameras. In early 2010 he moved to the UK for the next phase of his photographic journey.
www.flickr.com/photos/shoegazer/

Ásmundur Thorkelsson

A food microbiologist from Iceland who mostly shoots landscape on his 30-minute commute to work, Ásmundur's work has appeared in books, magazines, and newspapers.
www.flickr.com/photos/asmundur/

Laura Thorne

(aka Laura Mary)

Laura Thorne rarely leaves home without a camera, plucked at random from her large collection. She shoots photos of all things from all angles, documenting a bright, colorful, and fun perspective on life. Laura has organized and contributed to exhibitions for both Xynthetic, an art/photography/skateboarding collective, and flickr.

Trevor Williams

(aka tdub303)

A Canadian, who has been lost in Japan for the last eight years, Trevor has busy days, which leave him time only for shooting at night. His night shots have led to him being featured in the light-painting documentary Luminary and on Japanese television. He exhibits his works at various galleries in Japan.
www.flickr.com/photos/trevor303/; www.fiz-iks.com

Introduction

When I first started planning this book I got really excited about learning all the new techniques I was going write about: light painting, redscale, and Polaroid to name but a few. However, I quickly realized that writing about all of the techniques myself, learning some of them from scratch, was not going to produce the best book possible. There are many photographers I draw inspiration from and greatly admire, so, once I had a contents list, instead of just drawing inspiration from them, I asked some of my peers to contribute, to help me make this book as inspiring and as useful as possible for you.

The 15 photographers who helped me by contributing to this book represent a broad range of photographers from all over the world. Some are professional, while others are what I refer to as "super hobbyists." They are from all walks of life, and their ages range from 17 to 55; what they have in common is that they are all obsessed with their own particular photographic specialty. I hope my enthusiasm, and that of my fellow contributors, for our craft inspires you to take your photography to the next level.

While we have kept the instructions in this book simple, you will need a little basic knowledge to understand it all. If are new to photography, you should start by reading Photography fundamentals on page 282.

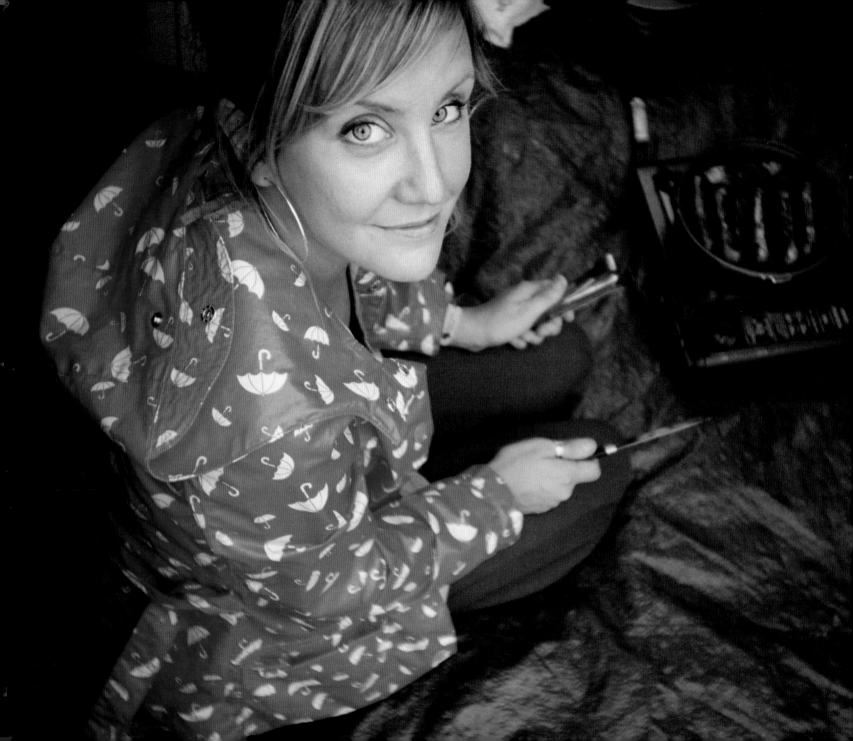

Portraits

A key skill

Kevin Meredith

Anna
I composed this portrait of Anna while she was cooking sausages and got her attention only when I had that right.

The Idea

Shooting portraits is a really important skill to have as a photographer. I am constantly amazed at the fantastic photographers I find who lack experience in portrait photography. Now that I teach photography regularly, I have discovered that this comes down to an issue of confidence–many photographers don't like to ask people if they can shoot them.

The Ingredients

> Any camera
> A subject

The Process

If you do see someone interesting who you would like to shoot, just approach them and ask if you can take their portrait. I find most people are more than happy to have their picture taken, and at the end of the day, the worst that can happen is that they will say no. If people ask why you want a picture, tell them that you think it will make an interesting photograph.

The key thing when you're photographing a person is to help them be relaxed so that they appear at their most natural. You can achieve this in a number of ways. Portraits don't have to be formal, with people looking into the lens, so try to shoot people doing something if you can. If people are performing an action, they will be taking less notice of what you're doing. Of course, if you want your subject to look into the camera, this approach might not work. One way around this is to compose the shot as you want it and then get the subject to look at you. In the instant they make eye contact with the lens, take the shot; that way they don't have time to look uncomfortable. Another good trick is get your subject engaged in conversation. If you have a person mid-sentence, they will not be as conscious of the way they are looking.

Focus can be key when you are shooting a portrait in which the subject's face is prominent. In this case, make sure you focus on the eyes. If a subject's ears or nose are out of focus it's not really a problem—most people viewing a picture of a person will look straight to their eyes—but if the eyes are slightly out of focus and you have a pin-sharp nose, the image will seem odd. (See page 282 for tips on getting perfect focus.)

Choosing the right camera is important. Big cameras can be intimidating. You will probably get the best technical image if you use a DSLR or an even larger medium-format camera, but your subject might be more at ease if you use a smaller, less obtrusive option. I have taken some of my best portraits with my Lomo LC-A and Contax T2. Both of these film cameras are small enough to fit into my pocket. The only drawback with using basic film compacts and zone focus cameras is that you lose a certain amount of control.

A new breed of digital camera includes Micro Four Thirds and hybrid cameras. These offer similar features to digital SLR cameras, including interchangeable lenses and full control over shutter speed and aperture. The added bonus is that they are small enough to fit in my pocket and they are very unobtrusive. At the time of writing, Olympus and Panasonic both have Micro Four Thirds cameras (The Olympus Pen EP-1, Olympus Pen EP-2, and Panasonic Lumix DMC-GF1) and Samsung has a hybrid model—the NX10—which has a sensor slightly larger than the Four Thirds sensor.

Portraits don't have to include the whole person; you can crop in and concentrate on one particular detail. This shows enough of the person without giving away the whole story and so preserves some mystery. In a similar way, you can take portraits where the subject is not the main focus of the image, but a smaller part of it.

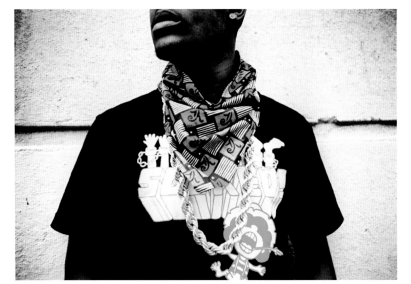

← Left:
Sangita
I took this photo of Sangita while she was talking, so there is no awkwardness in the shot.

↙ Below left:
Matthew
As Matthew is a fashion designer, I wanted to concentrate on his clothes: the scarf, necklace, and T-shirt. I also included his button earring at the top of the frame, but not his whole face.

→ Right
Lindy
In this shot of Lindy on the beach she is not even in focus and is a very small part of the composition, but she is still an integral part of the image.

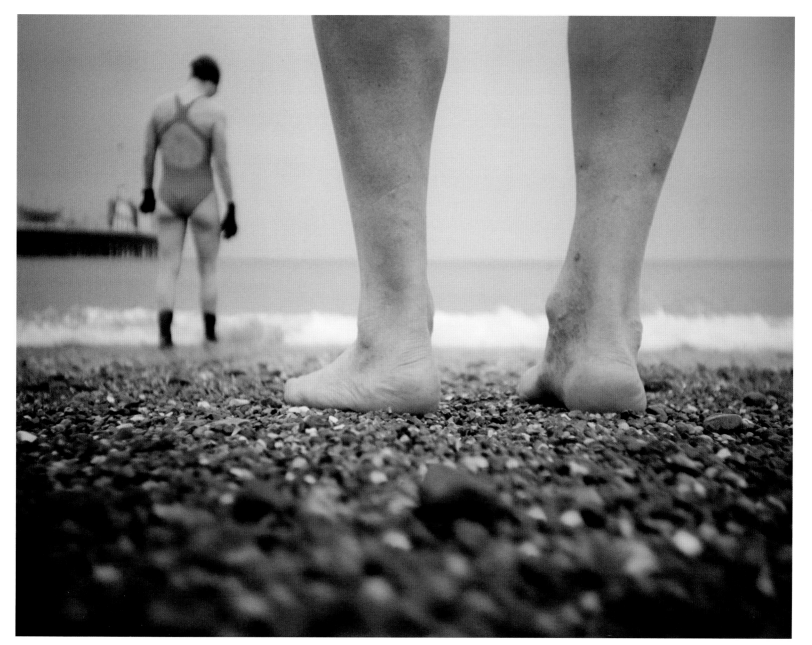

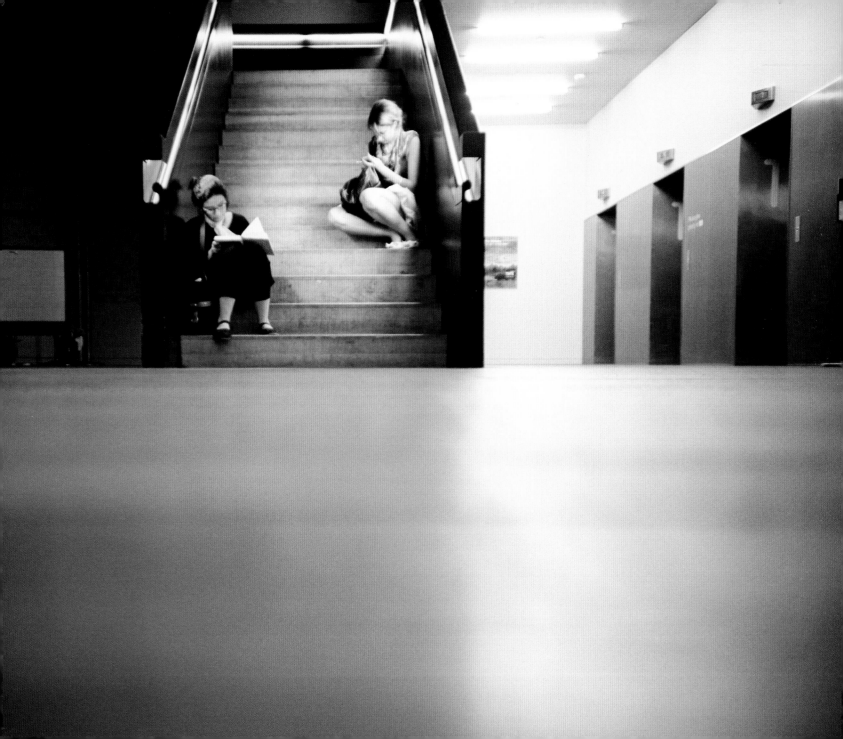

Low-down

A rat's-eye view

Girls on Stairs
Low-down photography
can be handy for getting
candid shots. Bend down
as though you are doing up
your shoelaces and take your
photo; it's not as noticeable,
or disruptive, as raising
a camera to your face.

The Idea

Low-down photography is an excellent way of
showing a scene from a different viewpoint. Images
taken at ground level are often more interesting than
those taken at eye level because we are not used to
seeing the world from a "rat's-eye view." A lot of the
time views from the ground will have great perspective
and depth, and it's a good technique to use at night if
you're out without your tripod—after all, what is more
sturdy than the ground you stand on?

The Ingredients

▷ Any camera
▷ Angle Finder (optional)
▷ Camping mat or cardboard (optional)

The Process

Rat's-eye view photos are very easy to achieve. A lot
of people who see my low-down photographs assume
I have to lie on the ground to get them when actually
all I do is place the base of the camera on the ground.

The most important thing is that you decide what
you want to focus on before you set your camera on
the deck. You will either want to focus on an object
that is near to you or capture the wider scene. If it is
the wider scene you are after, you will need to focus
on infinity. Use manual focus to do this. If you are
using a camera with autofocus and can't turn it off,
such a shot can be tricky. With autofocus, the camera
might be confused by the proximity of the ground and
focus just a few inches in front of itself. If you have
autofocus turned on, it is best to angle the camera up
slightly, press the shutter button halfway down to
get a focus lock on something in the background, and
then, without releasing the shutter button, lower the
camera back down and take your shot by pressing
the shutter button fully. (See page 282 for more detail
on focusing.) If it is important to have an object in the
foreground in focus, the best way to do this is to get
down and dirty and lie on the floor so that you can
look through the viewfinder.

Ground-level shooting comes into its own when
you are shooting in low light without a tripod, as it
avoids camera shake. It's great for getting night shots

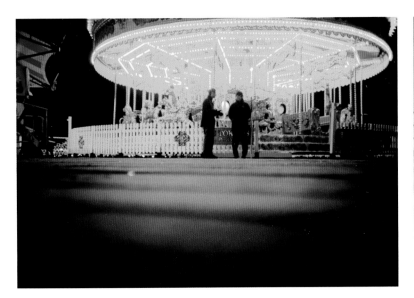

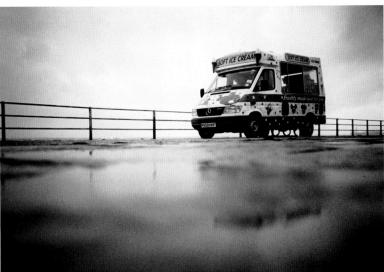

or shooting inside dark buildings. When you're shooting outdoors, it is quite rare to find a flat piece of ground. If your patch is slightly bumpy and you are shooting in low light, you need to hold the camera steady for the duration of the exposure—you don't want the camera pivoting on a bump and introducing camera shake.

When you have the base of the camera flat on the ground, this will generally put the horizon, or the meeting point of the floor and the wall, in the middle of your image. If you want more or less emphasis on the ground, you need to angle the camera up or down. This only really works if you are shooting in good light, otherwise you might get some camera shake as the base of the camera is no longer flat on the ground.

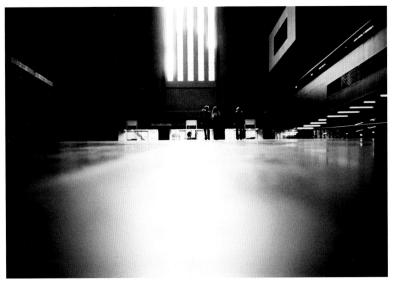

↖ **Left and above left:**
Carousel / Tate Modern Hall
Steadying your camera on the ground will help you avoid camera shake at night and when shooting indoors when there is low light.

↑ **Above:**
Ice-Cream Van
Shooting objects from a low viewpoint can give a different sense of scale.

Little Red Chair
Low-down shooting is a good way to capture small objects, like toys and this child's chair.

↘ **Below right:**
Yellow and Orange Stockings
If you are shooting things that spend most of their time at ground level, it makes sense to shoot them from that perspective.

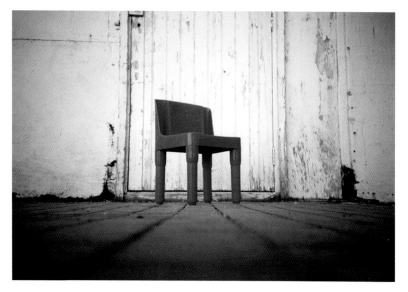

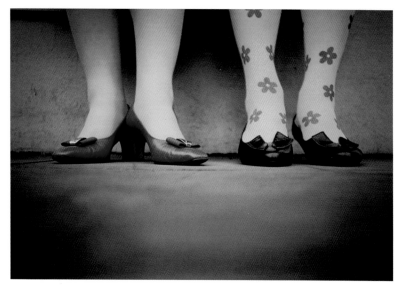

One of the things to look out for, especially if you are shooting on film, is any distracting objects very near the camera, such as cigarette butts and other trash. It's always good to give the area in front of the camera a quick sweep.

Extras

You don't need much in the way of accessories to make low-down shooting easier, but if you know you are going to be doing a lot in one day and you want to look through the viewfinder, I would recommend getting a camping mat to lie on so you don't get too grimy. Failing that, a bit of cardboard will do. If you have an SLR, you can get an Angle Finder. This will slot over your viewfinder and allow you to look down into the camera. I have a Canon Angle Finder, which fits both Canon and Nikon SLRs.

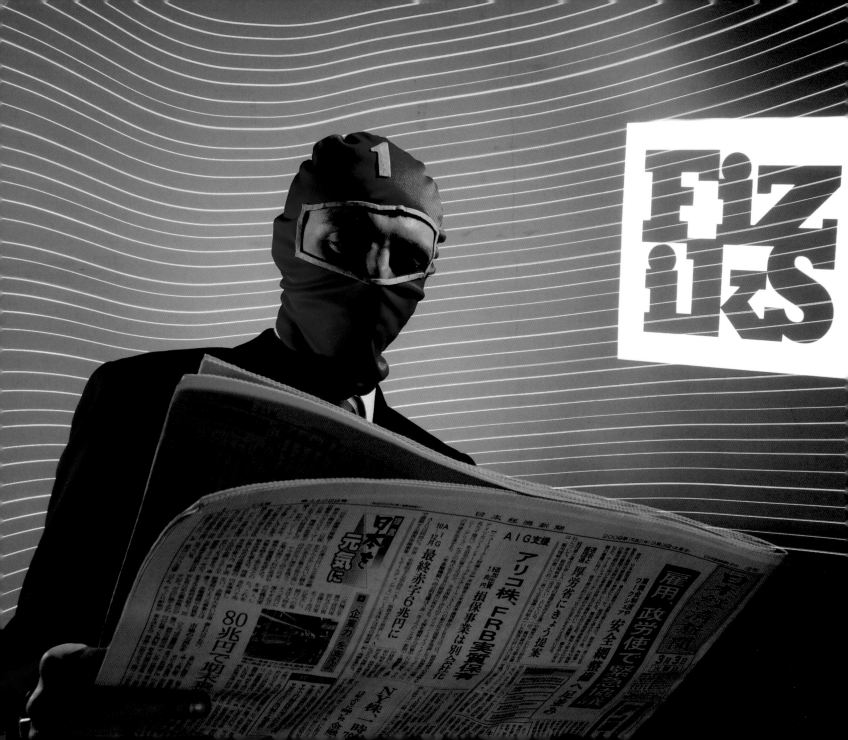

Light painting
Creative entertainment

The Idea

The plan is to use any available light source as a brush to paint things into your picture. This is all done in-camera while the shutter is wide open. I have found that the art of light painting has an incredible magic. It is a great way to turn a camera into an entertainment device and is also a great group activity. Give it a try and you will find yourself running to your camera every time the shutter closes to see what you have captured. The creative potential of this technique is unlimited.

The Ingredients

> Sturdy tripod
> Camera capable of long exposures
> Remote/cable release (necessary for exposures of over 30 seconds)
> Light source
> Flash or powerful torch for surface painting/location lighting

The Process

The best way to get started is to find a pitch-black room and secure your camera on a tripod. Set the ISO to 100, the aperture to f/5.6, and the shutter speed to 30 seconds or Bulb, if you have a remote or cable release. You must now think of your "performance." You need to perform a series of physical actions that will be recorded in a single image. As your skills develop and the scale of your pictures grows, this planning stage will become a necessary step in the creative process.

A good first project is to write your name. You will have to draw each letter backwards so it appears the right way in the final image. Once you have thought through the required steps, start the exposure and write your name backwards in front of the camera, with your light pointing toward the camera. You can write it as you would on a piece of paper, but it will appear as a mirror image in the final shot. Of course, you can just flip the picture later, but I try to do everything in-camera.

You should now have taken a picture with your name written in lights. If it isn't perfect, get used to it because most of your shots won't be. Part of the beauty of light painting is the organic feel it has, which simply cannot be duplicated with software. If you need to, do it again until you get it right. That was fun wasn't it? Now think of the potential. If you only had more lights, what couldn't you do?

Trevor Williams

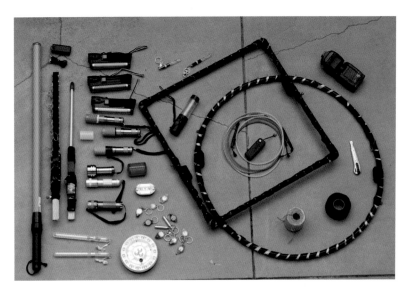
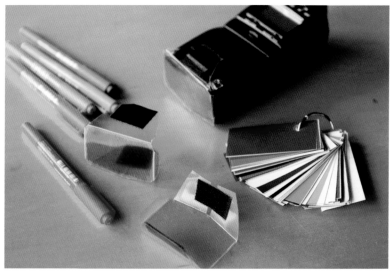

Light brushes

I refer to lights that are pointed at the camera or have their source exposed as "brushes." Welcome to your new addiction. You will now find yourself checking for lights in every store you walk into. There is a huge variety available, many of which produce neat effects. Look for things that are battery operated and portable. Here are my suggestions for some effective brushes.

LEDs are great for producing sharp lines. They can be bought in strings of 10 or 20, in a variety of colors, or in the form of a torch. Attach one or more strings to a stick to create a ribbon effect, or attach them to a Hula-hoop, which can be rolled or moved to create all sorts of neat displays. LED and Xenon torches are good for writing in larger spaces; LED lights give off a colder blue light than Xenon, which give a warmer golden light. I put an empty, clear 35mm film container over the end of the torch and wrap that in a sheet of paper. You can get any color you want by printing it onto the sheet. If a film case doesn't fit, you can cut

a Ping-Pong ball to the right size for the same result. Electroluminescent (EL) wire creates a smoky effect and is good for filling up empty space in the image. It can also be attached to a frame, in the shape of a hoop, a square, or whatever takes your fancy, for different effects. Finally, neon tubes or cold cathodes, which can be bought at automotive stores, create a broad, ribbonlike effect. They are usually 12V and plug in to the cigar lighter socket in the car, but this is not practical for light painting. You can modify them to make them portable by chopping off the car socket plug and replacing it with 1 × 9V and 2 × AA batteries– this adds up to 12V. Don't forget to add in a switch. I use pressure switches that turn something on when pushed. You can wire these switches into any of the lights you want to use as brushes; this isn't necessary, but it does make using them that much easier.

Armed with your brushes, the sky is the limit. Wave them behind a person to create a silhouette, write your name or message, draw abstract shapes, or doodle fun characters and objects.

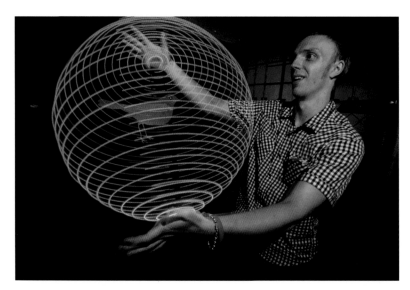

← **Far left:**
A selection of tools from my brush collection.

← **Center left:**
Use the free swatches available from lighting companies or just color a sheet of clear plastic with a marker.

← **Left:**
Catch a Fiz-Bird
LEDs attached to a Hula-hoop and then spun make neat light spheres. The bird in this image was created with a light stencil.

↙ **Below left:**
Wicker
I created these patterns by swinging lights attached to a string.

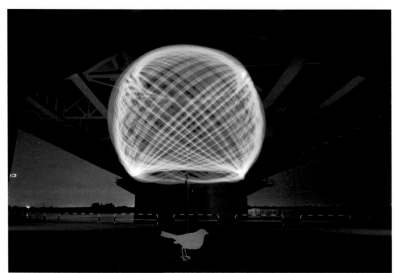

To make your pictures more intriguing, find an interesting location or include a subject in the frame. For this you will need tools for what I refer to as "surface painting." With surface painting, the light source is hidden from the camera and the light it provides is used to "paint" a surface, such as a wall or person. I recommend a flash, Xenon or LED torches, and some theater gels to add color. These can be used out of the frame or in the frame, but should be pointing away from the camera. If the light source is still visible when it is pointing away, block it with your hand or body to avoid "brushing." Simply attach the gels in front of the light to change its color. Gels can be found at any large camera or theater supply store. If you can't find proper gels, you can make them by coloring any transparent plastic with color permanent markers. The cardlike plastic often used in product packaging works really well for this. I also use it for attaching theater gels to flashes. I cut it to the size of the flash head, leaving large tabs on both sides. I then stick adhesive Velcro to these tabs, which allows me to attach it to my flash.

With colorful light sources you can now light up and alter the hue of elements in the scene. Ambient light from the moon or nearby streetlights can also provide location lighting. However, if the ambient light is strong, it will shorten the time you have to work with. Take some test shots to find the correct exposure time for your conditions. For human subjects you can use a flash as you would for any portraiture work or use a torch for a more surreal effect. I recommend using the flashes in Manual mode and firing them off-camera with the Test button at the most convenient time. Flashing a surface behind the subject will leave a neat silhouette. For example, you could jump in the air and fire the flash while in midair to freeze the silhouette of you jumping. If you choose to use a torch, the subject must remain still in order to avoid motion blur. Sitting the subject down or having them lean against

something will help with this. Personally, when I include models in an image, I leave them a natural color. If you are lighting models with a torch, try holding the torch close to them for a surreal effect or farther back for a shadowless spot-lit look.

Experimentation

Experimentation is the most important part of light painting–there is no right or wrong way to do anything. Experiment with white balance to color the whole picture a certain shade. To do this, take a picture of a single-color object and set the custom white balance to that image. For example, if you were to take a picture of an orange piece of paper and then go to your custom white-balance settings, if you set that image as the white balance, any following images will have a heavy blue hue; using green as your white-balance setting will give you a magenta hue. Try a range of different colors and see what you get.

You can also experiment with your brushes. For example, you could attach them to string and spin them around while you turn in a circle or run across the frame; or you can spin them in a circle and walk away from the camera to create a spiral tunnel. You could even try this near a large puddle or pond and catch the reflection in the frame for unique symmetrical images. Try using different light sources. I scour every store I walk into for lights and have found that dollar stores are gold mines. You can attach different things to the ends of torches to alter the effect. For example, roll thin paper into tubes and stick that on the end to create long light swords, or attach lights to Hula-hoops and roll them around to create neat, uniform patterns that can weave throughout the scene. If you plan your performance, think of your color scheme, and find a great location, you will get some exciting images and have a blast capturing them.

→ **Right:**
Un-Installation
With light painting it's possible to draw interesting shapes that look like solid structures.

↘ **Below right:**
Bucky
With El wire you can create a smoky effect.

→ **Far right:**
Native Species
Attach LED lights to frames to create cool brushes. The logo in this image is a light stencil, created using a technique I refined on my own. (For a tutorial, visit http://www.flickr.com/groups/lightjunkies/)

→ **Center right:**
Human
Wave tools behind subjects to create silhouettes.

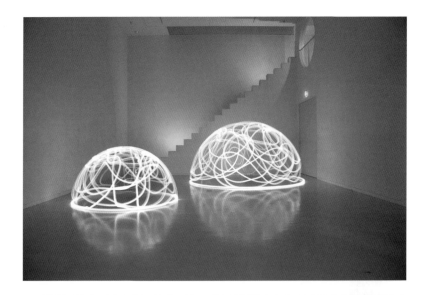

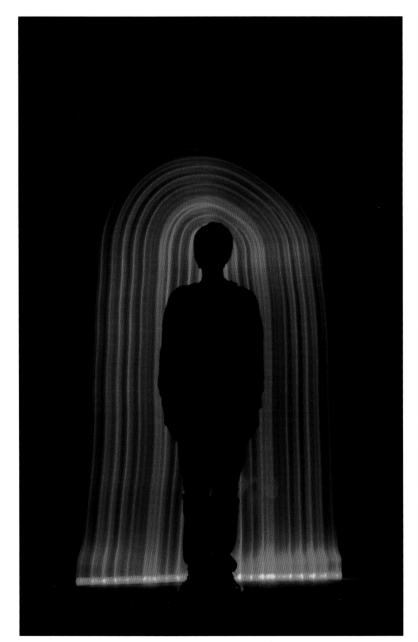

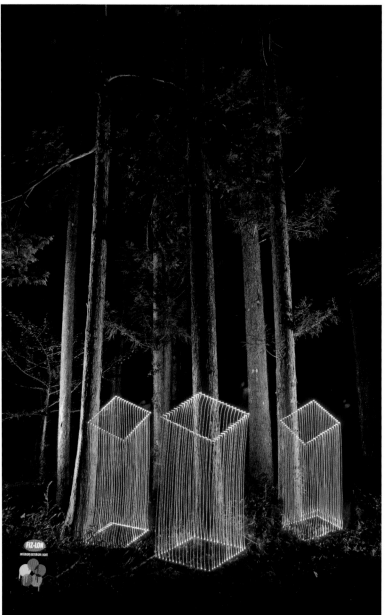

Keeping inspired
A receptive mind

I Have No Idea
I still have no idea about this shot. I couldn't work out what to do that day, so I just grabbed a load of props, put them together to see what worked, and this came out. It wasn't planned, it just happened. Sometimes that's the way it goes.

The Idea

I'm sat here staring at a blank page, looking for inspiration on what to write about being inspired ... Oh the irony!

Let's start at the beginning. A while ago I completed the 365 Days Project, a mammoth photographic project involving taking a different self-portrait every day for a year. When I started, I thought it would be easy. I always have a camera on me and I'm always where my camera is. Simple, just snap away. I *started* thinking it would be easy, but you run out of ideas pretty quickly, and there are only so many arm's-length self-portraits you can take before you either get fed up with them or want to push yourself and your photography further. Inspiration was forced upon me, and I learnt a few tricks along the way.

The Ingredients
> Any camera
> An objective

The Process

I had to look around me for inspiration. What was I doing that day that could influence the image? For example, one day I went to see *The Simpsons Movie*. I had the idea of shooting against a blue sky with clouds and putting a yellow filter on the flash to turn my skin yellow to replicate *The Simpsons* opening title sequence. What was happening in the news? The Air Guitar World Championships were happening in my home town, so I took a self-portrait of me playing air guitar. I made it a bit more interesting by putting on a long wig and trying to look as though I was in a band.

This is how ideas start to develop and flow. As you get on a roll you look around more for inspiration. What else can you do to take a new photo? I wanted to experiment with off-camera flash, so I just started playing around with a load of new equipment to see how it worked and what I could do with it. That's the way that I learn–just experimenting. The more you do, the more you start to think about what else you can do, and the more ideas for other images you think of.

As the days passed, I realized I was creating characters and dressing in costume for more and more of the self-portraits, so I decided to assign one day a week to a costumed self-portrait, which meant one less idea to come up with. I picked Friday, which I dubbed with the highly original name "fancy dress Friday." As these characters became more elaborate, I found myself in increasingly bizarre situations–like being a fully grown, supposed adult, dressed up as a Power Ranger in the middle of a local park. Or standing by

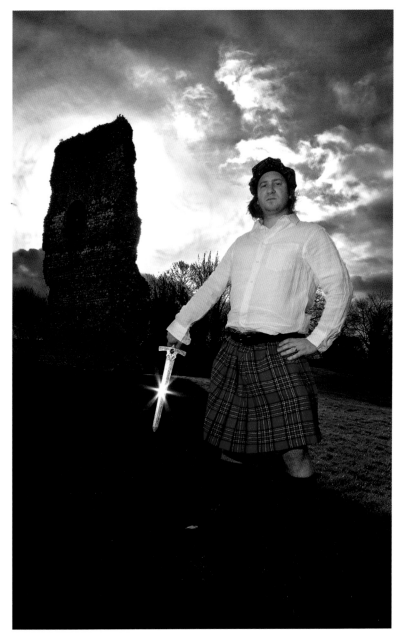
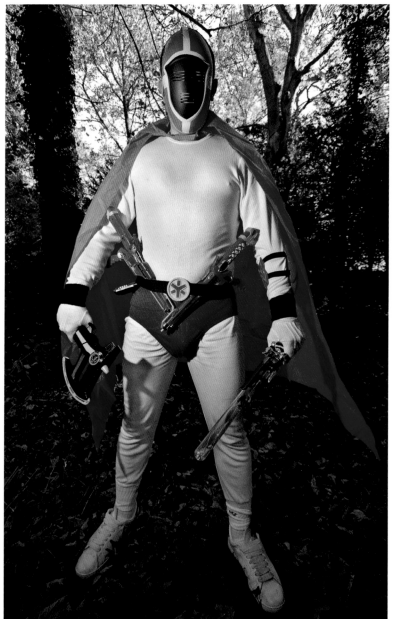

← Left:

Mighty Morphin Power Horse
One of the most bizarre situations I found myself in, dressed in white long johns and a mask, standing in the middle of a local park.

← Far left:

Adam the Brownhorse
This is probably the second most bizarre situation. This shot was inspired by Burns Night. I'm supposed to look like a Scottish warrior, but I don't think I'm scary at all.

→ Right:

I Miss You
The most personal shot of the project, the day we had to put my cat down. I didn't want to show my face, but didn't want *not* to take a shot that day.

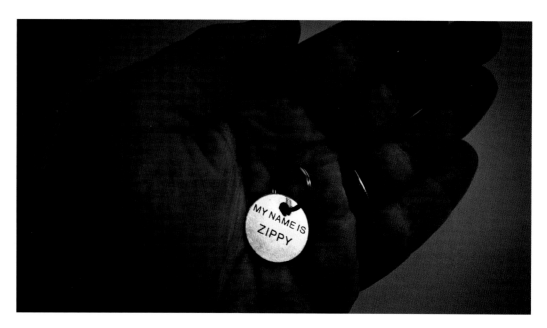

a ruined castle on Burns Night, dressed in a kilt and wig and carrying a sword, with my camera on a tripod and a flash on a stand, taking pictures of myself looking like a Scottish warrior. Lots of people walking their dogs gave me the strangest stares. Settling on this idea of dressing up narrowed the field for ideas so I could concentrate on a specific topic. Narrowing your scope should make it easier to come up with ideas.

The more you do, the more inspiration you get. Once you have the mind-set to look for ideas, you start to see them all around you in the funniest of places. I found ideas watching TV, adverts, and films; I looked in magazines and saw pictures that worked that I could do my own version of. Even going to the supermarket and looking at the brands and marketing gave me ideas. Once I got an idea from looking at the packaging of a child's game. Thinking about the time

of year and what is going on also works. I must have taken a good handful of Christmas images around the festive period.

Something else that really inspired me–and thinking back I might not have been able to complete the project without it–was flickr and the contacts I made through it while doing this project. There was a group of us doing the 365 Days Project at the same time and we commented on each other's pictures every day. Without this encouragement and feedback I would have found the project very difficult to complete, and the fact that I developed a following and had people expecting the latest image from me helped drive me– I felt that I couldn't let people down.

We moved house during the project, which meant that for a week I didn't have access to the Internet or to my flickr friends. That's when I realized that I needed

their support and encouragement to find inspiration. One day we had to put our cat down and I really didn't want to take a picture that day, but I didn't want to stop the project, so I took a photo of my cat's name tag in my hand. What I didn't expect was the number of kind comments and support that I got from the people on flickr. It really helped me get through that tough time. It is not, by any means, a good photo, but it is so personal and special to me, and it wouldn't have been the same without the flickr community.

One thing that really helps (and if you take only one tip from this whole section, make this the one) is to WRITE IDEAS DOWN. I put that in capitals because it is so important. In fact, I'm going to say it again. Write your ideas down. I kept a document on my computer that I could access quickly when I came up with an idea. I'd be watching TV and think "Oh that would be good," so I'd grab the laptop and write it down. There

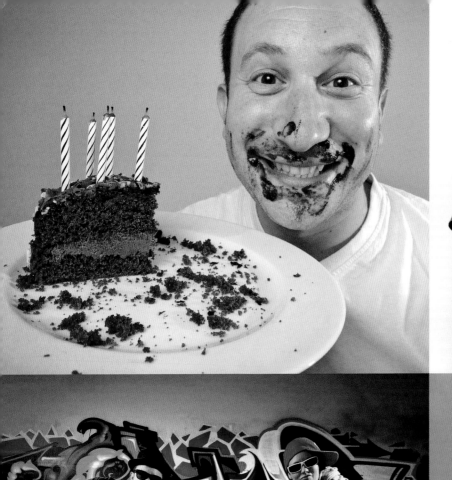
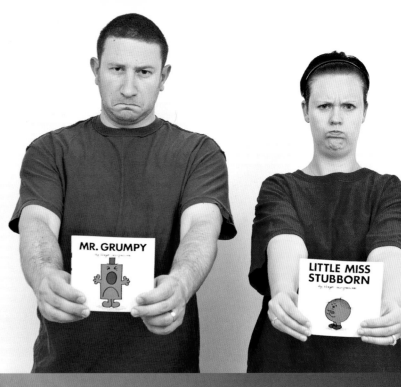

← **Facing page, clockwise from top left:**

Having My Cake and Eating It
This was taken on my birthday, and if you haven't guessed by now, I'm still not totally grown up.

Mr and Mrs
As a joke one Christmas my wife and I got each other Mr Men and Little Miss books that reflect our bad personality traits. I knew there was an idea for an image in them...

Adam Simpson
This shot was inspired by *The Simpsons* movie. It took ages to find a vaguely suitable cloud formation.

Ad Rock and the Funky Fresh Fly Girl
This is my favorite shot of the project—me and my wife just having a laugh. It all came together for this image: the costumes, the props, the location, and the lighting. I'm really proud of this shot.

↖ **Above left:**
In the Movies
The idea for this shot came from a piece of art that we have. It's a very graphic image and I wanted to do a real-life version of it with my wife.

← **Left:**
Pulp Friction
One of my favorites from the project, and an early character. The shot only worked when I pulled a funny face.

were always days when I couldn't think of anything to shoot, so I'd just open up the ideas document and see what shots I could do from the list. There is no way that I would be able to remember all the ideas I come up with—writing them down was invaluable.

Keeping inspired is a funny thing. Motivation is key. You need a goal—something that drives you. It may be that you want to try out something new; it may be that you have a project you have always wanted to do; it may be something totally different. You have to find what works for you. I find the anticipation the hardest. I feel fearful before I start something, but when I do start, I find that it's easy to do and my fears were unjustified. Just like writing this section of the book: I had the fear beforehand, but once I started it kinda fell into place.

If there is something you have always wanted to do, just go out and do it. You don't have to get it right first time. It may take a few attempts, and it may lead to something else that is much better. You'll never know unless you give it a go. So do me a favor ... pick up your camera and do it.

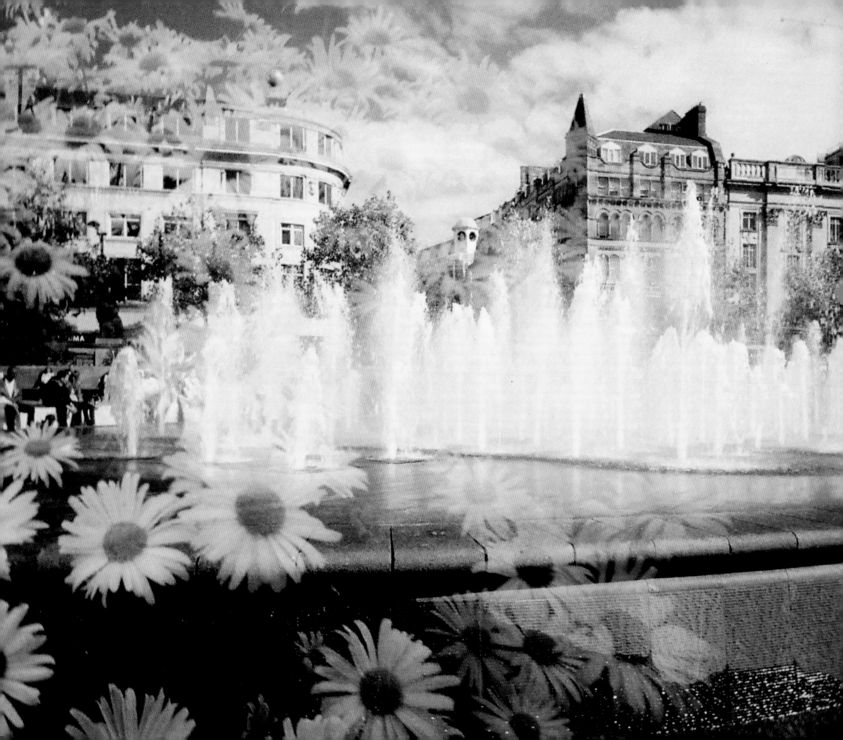

Redscale
Warming up your photography

Urban Conflict
The key to achieving this more subtle effect is overexposure. I shot the daisies 2 stops over and then reshot the fountains, also 2 stops over. There was a lot of light reflecting off that water. The softer tones give it a less bombastic character than generally associated with redscale.

The Idea

Get bold, eye-catching reds, oranges, and golds in your photographs without using filters, even on rainy days. Take some color film and put it in your camera the "wrong way" round so that you are exposing the back of the film to the light instead of the front. Most people respond to this idea in one of two ways: with utter disbelief, or with an astonished "Why?" Well, it really can be done. Try it and see the results for yourself.

The Ingredients

> New roll of color film
> Old roll of film
> Scissors
> Sellotape
> Old wooden peg
> Dark bag (or a lightproof space under the quilt)
> A little patience

The Process

For these photos I used a Vivitar Ultra Wide & Slim (UWS), a palm-sized, lightweight plastic camera with a 22mm plastic lens. Originally given away as a free gift for bank customers in the Far East, you can find Vivitars on eBay and, occasionally, in thrift stores. You can use any camera you like, but lo-fi cameras are particularly suited to this technique. On a practical level, the more high-end cameras have an automatic rewind function, which rewinds the film all the way back into the canister after you've shot it. On top of that, as automatic rewind motors are quite powerful, it is possible that the film will be pulled off the tape while it is still in the camera. With lo-fi cameras you don't have these problems. Another advantage is that the aperture and shutter speed on a Vivitar UWS are fixed at f/11 and 1/125 sec. This means that, on a sunny day, it lets in quite a bit of light, and you need that with redscale.

Aesthetically, redscale can give you vibrant, punchy colours and plenty of vignetting, both of which are expected with the output from lo-fi cameras. They are neither the inevitable nor the most subtle results you can get with redscale, but they are the easiest to achieve, and the ones most people expect.

If you have a very cheap roll of film and you are prepared to waste it (heresy, I know), you can do a practice run in daylight so that you can actually see what you are doing. Otherwise, just take your time. You'll probably need 15 to 20 minutes the first time you try, but once you gain confidence you'll be able to redscale a whole roll in less than five minutes.

An ISO 200 or 400 film would be a good choice for your first try. Because redscale film is reversed, when you take a picture, the light has to travel through the camera and the thick red layer normally on the back of the film, so you need more light to get a reasonable image. This means you usually need to shoot 1, or even 2 stops brighter than intended for the film; 200 film can be exposed in 100 or 50 light conditions. Using faster film (200 or even 400 film) gives you a better chance of getting enough light. Just follow these steps:

1. Clear a table or flat surface and put everything you need in front of you.

2. At the table, carefully pull the old film from its canister, all the way out. Using your scissors, cut the film with a clean, straight cut, leaving about 6in (c. 15cm) attached to the canister. Discard the excess film. You should now have a mostly empty canister with about 6in of film protruding. Put this to one side.

3. Take your new film canister, carefully pull the film leader from it, then cut it to give it a straight edge along the full width of the film. Try to cut as close to the point where the leader opens out as possible so that you don't waste film.

4. Join the new film to the end of the old film, taking care to attach the new film the "wrong way" round. To do this, place the old film canister in front of you so that the shiny side (the front) of the remaining 6in (c. 15cm) of film is facing you. Place the new film canister in front of you so that about 2-3in (5-7.5cm) of the new film—and no more—is exposed, with the matte side (the back) of the film facing you.

→ **Right:**
Life Force
In order to achieve these greens and blues, I over-exposed both layers of the composition as much as I could get away with. There's more to redscale than red.

↘ **Below right:**
Dominates
This was double-exposed, but very little of the first layer came through; I deliberately underexposed it to keep the dark tones in the background. Exposing the second layer over such an expanse of white not only provides a good contrast, it also adds to the overall level of overexposure, which, in turn, results in this more muted color palette.

→ **Far right:**
The Great Escape!
This was shot conventionally, then redscaled and shot again. Once you've gained confidence, you can start to really experiment with the technique. The natural print-film colors blend with the characteristic redscale tones.

5. Cut a piece of Sellotape and use this to join the two film strips. Wrap the tape around both sides to make sure the film is secure. You can overlap the film a little if you like, but try to avoid wrinkles and excessive layers of tape. Don't use electrical tape for this–it's too thick and may cause your film to jam in the canister.

6. The film strips from your two film canisters should now be joined so that, from whichever side you view it, the section on one side of the Sellotape is shiny and the section on the other side is matte. Check this to make sure you have joined your film strips correctly.

7. You now have to wind the new film all the way into the old film canister. Take one half of a wooden peg, stick it in the round hole at the top of the old canister, and rotate it 360˚; you should see the film moving from the new canister into the old canister. If you are confident that the film is moving in the right direction, put the two canisters and the peg into your dark bag (or get under your quilt in a darkened room) and continue to turn the peg in that direction until all the film has been spooled into the old canister. You'll know this is done when the new canister is touching the old one.

8. You can now take the canisters back into the light. Pull the new (now empty) canister a little so that there is some give in the film and cut it off. Cut your own leader into your newly redscaled roll of film.

9. Use a sticker to identify the old canister or keep a note of what film you have redscaled.

10. Place the film in your camera of choice (try to avoid cameras with wind-on motors unless you are supremely confident in the strength of your taping), and you are good to go.

General principles

It is generally understood that, for optimal results, redscale film should be overexposed by 2 stops. This gives the light a better chance to penetrate the red layer on the back of the film. So, if you have redscaled an ISO 400 film, the accepted wisdom is that you should expose it at ISO 100. Try not to get too uptight about that though–it's more helpful to think of what mood or tones you are trying to achieve and change your exposure according to that. Optimal exposure leads to strong red, orange, and gold tones with a little vignetting, and matte black shadow tones. Each extra stop that you overexpose decreases the saturation of those red tones, and each stop under-exposed increases it. As you overexpose, more subtle yellow, tobacco, and even sepia tones will take over, and there will sometimes be considerably less vignetting. The more you underexpose, the darker and more intense the image will be and the greater the degree of vignetting you will get.

While the bold oranges and reds are dramatic, don't fall into the trap of thinking this is all you can achieve with redscale. Given a chance, redscale will pick up greens and blues. This generous exposure latitude works beautifully with double exposures, and, because of the method of making redscale, if you fancy some hybrid double exposures, you can even shoot your first layer of film before you redscale it. Don't be afraid to try different types of film–even slide film can be redscaled if you have the budget and the inclination. Once you've shot your carefully prepared film, it can be developed like any color print film. Give it a try. You really are limited only by your imagination.

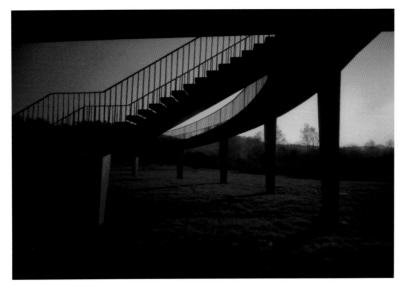

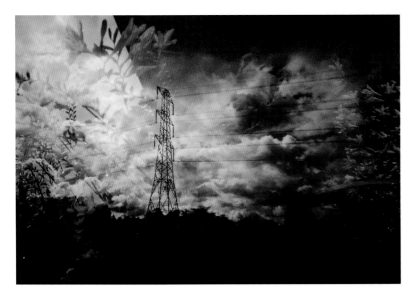

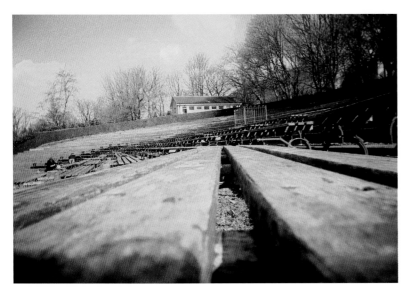

← **Top, far left:**

Under the Overpass

Another image taken from my first roll of redscale film, and underexposed by about 1 stop. This uses the bright sun to get the correct exposure and the colors I wanted, but hides it behind an interesting silhouette.

← **Top, center :**

The Dead Live On

The overall color of this image is more pink in tone. Experiment with different film and levels of exposure to find the tones you most like to work with.

← **Top left:**

The Gathering Storm

I used natural textures to underpin a double exposure, but this time significantly underexposed the film on both layers. The second layer was taken from the passenger seat of a car, so there is motion blur as well. This adds to the dark mood and vignetting in the final image.

↙ **Bottom, far left:**

Glastonbury Patterns

If you want an abstract image, try double exposing without fastidiously lining up your film; frame boundaries can sometimes make interesting juxtapositions.

↙ **Bottom, center:**

After the Battle

I took this on the very first roll of redscale film I was given. Placing a dazzling low winter sun behind a suitable tree and shooting straight into it provided me with the bright light conditions required to overexpose by 1 stop.

↙ **Bottom left:**

Red Decay

This was taken in optimal conditions—full sunshine on a very bright spring day—so there was no need for silhouettes or sun flares to get the best from the redscale tones. Placing the camera on some old wooden benches in an amphitheater gave me an unusual angle and a wide viewpoint full of textures and tones.

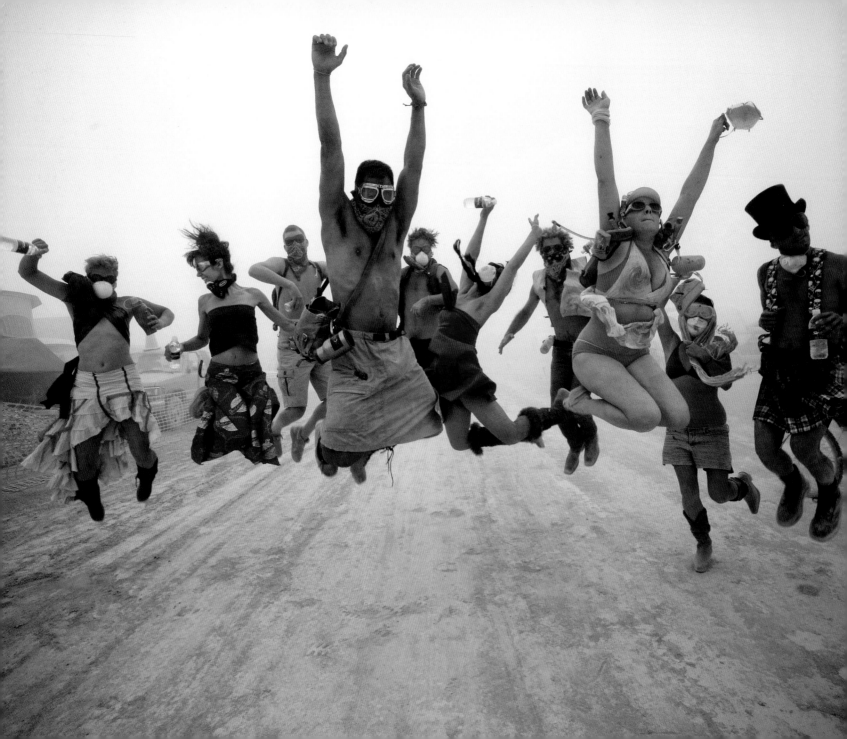

Jump shots
A true show of emotion

Relaxomats Jump
Stagger large groups for an image with greater depth rather than having your subjects jump in a single-file line.

The Idea

Renowned portrait photographer Philippe Halsman started a phenomenon in the late 1950s when he began wrapping photo shoots by persuading his celebrity (and often esteemed and stoic) subjects to jump. He coined the term "jumpology" and employed it as a technique to break the mask that people often wear when sitting for a portrait. Try it yourself to get some exciting shots of friends and family; don't let the same old vacation shots in front of buildings or monuments get you down.

The Ingredients

> Any type of camera
> Any number of friends
> A lot of energy
> (No trampoline necessary!)

The Process

Sometimes the willing subject of your next portrait masterpiece simply doesn't know what to do. "Smile or no smile?" "What do I do with my hands?" Most people default to their ingrained "Say cheese!" expression. It can be tough to break their habit if this look isn't what you're going for. Fear not! A momentary reprieve from natural self-consciousness will shake things up and change the dynamic of the shoot. Your friends might not be professional models, but jumping is something that most anyone can do, and it will lighten the mood and reveal their true personalities.

Make sure the participants of your jump shot know they don't need to be athletic to look good in the photo. I always encourage unseasoned jumpers to kick their own butt when they leap. Bent knees will give the impression of more space between them and the ground than a quick, straight-legged hop. An alternative is to find objects to jump from: park benches, haystacks, moving vehicles—even smaller humans. Just make sure they won't hurt themselves! Another way to give your subjects superhuman height is to shoot from a low angle, close to the ground. For outdoor settings, experiment with framing the shot so that they are completely above the horizon. Be sure to remind your subjects to remove valuable objects from their pockets before you give the jump command. The show of emotion that results from a smashed cell phone is something you want to avoid.

6

Steph Goralnick

Keep in mind that your goal is to capture the moment when the jumper is suspended in midair. In order to freeze motion, you'll want to use the fastest shutter speed available given your light situation. In low light or backlit situations, when you've forgotten to bring your studio strobes, consider a silhouette. While their Oscar-winning facial expression might not be visible, the unexpected ways in which "accessories" such as hair or clothing react can be just as expressive when they become the focus of the image.

Multiple exposures

When photographing enthusiastic and highly energetic friends, you may find yourself with a slew of winning images. If you have several shots with the same background and can't pick a favorite, try layering them in Photoshop for a multiple exposure composition that showcases the full range of your subject's motion. Film shooters with a skill for advance planning can, of course, achieve this technique in-camera. For digital images, load all the photos into one Photoshop document with each as a separate layer set to 50% opacity. Try using Masks or setting the Layer Transparency to Multiply in areas where the jumper overlaps him- or herself. If you didn't use a tripod, consider using the script to "Load files into stack." Be sure to check "Automatically align source images" to get the backgrounds to line up exactly.

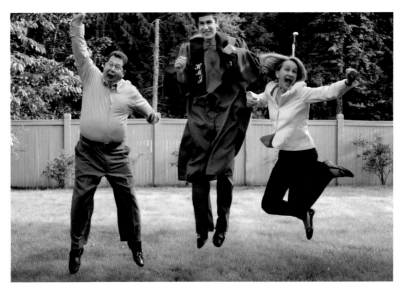

← **Left:**
And Circumstance
Portrait subjects don't know what to do with their hands or how to smile? Have them jump!

↙ **Below left:**
Flying Sand
It's not just the action of your subject you can freeze— get them to kick or throw something when they leap.

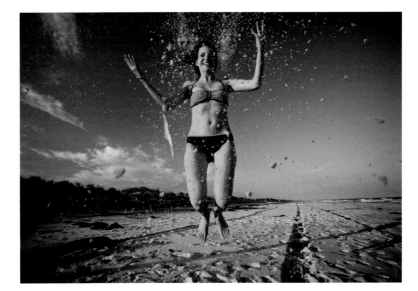

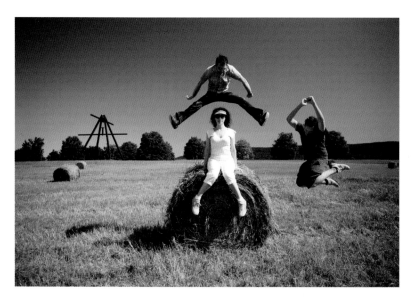

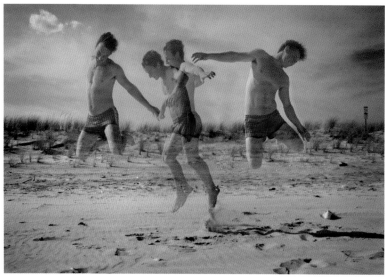

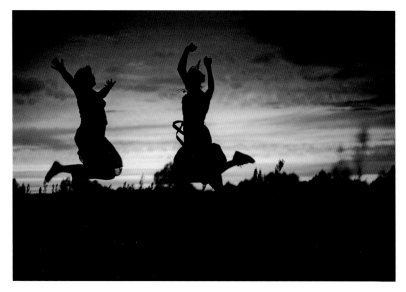

↗ **Above right:**
Beachrobatics
Take a multiple exposure in-camera on film, or layer several images in Photoshop to achieve a similar effect.

↑ **Above:**
Hay Jump
For superhuman height, direct participants to jump from objects, leap above the horizon line, kick their own butts, or all of the above.

→ **Right:**
Farm Girls
Try a silhouette, especially during sunset or when your model is sporting distinctive hair or clothing.

Large groups

If you thought capturing a group shot without anyone blinking was a challenge, try getting them all in the air at once! If possible, find an area with lots of space, like an empty warehouse or a vast desert. Instead of having everyone stand in single file, stagger them so that there are people in the foreground, middle ground, and background. Make sure they are spaced so that the folks in the back will be visible. Some people are naturally inclined to squat down in an attempt to spring high into the air on the count of three, but this tends to result in everyone jumping at different times. Catching jumpers midair can be difficult, especially with a large group. So while it might be counterintuitive, don't delete the discard shots where you missed the jump. Sometimes the gesture of a failed attempt can turn out to be the most interesting and dynamic.

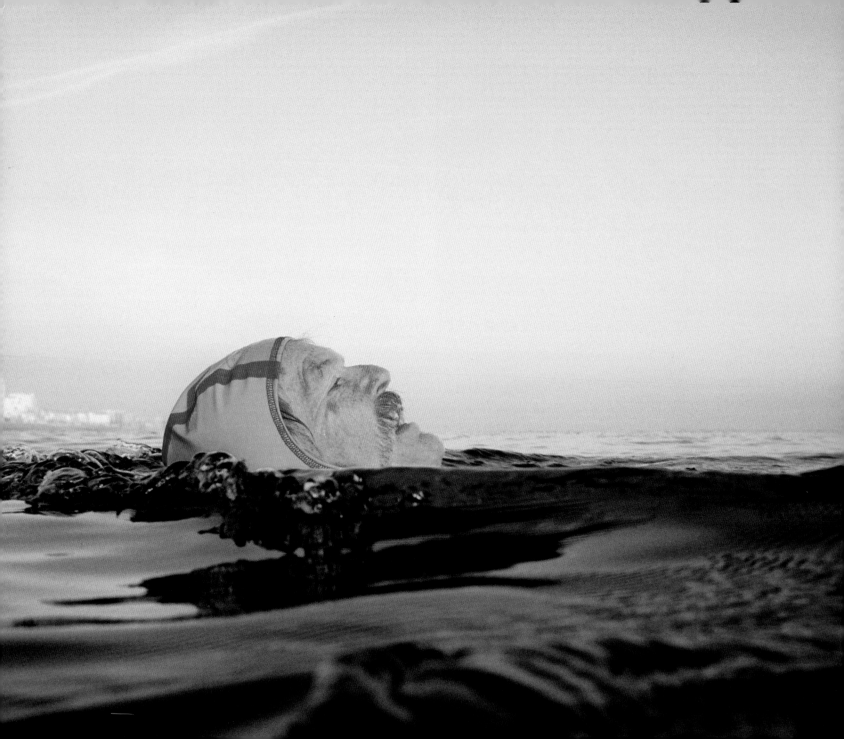

In the water
A unique angle

Backstroke
This type of image is difficult to capture from a boat or on land; the only way to get this sort of intimacy is to get wet.

The Idea

Water and cameras are usually not a good mix, for obvious reasons, but if you own a waterproof camera you can have great fun getting shots in wet and wild conditions. It's not just swimmers who can benefit from shooting with a waterproof camera; if you are into other watersports or you just want to take photos in bad weather, there is a huge benefit in having a camera you can take into all sorts of conditions. A big part of getting unique photos is being in a position from which photos are not usually taken—a waterproof camera will allow you to capture images you would not have dared to try shooting before.

The Ingredients

> Waterproof camera OR
> Camera and waterproof housing
> Flippers
> Water

The Process
Camera options

Waterproof camera gear can cost you anything from a tenner to thousands! In this day and age we are spoilt for choice. The cheapest option is a disposable waterproof film camera. These usually cost just a little more than their land-loving counterparts. They are great if you know that you don't want to become a serious in-the-water shooter and you only need the camera for a short time—while on a beach holiday, for example. They usually come loaded with ISO 400 films so they're good for most daylight conditions. An advantage of the disposable option is that you don't have to worry about focusing, which can be a real headache when you are in the water.

The next most affordable option is a waterproof digital compact. Some models don't even look waterproof. Most manufacturers produce a waterproof model and, surprisingly, these waterproof compacts don't cost much more than nonwaterproof models with similar specs. The major drawback with this type of camera is shutter lag. Shutter lag is the delay between you pressing the shutter button and the picture being taken. If you are in the water you are, at some point, going to want to capture action; for this, shutter lag can be quite annoying as it means you will constantly miss the moment you are trying to capture. I tested five waterproof digital cameras for a magazine. I had to swim alongside a swimmer, taking multiple shots, hoping I would get what I wanted. I ended up with one good shot for every 30; usually it takes me about five.

The most expensive option is to get a waterproof housing for your current camera; the matching case for a digital compact will sometimes cost as much as the camera again. This option is for the more serious water shooter, and it's quite a risky option as you could end up damaging your camera if anything goes wrong with the housing.

My weapon of choice is the Nikonos-V (made by Nikon). The Nikonos-V was designed in 1984 and is considered by many to be the classic 35mm waterproof camera. The shutter speed is set automatically via its through-the-lens (TTL) light metering. (See page 284 for more on light metering.) All the controls are designed for use by fingers encased in diving gloves, so it's really easy to use. The simple controls make it a great camera to use out of the water too.

Top tips

My top tip for photography on the surface of water is to watch out for water drops on the lens: they can cause areas of your images to be distorted and blurred because each water drop acts as a little lens of its own. This effect is even worse on the smaller lenses of digital compacts and disposable cameras as the droplets of water are proportionally bigger. There is a simple solution to this problem–lick the lens. A thin coating of saliva will stop water droplets adhering to the lens.

For film shooters my advice is to try to use at least half, if not a whole roll of film every time you go in the water. I say this for two reasons: first, because you will probably be moving at least a little most of the time, so your shots might not turn out how you expected them; and second, when you come to

→ **Right:**
Christmas Day Dip
I took this at an annual event that attracts many photographers. Because I was in the water, I was able to get unique shots. I could capture the faces of the swimmers as the shock of the cold water hit them and, at the same time, get the crowd in the background.

↘ **Below right:**
Distortion
Once your camera has been submerged, make sure there are no drops on the lens.

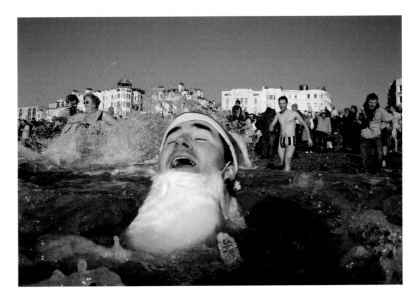

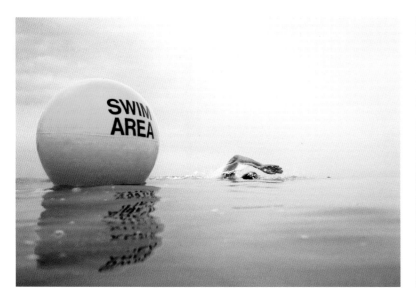

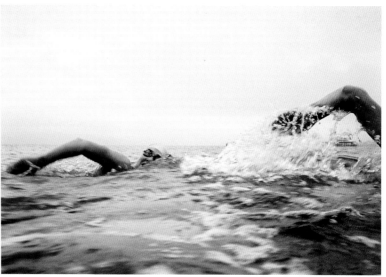

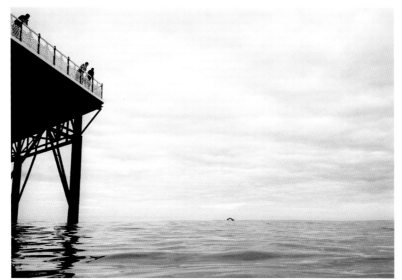

↑ Above:
Swim Area
I used an object to add an extra something to this shot. The buoy adds depth and a sense of scale, so it helps draw your eye to the swimmer.

↗ Above right:
Passing Swimmers
Trying to get a shot like this as a swimmer passes you is hit-and-miss because you have to rely on their arm being out of the water and in the right pose as they pass.

→ Right:
Lonely Swimmer
I wanted the arm of this swimmer just visible—the end of the pier gives a sense of scale to the image and makes the swimmer seem tiny and alone.

change your film it is quite time-consuming as you have to get out of the water and dry both yourself and the camera before you can change the film. It is quite a palaver. If you make sure that you enter the water with a full or half-full camera, this means that you have enough exposures available to get a decent amount of shooting done. There is nothing worse than firing only three shots and then having to get out!

Shooting swimmers

Photos taken in the sea or a large lake can have a grand sense of scale, but capturing action in the water can be tricky. When I am shooting my swimmer action shots, I try to capture an arm out of the water to create a really dynamic pose. I usually swim alongside them, looking through the viewfinder, and wait for the arm to get to the right point. I stick with them for a few strokes so I know I have the shot.

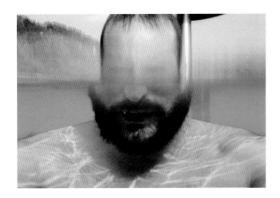

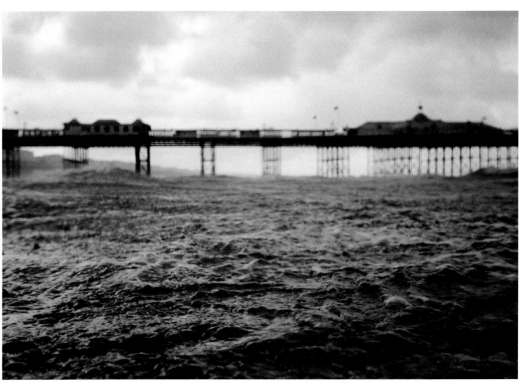

↑ **Above top:**
Self-Portrait
The odd effect in this self-portrait is due to me being half submerged: objects appear closer under water.

↑ **Above bottom:**
Blowing Bubbles
Bubbles are great fun to shoot; underwater they can look like mercury.

Capturing this type of shot on a digital compact can be really hard because of shutter lag. If your camera has a Burst mode (a setting that allows it to take lots of images in quick succession), use it; if not, just take as many photos as you can till you get what you want. (For more on shutter lag see Camera types on page 280.) If you are trying to capture action in the water, a pair of flippers is essential because you need to be able to swim and maneuver quickly. Trying to keep up with someone who is using their arms and legs when you can use your legs alone is quite a job!

Surface and half-submerged shots
The surface of the water can make really interesting shots on its own, as the patterns differ depending on the conditions. In the rain there is a real dreamlike quality to it. Next time it rains and you are near the water, why not take a quick dip?

Taking shots while you are half-submerged has the bizarre effect of making the part of the object in the water look bigger than the part above the surface. This is caused by the optical qualities of

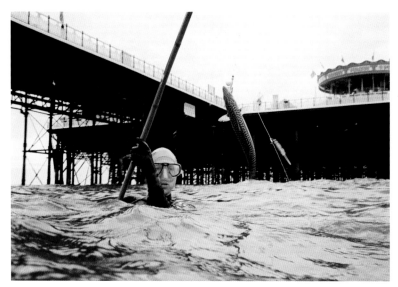

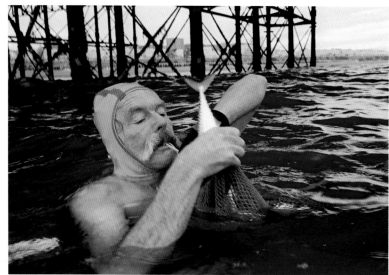

← **Left:**
Rainy Swim
The water surface changes radically depending on the weather conditions, which makes for interesting images.

↗ **Top, above and right:**
Sea Dwellers
"Sea dwellers" can be really interesting characters, like Yvo and David, who go fishing while they swim and provide me with breakfast and great subject matter.

→ **Right:**
Henry Mid-Stroke
A swimmer mid-stroke would be near-impossible to capture on a digital compact because of the shutter lag.

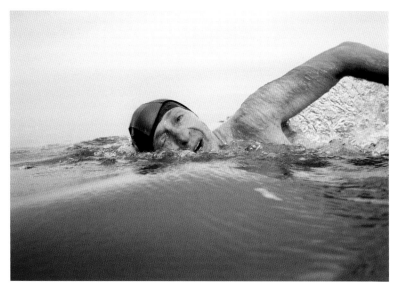

water; objects under water appear closer than they do on the surface. Getting these shots can be particularly tricky, depending on what camera you are using, as you have to position the lens half in and half out of the water. The smaller the lens, the harder this will be. With my Nikonos-V, and with disposable cameras, the image you see through the viewfinder is not what ends up on film as the viewfinder lens is just above the lens that captures the image. This means that, although you see a half-in and half-out image in the viewfinder, the "real" lens will actually be totally submerged. I have found that the best option for getting these shots is to ask the person you are shooting (if you are, in fact, shooting a person), "Is the lens half-submerged?" Get them to tell you whether to move your camera up or down. If it's a self-portrait you're taking, it's as simple as checking that the lens is half-submerged yourself.

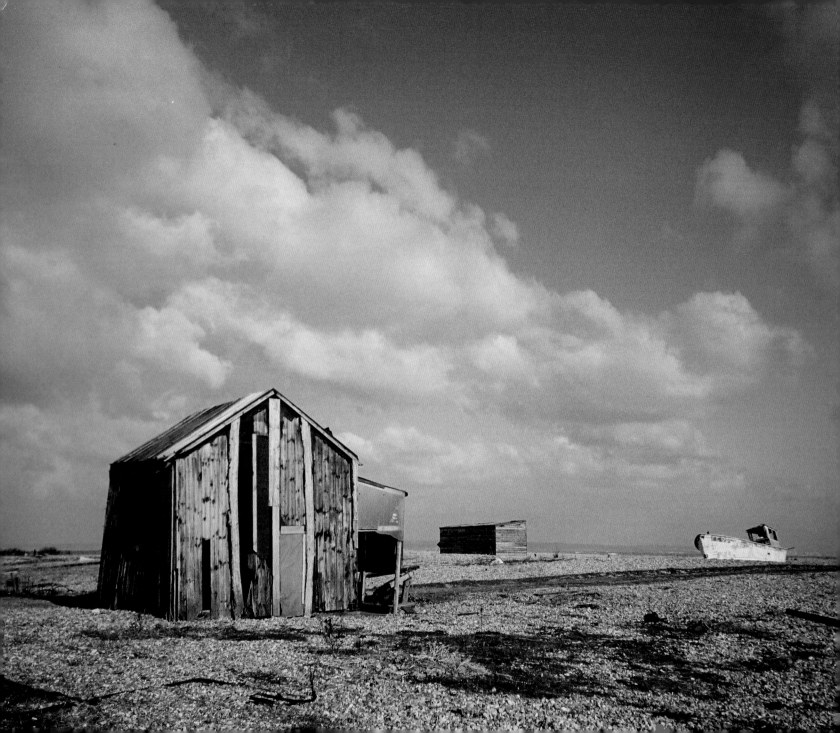

Landscapes
Just you and the scene

Kevin Meredith

Dungeness Huts
Half the battle in getting good landscape photos is finding a great location. Use online maps to help you in your search.

The Idea

Landscape photography is one of the more relaxing types of photography. You don't have to worry about people adversely affecting your images; it's just you and the big wide world.

The Ingredients

> Any camera
> Tripod
> Shutter release
> Wide open space
> Good pair of walking boots

The Process
Composition

Composition is really important for landscapes, so spend some time considering it. If the horizon is going to be obvious in your image, don't put it in the middle of your composition unless there is a really good reason to. It's better to give more weight to either the land or the sky. I usually line my horizon one-third or two-thirds of the way down the image, following the rule of thirds. (You can read more about the rule of thirds under Composition on page 282.) With open landscapes it's good to have something for the viewer to focus on—a hut or a tree stump, for instance—otherwise their eye will wander. Having a point of interest, especially in the foreground, helps to give a sense of depth to an image.

An alternative to a single point of interest is to make use of lead-in lines. These are elements in an image—a road, a row of trees, a line of footprints—that lead the viewer's eye through the image to a specific point.

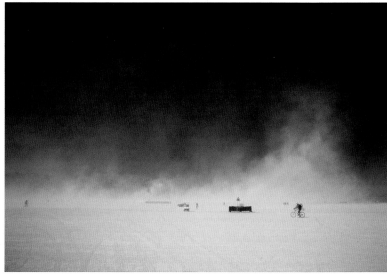

Depth of field

For the most part, when you are trying to capture a landscape, you want as much of it in focus as possible, from what is right in front of you to what is way off in the distance, so it's best to select a small aperture (which means a big f-number–around f/11). With this setting you will get as much in focus as possible. Landscape pictures need to be sharp; people are willing to forgive a blurry street portrait that was caught in the moment, but there is no excuse for not capturing a mountain in super-sharp detail, as it is not going anywhere! As I mentioned before, a small aperture will help you get your images as sharp as possible, but don't be tempted to close your aperture right down to the smallest it can go: your images might start to get more blurry due to something called diffraction.

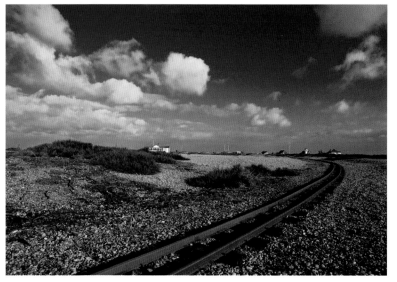

↖ **Above left:**
Sussex Downs
This image shows a good application of the rule of thirds: the horizon line is two-thirds of the way down.

↑ **Above:**
Dust Storm at Burning Man
Make the weather a feature of your landscapes. I added emphasis to the sky, and therefore the dust storm, by placing the horizon two-thirds down the image.

← **Left:**
Dungeness Railway
The gentle curve of the track draws the viewer's eye into the image. This is referred to as a lead-in line.

When it comes to lens selection for landscapes, the wider the better, as wide lenses have a greater depth of field, but avoid lenses that are so wide they cause barrel distortion, as this will leave you with a curved horizon line. There is no easy rule regarding how wide a lens you can use without getting this distortion– it all depends on the quality of the lens.

Camera shake

If you are shooting with a small aperture, less light will enter the camera, so you will need a slower shutter speed, which increases the risk of camera shake. To avoid camera shake, hard-core landscape photographers always use a tripod. One of my top tips for buying a tripod is, get the lightest one possible. At the time it felt like I spent quite a bit on mine, but with hindsight I wish I had spent a little more and got the superlight carbon-fiber version. Remember, when you are lugging your tripod, you will be carrying your camera gear too!

If you don't want to shell out lots of money or lug a big tripod around, there are many good mini tripods that will fit into you camera bag. One of the popular options is the Gorillapod, which is available in small versions for compact cameras and bigger ones for SLRs.

If you don't have a tripod, try to find something sturdy to rest your camera on, like a fence or a tree. Failing that, I love getting down and dirty and shooting from the ground.

→ **Right:**
Yosemite National Park
Using a circular polarizer will give you deep-blue skies.

As an extra insurance against camera shake, it's a good idea to use a cable release. If you don't have one, you can always use your camera's Self-Timer mode; this will remove the need for you to press the shutter button and the consequent risk of camera shake.

The horizon

Getting the horizon level by eye can be tricky and, even though it is easy to fix on computer, it's good to get it right first time round. A really cheap, but handy photography accessory is a hot-shoe spirit level. It is designed to slide into the flash hot shoe of your camera and will help you to get your camera level.

The sky

Landscapes can be made or broken by a killer sky. One way to get the blue to pop out of the sky is to use a circular polarizing filter to cut out reflective light. There is a lot of reflective light from water particles in the air, which we see as haze. If you cut that out, the sky will appear a deeper blue.

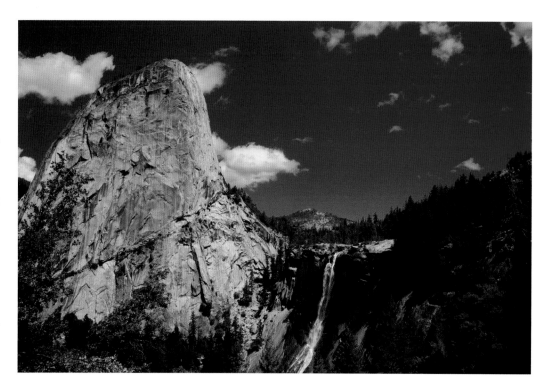

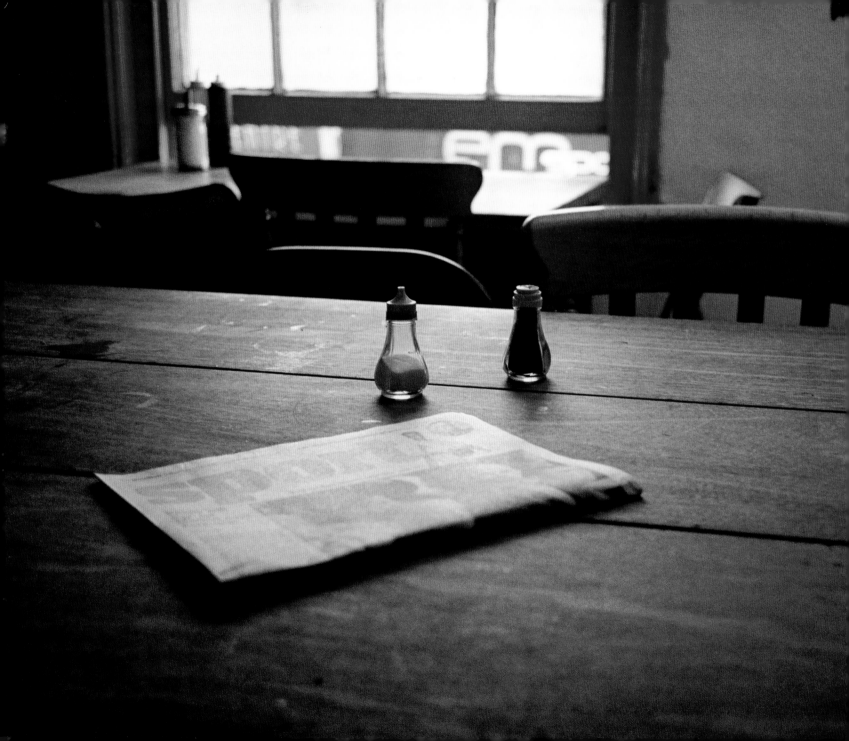

Everyday subjects
Wonder in the mundane

Salt and Pepper
Time spent in a cafe waiting for a meal to be served, or time spent waiting for a bus, can be used to take photos. Why not get a shot out of it?

The Idea

It is not always essential to have a fantastic subject to shoot; sometimes the mundane and the everyday make wonderful photos. Interesting images can be made of a great many seemingly ordinary things: a solitary leaf, abandoned clothing, memorial flowers by the roadside. One way to develop as a photographer is to take more photos–after all, practice makes perfect. The questions are, what do you take photos of, and when do you find time to take them?

The Ingredients

> Any camera
> Shot list

The Process

One very simple thing you should do to ensure that you *can* always get good photos is make sure you always have a camera on you. I must admit that I go a bit overboard with this and always have two cameras on me: one loaded with slide film to be cross-processed and another loaded with negative film so I know I am covered for all eventualities. Even if you are the type of photographer who likes to shoot very considered photos, with your DSLR on a tripod, think of a small camera as a kind of sketchbook. Camera phones are not known for their quality, but I bet everyone reading this has one. If you are just getting serious about photography, a lot of people will tell you to get a DSLR because a DSLR you will allow you the greatest creative control over your photographs. While that may be true, you won't be able to carry it around with you all the time so you will miss shots. Think carefully about what you want from your camera; size should be a real consideration.

Kevin Meredith

Scavenger hunt

A good exercise to get the creative juices flowing, and one that I use when teaching, is to go on a photographic scavenger hunt. It's best to do this with friends, so sit down together and make your list. I issue each student with a list of 66 things to shoot. I choose 66 because this roughly fits onto two rolls of film, allowing for a few mistakes, and should take about three hours. You can, of course, shoot on digital, but as this is meant to be a quickfire exercise you shouldn't reshoot a photo once you've taken it, so no deleting. It is very easy to spot a missing file number!

I always make sure that some of the things listed are very literal (for example, food I ate, perspective, silhouette, red, etc.), but I also include things that are more open to interpretation (religious icon, something natural, epitome of tackiness, etc.). It's a good idea to include a few things that are specific to your location, so, for instance, if you were scavenging in New York you could include "yellow cab." That example is a bit obvious, but you get the idea.

Photo scavenging is good because it forces you to take shots of things you might not otherwise consider shooting. I've been using this exercise to teach for a year now and whenever I run my course I take part. I always get some great photos out of it too so it's not just for beginners. The reason I run this exercise is because I find that if you just go "photo walking," shots can be very unfocused, unfocused, that is, in the mental rather than the optical way.

→ **Right:**
Pink Coat
Keep an eye out for abandoned objects or things that are not in their "right" place.

↘ **Below right:**
Graffiti
When I took this, I decided to concentrate on the small detail of the padlock rather than shoot the whole piece.

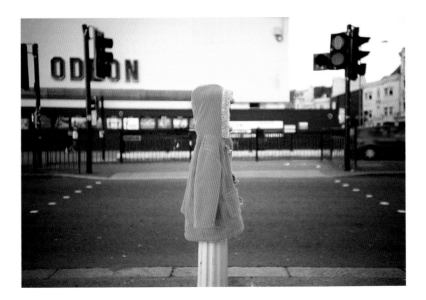

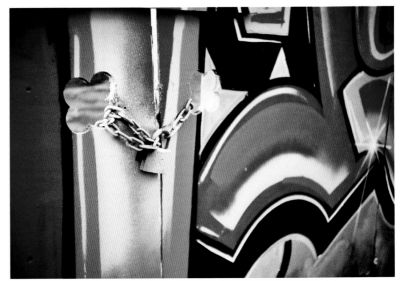

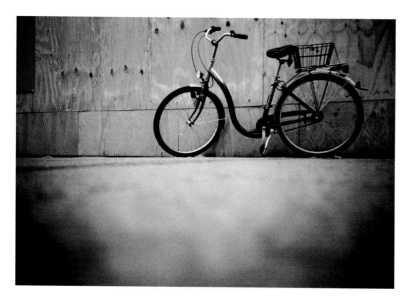

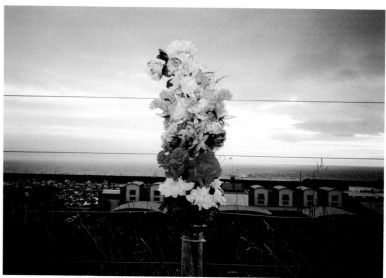

↑ Above:
Bike
Shooting everyday items from different angles can make them more interesting.

↗ Above right:
Flowers
Things like roadside tributes can make interesting photos because of the assumed story behind them.

→ Right:
Grounded Road Sign
Color contrasts can make objects jump out—the red of this road sign really pops out against the dull gray ground.

Start obsessing

Moving on from the scavenger-hunt idea, it's worthwhile setting yourself mini projects, which can turn into lifelong obsessions. You can use the result of a hunt to kickstart a mini project. If there was one shot you took that particularly interested you, try to go after that subject again. At times single images aren't very strong, but with lots of them, they become greater than the sum of their parts. I find that people are often more impressed with a collection of images of the same thing than a single image–people tend to be fascinated by other people's obsessions. I am a sucker for shooting shoes and full English breakfasts.

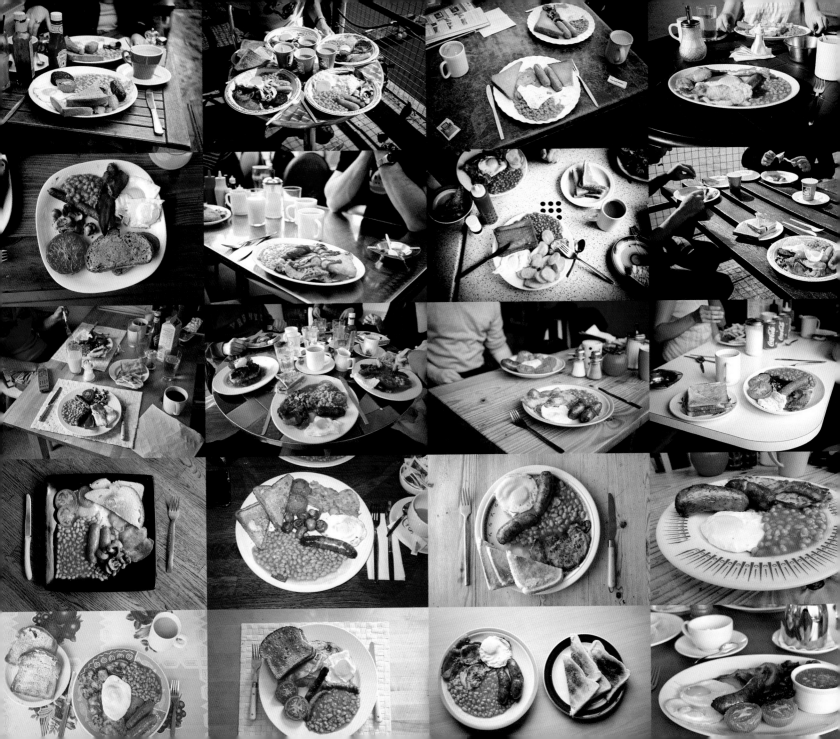

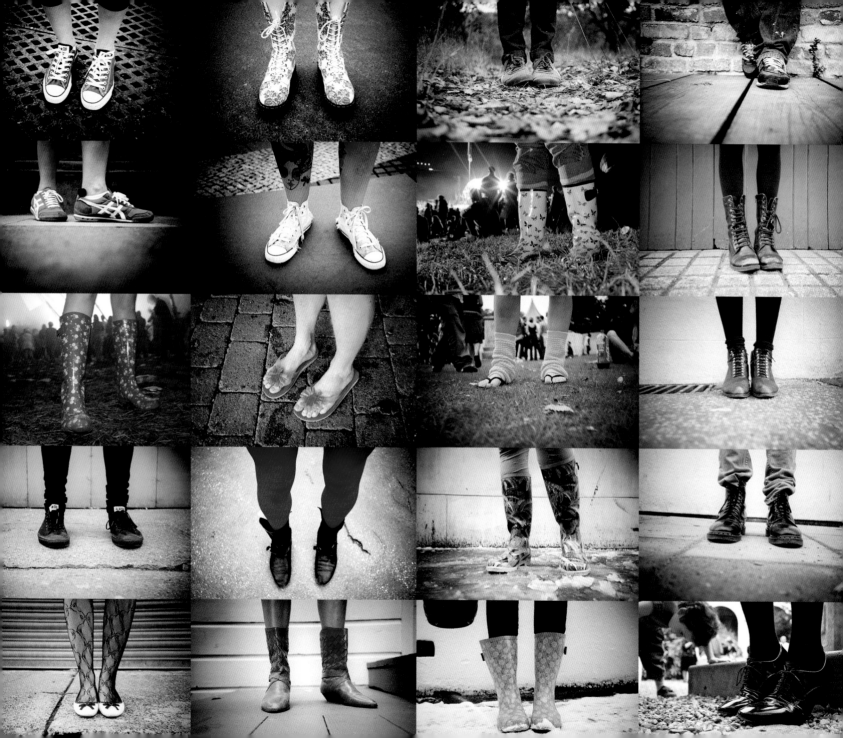

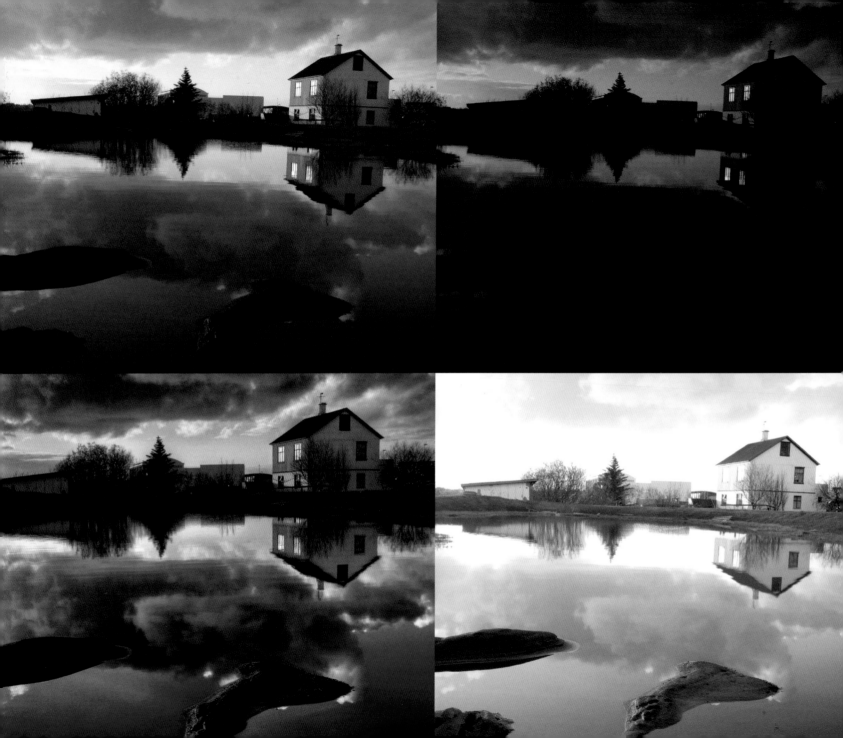

HDR: High dynamic range
Hyperrealistic, painterly images

← Clockwise from top left:
A standard exposure will capture the midtone detail.

Underexposing will capture the highlights.

Overexposing will record the dark elements.

Combining all three gives rich color and detail.

The Idea

Most landscape scenes have such a wide dynamic range (that is, such a difference between the brightest parts and the darkest shadows), it can't be captured in its entirety, even with a state-of-the-art DSLR camera. What you get is either blown-out highlights in the sky or a foreground that is too dark and with no visible detail.

The idea behind this remedy is to take three exposures–one normally exposed to get the midtone detail, one underexposed to register all the highlights, and one overexposed to capture the wonderful dark elements–and then combine these with the help of image-processing software. The result is an image in which every part has loads of wonderful detail, often resembling a hyperrealistic oil painting.

The Ingredients

> DSLR camera or digital camera with AEB (auto exposure bracketing)
> Sturdy tripod
> Remote shutter release (optional, but highly recommended)
> HDR image-processing software
> Image-manipulation software (optional, but highly recommended)

The Process

This HDR method can be applied to any still-life subject conceivable. Landscapes, cars, machinery, and macro are recurring themes in HDR images. Even scenes which are not entirely still life–coastal rocks with heavy waves beating them, waterfalls, and fields with vegetation moving gently in the wind–can make for very nice images. It's all up to what sparks the photographer's interest. The most common mistake people make is to shoot dull subjects without thinking much about composition or what the image should be about. Neglecting these aspects is guaranteed to produce bad images.

HDR photography provides the greatest advantage in situations where the dynamic range exeeds what your camera can handle. Let's take this example of reflections in a pond with beautiful buildings next to it, against a magnificent sunset. Most equipment would give you either white sky with some detail in the buildings or all the colors in the sky with a silhouette of the building. HDR photography allows you to combine the detail captured with different exposures to render one image in which every detail is clearly visible.

Ásmundur Thorkelsson

Preparing for the shot

When you've found something that inspires you, set up your tripod and compose the image by looking through your camera's viewfinder. This is where things start to get a bit technical. Set your camera to Aperture Priority mode because you want the aperture to remain fixed throughout the consecutive exposures. You can, of course, choose any aperture you like. You should also set your camera to AEB (auto exposure bracketing). This tells your camera to take three (or even five or seven if you have a pro camera) consecutive exposures. If you select AEB, your camera will also expect you to select the interval between the f-stop of each exposure. This can be done in increments from ⅓ stop up to 2 stops in most camera models. I recommend going the whole hog with 2 stops between exposures. This will enable you to capture more dynamic range and retrieve more information on the tonal values in shadows and highlights.

There are three more camera settings that must be taken care of before you commence your shoot. First, it's great to have the shooting mode set to Burst or Continuous Shooting if possible. This is mostly a matter of convenience–with it you will only have to press the shutter-release button once for each set of exposures you take. Second, set the ISO to 100 or the lowest setting available. This is to make sure that as little noise (graininess) as possible is recorded, as noise tends to increase almost exponentially during the image processing. Third, you should set the camera to write RAW files to your memory card rather than JPEGs, as they store more detail on each pixel than JPEGs do.

Finally, I recommend that you hook a wireless remote or cable shutter-release botton to your camera to avoid any movement or shaking. Camera shake can result in the three exposures being imperfectly aligned, which can sometimes be a bit difficult to correct. And now, I think it's time to start shooting.

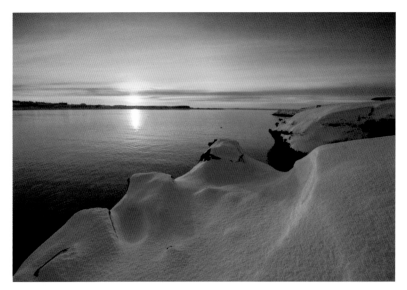

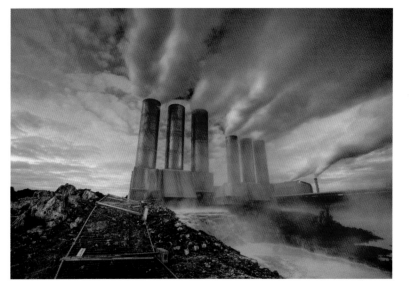

← **Left:**
Remains of the Day
The use of HDR makes it easy to capture the formation of the snow against the setting sun.

↙ **Below left :**
Chimneys
The saturated colors in this shot were achieved with a circular polarizing filter.

↗ **Top right:**
Needs Fixin'
I have found that abandoned houses make a great subject for HDR images.

↗ **Top, far right:**
December Sun
I used a neutral density filter to get this soft creamy blur of a small waterfall.

→ **Right:**
The Perilous Bridge
I took this image against strong, low-angle backlight, which illuminated the steam rising from the warm water.

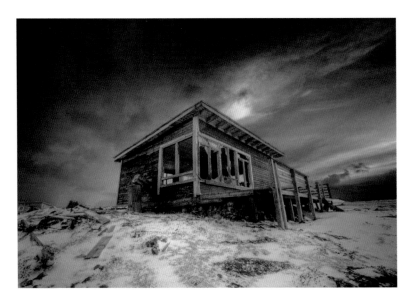

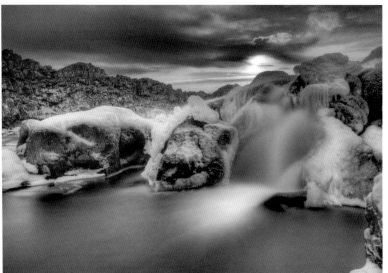

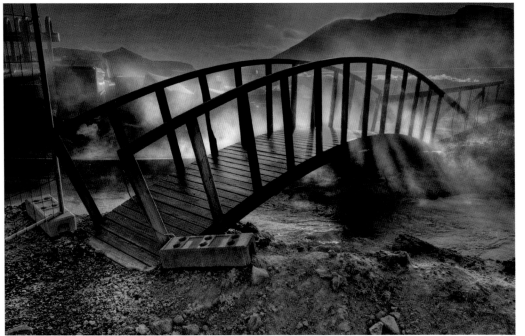

Post-processing

When the shooting is done, transfer your images
to a computer and decide on a software package to
do the HDR rendering. There are dozens of packages
to choose from, and most vendors offer fully functional
trial versions free. Photomatix (www.hdrsoft.com),
Photoshop CS2 or higher (www.adobe.com), and FDR
tools (www.fdrtools.com) are all fine pieces of software.

The workflow for HDR in these packages is pretty
straightforward and can be found in the help dialog.
The process of making an HDR image has two parts.
The first is the generation of an HDR, and in this
there are very few, if any options for you to worry
about. The second is tone mapping, which involves
a few controls for you to operate. Just play around
with the controls until you have something that
pleases your eyes.

It's a common misunderstanding that, once the tone mapping is complete, you have a finished image. This is rarely the case. A tone-mapped image requires the same digital processing as any other image shot with a DSLR camera. This can be done in Photoshop, Lightroom, or similar image-processing packages. Sometimes it's enough to increase the contrast, but it might also improve the image to increase saturation, correct colors, dodge, and burn. Try converting your HDR image to black-and-white. You will find that many of them work really well without colors.

HDR photography is a relatively new phenomenon, which has been debated passionately. It is frowned upon by many photograhers, while others have welcomed it with open arms. One of the criticisms is that HDR images look unnatural; more like paintings than photographs, but it is likely that digital cameras will handle scenes with high contrast better in the future. Try this type of photography to see if you come up with a new look or style that you want to pursue and develop even further. Don't pay too much attention to those who say that this is not real photography; something like this would never have been possible with film. If you succeed in making images that please your own eyes and you have fun while you're doing it, that's all that matters.

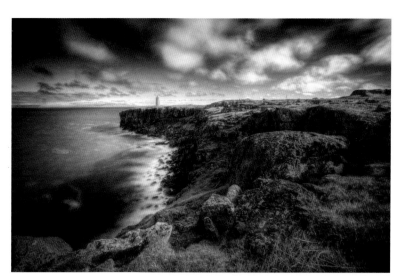

→ **Right:**
Sunset at the Beach
Sunset is a great subject for HDR photography.

← **Left:**
Hólmaberg
This was taken through a neutral density filter, which enables unusually long exposures. The result is this blurring of the constantly moving water and clouds.

→ **Right:**
Ice and Fire
An image taken at dusk with just a little light illuminating the snow against the intensely lit steam. This scene would have been very difficult to capture with one exposure.

↓ **Following page:**
Summer Night
A panorama from a total of 12 exposures. I made four HDR images, which I then combined in Photoshop using a panorama stitch utility.

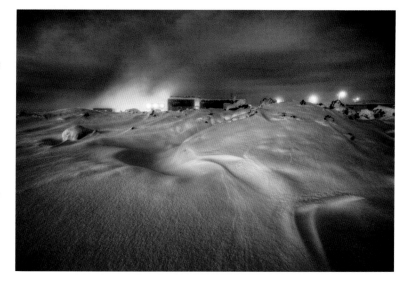

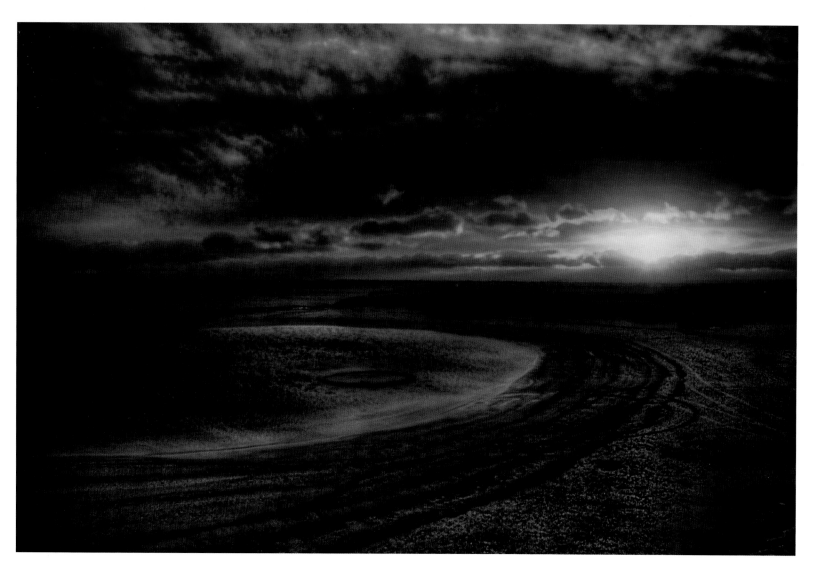

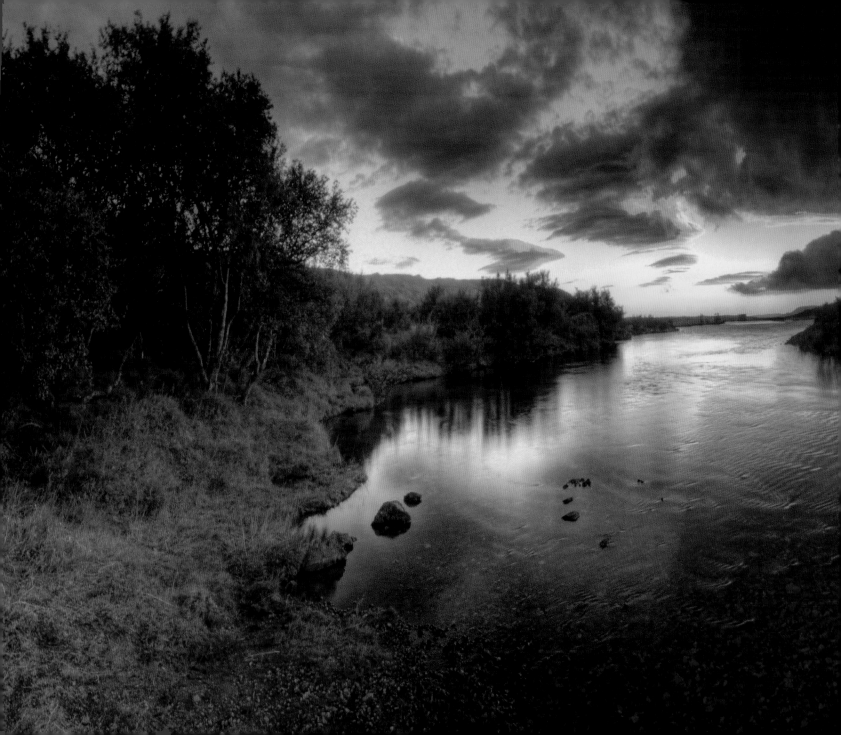

Zone-focus
The Lomo LC-A and friends

Cross Walk
Zone-focus cameras are great little cameras that you can whip out of your pocket to take a quick snap without having to worry about start-up times and shutter lag.

Kevin Meredith

The Idea

Get to grips with low-tech, zone-focus cameras. A Lomo LC-A is a chunky-looking piece of 1980s Soviet design which takes such magical pictures it sometimes defies belief. After a rough history, including a brief break in production in 2004, it is still being manufactured, though the country of manufacture today is China, where one factory is churning them out for the Lomo-loving masses to enjoy. I could write loads about all the things that make this camera great, but, as with most cameras, what makes the picture is the lens.

I have laid out my top tips for using the LC-A here. These also apply to other cameras from the same era that function in a similar way, including the Cosina CX-2 and the Olympus XA-2.

The Ingredients

› Any zone-focus camera
› A subject

The Process

For the most part the Lomo LC-A is really simple to use—just press the shutter button and wind on the film—but there are a few mistakes I see newbie Lomo users make all the time. Here are my tips for avoiding common Lomo mishaps.

Keep the shutter button pressed

One of the most common mistakes you see on a first roll of "Lomo film" is that a lot of frames are either very underexposed (too dark) or blank. This is because the photographer did not follow through with keeping the shutter button pressed down. One of the things I love about this camera is the way it chooses the exposure. With most cameras, when you take a shot the camera will decide what aperture and shutter speed to use. The LC-A will open the shutter and leave it open until the film has had enough light. If you release the shutter button before the film has soaked up enough light, the shutter will close prematurely and the shot will be underexposed. You need to keep your finger on the shutter button until you hear a second click—this is the sound of the shutter closing.

Don't be afraid of the dark

If you think it might be too dark to take a shot, you can check by looking through the viewfinder and holding the shutter button halfway down. If a red LED light appears in the right of the viewfinder, it means that the available light is low and you need to make sure the camera is steady or you will get camera shake, which leads to blurring in the photo.

This is caused by the camera moving while the shutter is open—the longer the shutter remains open, the more likely it is that you, and therefore your camera, will move and the more blurring you will get. In low light the shutter needs to stay open for longer. To keep your camera still, place it on a level surface—a table or a wall—to take your shot.

If there is nothing to lean on, hold the camera to your face with both hands and rest your elbows against your body to make yourself a tripod. In low light one of my favorite things is to place the camera on the floor to take the shot. The one thing you must remember is to keep your finger on the shutter button until you hear the second click—the vital sound of the shutter closing. But be warned—if it is really dark, the exposure can run to minutes, so get comfortable!

↖ **Above left:**
Lying Dog
Lens vignetting can really help frame a subject.

← **Left:**
Waiting Bride
Sometimes it just isn't right to pull out a ruler. On such occasions, when I am focusing at 80cm (c. 2½ft), I point at my subject, as I know my outstretched arm is roughly that length. It's not such an issue when focusing at 1.5m (c. 5ft) and 3m (c. 10ft); with these distances, you have more margin for error.

Measure up when close up

The minimum focusing distance on a Lomo LC-A is 80cm (c. 2½ft). If you are shooting a close-up shot you can judge this distance by eye, but, depending on the lighting conditions, you need to be accurate to within a few centimeters (about an inch) to make sure your shot will be sharp. I am lucky—if I stretch out my arm and point with my index finger, the distance from my eye (where the camera is) to the tip of my finger is dead on 80cm. For most people, the length of their outstretched arm will be near enough to this, but if you want to get it exact, use a ruler. A fold-up ruler is very handy. A tape measure is also good, but it doesn't have the rigidity of a ruler, which allows you just to point it at your subject.

Battery power

Modern cameras refuse to work if their battery runs down, but the Lomo LC-A will try to do the job even when its juice is low. You have to keep an eye on your battery level so you don't unwittingly shoot a whole film with no battery power, which means no light meter and poorly exposed shots, but this is quite simple. If you look through the viewfinder while you press the shutter button halfway you should see a red LED light on the left-hand side. This is the battery indicator light. If it is dim or not on at all, replace the batteries with three shiny new LR44s and you're ready to rock once more.

← **Facing page :**
Little Graffiti Men
The minimum focus distance on a LOMO LC-A is 80cm (c. 2½in). Depending on the aperture used by the camera, you might have to be accurate to 3m (c. 10ft); I carry a folding ruler so I can measure out my close-up shots.

← **Left:**
Rape Field
Without post-processing, digital photos tend to be really flat, but shooting with film can give you fantastic colors, depending on what film you use.

↙ **Below left:**
City Surfer
The size of the LC-A and similar cameras enables you to carry them anywhere, so you never miss a photo op.

Take your LC-A everywhere you go

I have got fantastic shots by taking my LC-A with me when just popping out to get a pint of milk. How are you going to get a shot if you don't have a camera with you? So remember, when you leave the house: check keys, phone, wallet/purse, Lomo. (And this should be applied to whatever camera you own.)

Have fun

My top tip is just have fun with your Lomo. I have given advice on how to avoid blurred shots, not because blurred shots are bad, but so that you know how to avoid blurring if you want to. All of these tips are just that–tips, not rules.

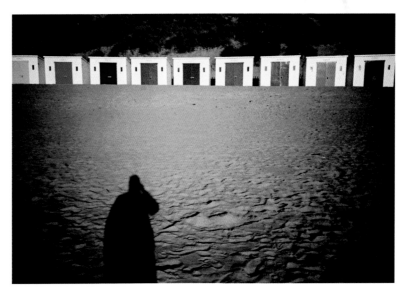

← **Left:**
Woolacombe Beach Huts
The extent of vignetting can sometimes be unpredictable. In this shot, taken in daylight, the edges on the image are almost solid black.

→ **Right:**
English Athletes
The LC-A is well suited to low-down shots.

↙ **Below left:**
Rusty Truck
Even if you shoot most photos on a super-slick DSLR, think of a small camera as a sketch-book that you have with you all the time.

Extras

The Lomo LC-A has a single-group, 32mm Minitar lens. In a lot of cameras the lens is composed of several different lenses, known as groups. The fact that the Lomo has only one group means that it doesn't need as much light to get the job done because there is less glass for the light to pass through. The LC-A's lens is known for its vignetting effect–photos taken on it tend to have dark corners. When this is combined with cross-processing, it is exaggerated to the extreme. Some see the vignetting as an imperfection, but I think it's great for adding character and for framing subjects.

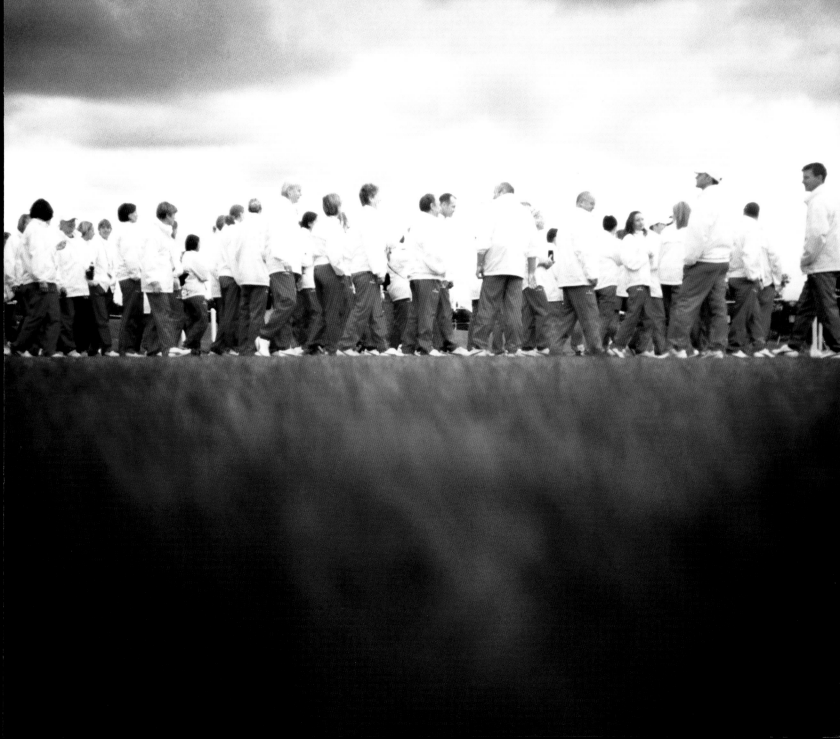

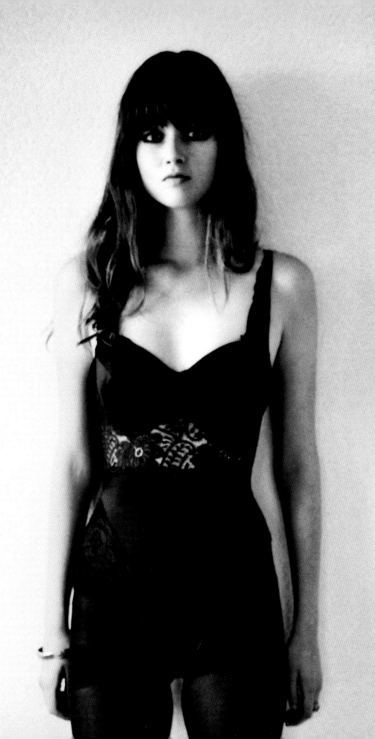

Working with models
Out with the rule book

Elin: One Week Later
Elin is a natural beauty and a fantastic model, but this shoot was all about slowing down and waiting for the moment—the gaze—to really work. This was part of a vanity project shot in available light in my flat. (Model: Elin Amos.)

The Idea

What is it about working with models that throws everything off? All the rules and all your knowledge goes out the window as you find yourself transfixed by the person in front of you.

The Ingredients

> Any camera
> An image concept

The Process

For me, working with a model is all about rapport or control, about achieving an expected outcome or seeing something develop in front of you and taking the shot at the perfect moment. To really make the best of this, you need to know what sort of image you are trying to achieve. Is it a fashion shoot, is it about the model's body shape, about his or her face, their poise, or their attitude? Or is it essentially about you, the photographer, projecting your ideas onto your subject/canvas? You need to think about all of these things while you are considering your shot.

It has taken me years to learn to shoot people, and it feels like the first part of a long journey. Only recently have I begun to drop the idea of a preconceived image and concentrate instead on the individual in front of me. I think there is something intrusive involved with taking someone's photo, and it shouldn't be approached lightly. In the past I tended to obsess about that and build it into my idea before the person even arrived. Now I am learning to make almost all of these decisions and judgments within the time frame of the subject arriving and me taking the shot. The tips that follow are "the pearls" from what I have learnt.

12

Kevin Mason

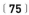

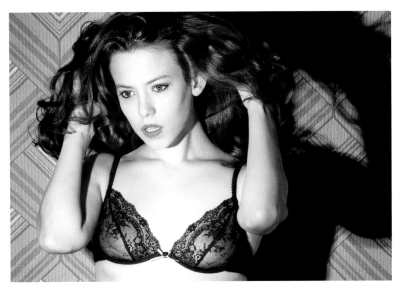

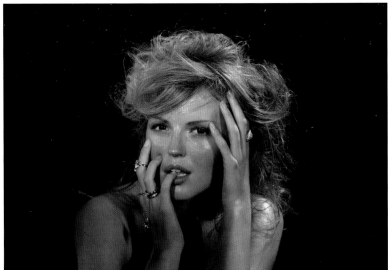

Tip 1

Until you understand everything you feel you can about natural light, don't start to shoot people or work with models. Put it off as long as you can. Once you can pick the time of day, position, camera, lens, and approach that will make something inert like a phone booth or trash can look interesting, then move onto models. If, when you are talking to someone and they turn, the emotive highlight down the side of their face catches your eye; or you notice how a friend looks different on those heavy, overcast days; if you see how their cheekbones are highlighted by the afternoon sun and it stops you hearing what they are saying so that all you take in is the light and how it shapes them and how that makes you feel, stop reading and start shooting people now.

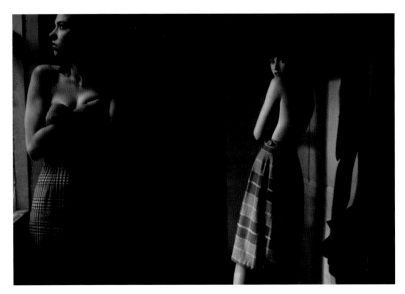

↖ **Above left:**

Sally Can't Dance
A harsh 1970s-style flash with strong directional lighting, along with the pose and distance of the model's expression, really sell this image. (Model: Sally Reynolds.)

← **Left:**

Editorial for GangUp *magazine*
On a shoot there is often tension between models and this can be used to really build a shot. Here the lighting and composition, along with very specific head positions, build a narrative in the image. (Models: Sally Reynolds and Elin Amos.)

Tip 2

Working with models is about confidence. If you don't
have confidence in your skills, you should make up for
it with confidence in the way you talk to models and
vice versa, but don't get so caught up in the technical
detail that you miss the image you are trying to make.

Tip 3

Remember that no two models are the same.
Adapt your response to each person. There isn't one
standard approach that can be applied to everyone,
but when talking or working with a model, never stop
looking. Watch everything about them—how they
hold themselves, what they project, the shape of their
face—and use all of this detail to inform your images.

Tip 4

Don't panic and don't rush. If you book a one-hour
session with a model, spend 45 minutes just looking
and talking, then shoot 10 shots in the last 15 minutes.
Take your time, and don't forget what you already
know about photography.

Tip 5

Don't rely on the model to make the image; it's your
eye and your vision, so pay attention to every detail.
The touch that transforms your work may be as
simple as turning out an ankle or lifting a chin. Don't
be fearful of giving directions; most models will be
relieved that you know what you need or what you
want to see.

Tip 6

Try to "read" your model. Several of the images here
have very direct eye contact, which is almost, to use
a cliché, piercing. What you are trying to get at is the
essence of the person, or an idea of it at least. I tend
to set up my shot and wait, and then wait just a little
longer until I see that flicker of "something else" on
the model's face—that's the moment you take the shot.

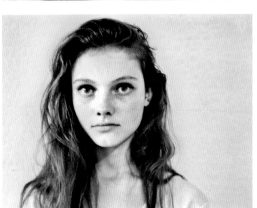

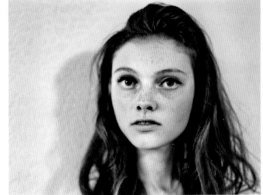

Tip 7

Composition is key. Remember that your frame is dynamic. A great subject should be enough, but sometimes you have to work hard to exploit the frame you use. If you work hard at your composition, the frame should reveal itself to you. This is as true for posed fashion shots as it is for portraits.

Tip 8

Study the work of others and deconstruct why their images have so much impact. Get as broad a range of inspirational images as you can and challenge yourself not to replicate, but to go one better. If you can also inspire the model to do this by showing them some of your source material, even better.

Tip 9

Have passion for what you do. There is something to be said for laboring away, and sometimes good images do result, but if you are not enjoying the shoot, or at least feeling some passion for it, then stop. Go watch TV instead. Or, if you really have passion and want to make an image worth keeping, don't stop. Keep trying and never be satisfied.

Tip 10

Look around you. Study film, light, people, faces, communication (spoken and unspoken), then find your own way of doing things. If you want your work to stand out, it has to be your own voice and vision.

The muse

The biggest tip, and it's a classic, is to find a muse—someone who will encourage you and stimulate your mind. Doing this changed my photography more than I could imagine. Shoot and shoot them, just don't drain all their patience. If you do it right, you'll both learn.

← **Far left:**

Commercial Shoot for Delarge T-shirts
Sally was my muse for four years, and this T-shirt shoot took only 20 minutes before we had what we needed. She is incredibly relaxed and fun in front of the camera, with bursts of activity, so it was a case of controlling that and pulling out her character. I love this shot. (Model: Sally Reynolds.)

← **Left:**

Your Life is My Vanity Project: Week 6
This project is all about waiting and constructed encounters with a fantatstic model. It is constantly evolving, both in the hour we meet and over the weeks. These four shots would have been taken during the last 20 minutes of a one-hour session. Georgie has a stunning directness and incredible range. (Model: Georgie Hobday.)

→ **Right:**

Toots VonFury
I had the cape made especially for the shoot, which I also styled. The colors complement each other, but the key factor is the strength of the model, Kelly, who draws you in, but also holds something back. She is a wonderful girl to know and shoot with. (Model: Toots VonFury, aka Kelly.)

The story

You'll want your image to be more than just a literal representation of someone. In fact, that's the last thing you'll want it to be. Instead, to really grab the viewer, your image should have a story, a narrative, a background that the viewer feels they have uncovered through their own insight. Don't hand everything to your viewer on a plate; don't expose your subject without allowing them to keep a piece of themselves back.

The commitment

Make an image that you want to look at again and again. It's the hardest thing to find a voice that is yours and unique, but persistence really does pay off. Take time to master the technical and never ever stop looking. Frame everything, even if only in your mind, from waking to sleeping.

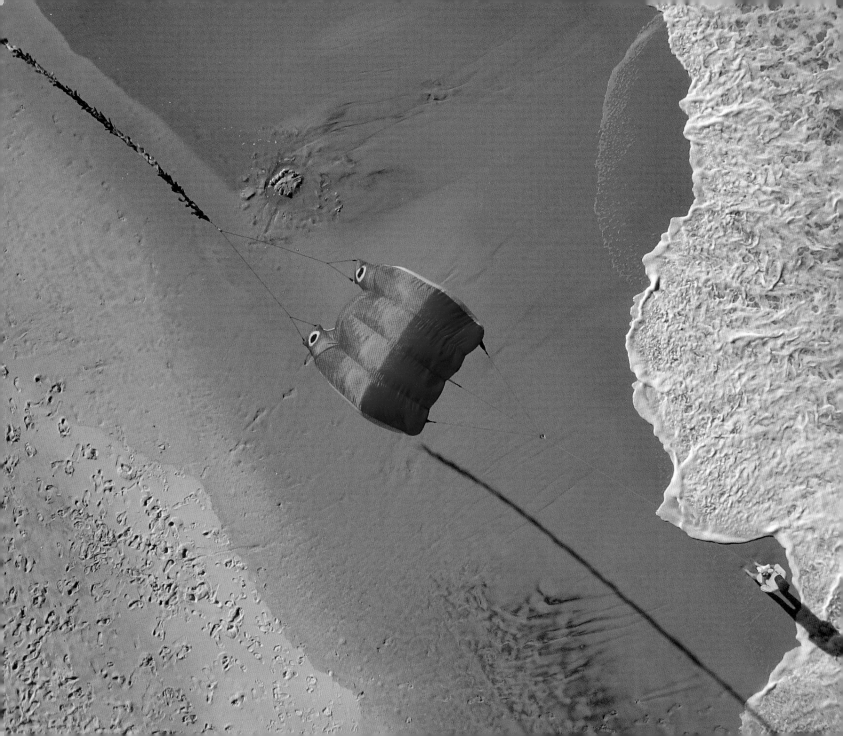

Aerial: kite shots
A bird's-eye view

A Flowform kite, one of the most popular kites for KAP photography.

The Idea

Flying has long been a universal dream. Today balloons, airplanes, and satellites enable us to view the Earth from above, but they are very expensive tools beyond the reach of most people. If you dream of photographing the world as seen by birds, there is a simple and cheap alternative: harness the power of the wind and loft your camera with a large kite. You won't have to take your feet off the ground, it's inexpensive, it's safe, and it's a lot of fun.

The Ingredients

> Good, large, stable single-line kite (Flowforms, Rokkakus, and Doperos are all good)
> Small, lightweight camera with an intervalometer or time-lapse function OR
> A means of triggering your camera remotely
> Cut-resistant gloves
> Line and winder
> A system to attach the camera to the line of the kite (e.g., a Picavet rig)
> A friend
> Wind
> A spirit of adventure

The Process

Kite Aerial Photography (KAP) is a tried-and-tested technique. It has been used around the world since 1888, but, as one might expect, a few things have changed since then. With our large-capacity memory cards we can now take many more pictures per flight, and our cameras, being lighter and smaller, can be lofted in a wider range of wind speeds. The kites, too, have evolved. The materials with which they are now built make them lighter and stronger. These are just some of the reasons for the increasing popularity of KAP. I'll explain some of the basics to help you start your journey with confidence and, I hope, without breaking the bank. In the past, when men were men and hackers were people who made furniture with an axe, you had to build your own KAP equipment from scratch. Today you can open your web browser or go to a kite store to buy all your kite equipment.

Ricardo Mendonça Ferreira

Camera equipment

To become a kite aerial photographer (KAPer), you will also need a camera and some way to trigger the shutter automatically or remotely. To make things as simple as possible, use a camera with an internal intervalometer or a time-lapse movie mode; if your camera doesn't have this function, you'll have to find another way to trigger the camera. You can search the web to inspire your own creative solution or buy an off-the-shelf option. If you don't mind reading manuals or using software that is a bit rough around the edges, and you have a Canon point-and-shoot, check if your model is compatible with CHDK (Canon Hack Development Kit), a free piece of software that teaches new tricks to your camera, giving it the capabilities, for example, of sophisticated intervalometers. And finally, you must find a way to tie your camera to the line of the kite. Once again, you can use the web to find and buy a ready-made solution, but I'll give you some tips if you want to build your own.

← **Left:**
Some of the ingredients for homemade KAP equipment: fuzzy tail and Flowform #16 kite at back; digital camera, line winder, and Picavet at front.

→ **Right:**
A Picavet is a system of pulleys that suspends your camera from the line of the kite and holds it as level with the ground as possible. You can make a Picavet from metal, wood, or any strong and lightweight material. It must be able to withstand vibrations and hold the camera even under the stress of turbulence. There are many plans for homemade rigs available on the web, but David Hunt's page [www.kaper.us/basics/BASICS_picavet.html] is the one I like best.

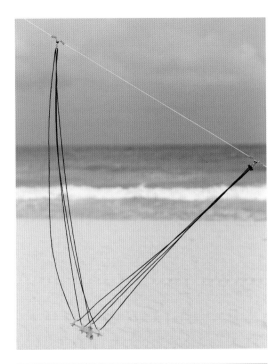

→ **Right:**
Bend lengths of wire into a crook you can use to hang your Picavet on the line of the kite without damaging the line, and in a way that will prevent the Picavet from sliding down toward you. You can make a couple from one short length of wire. I use electrical wire, but other types of stiff wire will work just as well. As they are so cheap and easy to make, always carry some spares, just in case.

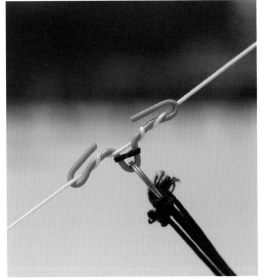

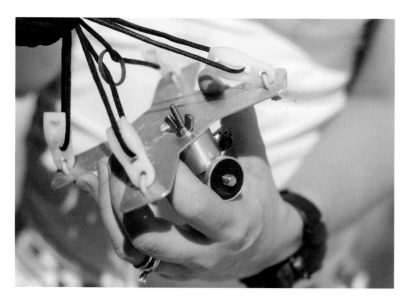

↑ Above:
You need a rig attached to the Picavet to hold your camera. This can be almost anything you want. It can have motors and electronics to rotate your camera via a radio transmitter, or you can just use duct tape or Velcro. You can see that I salvaged a small tripod head to use on this Picavet. It is simple, but effective.

→ Right:
A happy KAPer at work.

Kites

There is no single "best kite." This will depend on the wind scenario. Each kite has its own wind range, but generally, the stronger the wind, the smaller the kite should be and vice versa. If you try to fly a kite without enough wind it won't loft your camera, while too much wind will make it unstable, damage it, and/or make it fall down. Some of the most widely used kites for KAP are Flowforms, Rokkakus, and Doperos. Talk to a kite maker or seller and they will help you choose the right kite for the typical winds where you live. If the KAP bug really bites, you will eventually buy more kites so that you are able to fly in a wider range of wind conditions, but I suggest you do that only after gaining some experience.

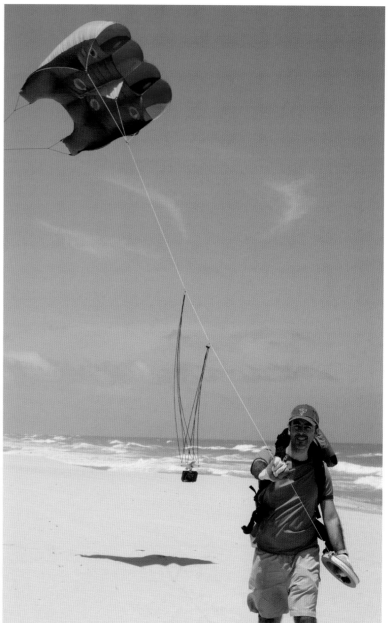

Flying your kite

Now go fly a kite! But first, do it without attaching the camera. You must get to know your kite well, so try to launch it several times in different places until you are confident both in the kite and in yourself. For your own safety you should:

- check your equipment before every flight
- always wear gloves to handle the line
- never fly your kite near power lines
- never fly near airports or airfields
- never fly in stormy weather
- never fly over roads, people, or anywhere your kite might cause damage or injury if it falls
- avoid areas with obstacles such as buildings, trees, and other kites
- have a friend to help you

Rig and suspension system

Before you attach the camera to the kite, wait a minute! If you don't want to smash your beloved camera to pieces, try to fly with a dummy of similar weight first. A plastic bottle filled with water could do the trick. Not only will you get practice, you will also get to test all of your equipment without risking your camera. After a number of successful tries, you can move on to the real thing.

Most KAPers create a rig to hold the camera and a Picavet system to suspend it from the line of the kite. This might be the biggest challenge of KAP, but it's not as hard as you think. Of course, you can fix your camera to the line with duct tape if you want to, but believe me, a simple KAP kit is a great investment of money, or time if you prefer a DIY approach. The simple equipment described here can be made on a small budget; if you would like to try your hand at making a Picavet rig, have a look at the many details available on the web.

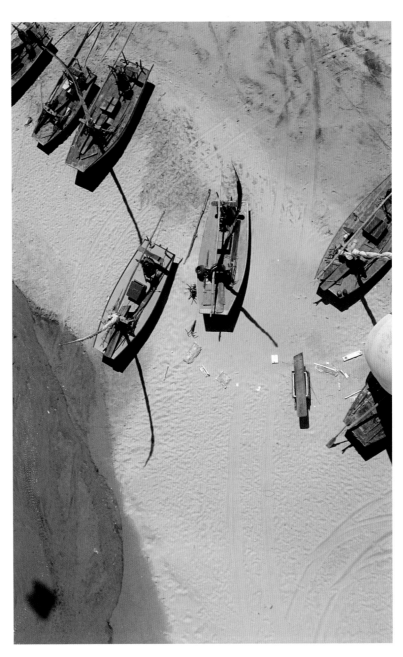

← **Left:**
Jangadas
Fishermen's ships resting on the beach in Beberibe, Ceará, Brazil.

→ **Facing page, clockwise from top left:**
Blue-and-White / Green-and-Yellow / Lime / Orange
Colorful umbrellas at the Porto de Galinhas beach, Pernambuco, Brazil.

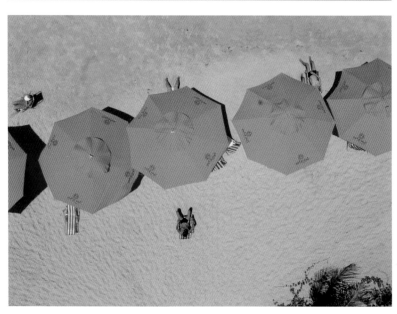

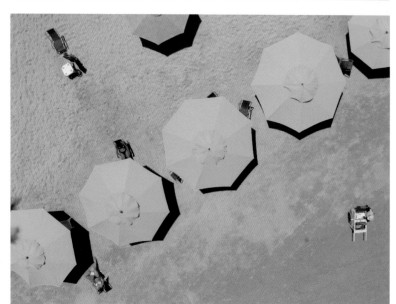

Configuring your camera

Now that you have your basic equipment and some kite-flying experience, all that is left is to configure your camera correctly. This is crucial because your camera will be moving sideways and up and down most of the time, so if you leave this step out, all your KAP pictures will be blurry. You'll need to configure your camera for a faster shutter speed, around 1/800 sec if possible, in Shutter Priority mode (Tv). If your camera doesn't have this function, you can use the Sports mode. You can also try a higher ISO rating, but on most compact cameras this will degrade the image quality, so leave this as a last resort, and to alleviate the problem, avoid flying when there is not enough light available.

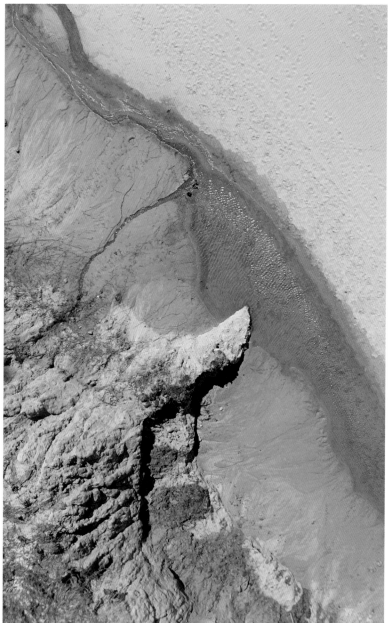

← **Left:**
From Above
Natural colored sand in Praia das Fontes beach, Beberibe, Ceará, Brazil.

↙ **Below left:**
Salt Pond
Salt pond on Menlo Park, California, USA. The striking colors of the salt ponds in the south of San Francisco Bay—ranging from pale green to rich red—are caused by microorganisms like tiny brine shrimps and halophilic bacteria.

→ **Right:**
In the Heart of Fun
Partial view of Maremoto, Beach Park's wave pool in Aquiraz (near Fortaleza), Ceará, Brazil.

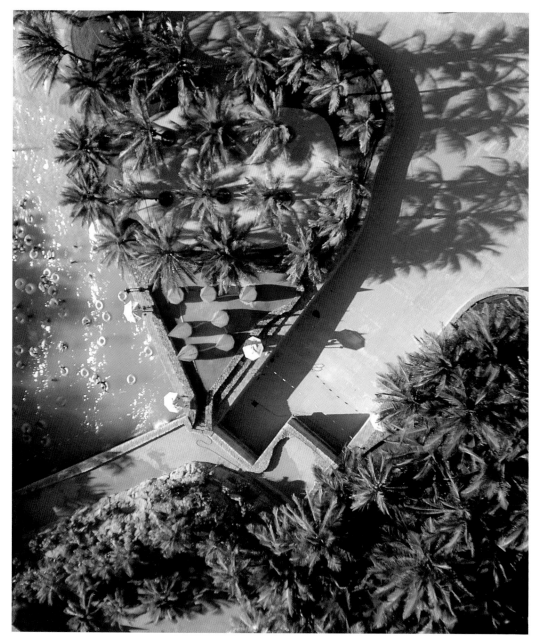

KAPing

Here are the basic steps to follow for every flight:

- always follow the safety advice listed above
- choose the subject you want to photograph
- check and configure your camera before launching the kite
- launch your kite and let it fly about 20m (65½ft) off the ground for 5 to 10 minutes to see if the wind is stable and your kite is flying without problems (never skip this step!)
- after you have watched your kite flying for some time, attach the Picavet to the line
- attach your camera to the rig and start the intervalometer (or time-lapse video)
- let out some line for the kite to gain altitude
- take some pictures, then bring the equipment and the kite back down

Now it's time to check the results. I hope you get some nice pictures. If you're lucky, your camera might capture interesting things that you weren't even aware of. This randomness is one of the most thrilling aspects of the KAP experience, in my opinion. Enjoy!

Avoiding tourist clichés
Unfamiliar surroundings; unusual views

Kevin Meredith

Eiffel Tower
I couldn't get this image of the Eiffel Tower without the tree, so I composed the shot to make the tree an integral part of the image.

The Idea

You're always going to be shooting the most when you are somewhere new, as everything will seem so fresh and different. When you take photos in unfamiliar surroundings, you might want to avoid taking the tourist clichés, or at least avoid showing them to friends and family when you get back and boring the pants off them. If you want to find things to shoot off the beaten track, or to shoot well-known monuments in a different way, read on.

The Ingredients

> Any camera
> A car or a plane/train/bus ticket

The Process
Finding where to shoot

If you want to avoid taking the typical tourist shots of a town, it's good to find out what the locals like to shoot—after all, you don't have to live in New York very long before you get tired of taking pictures of the Statue of Liberty. Wandering around without a clue where you are going is a great way to find interesting spots, but a little research won't hurt. You can get an idea of interesting things to shoot in an area through a location search on flickr (www.flickr.com/places). This will bring up places that aren't necessarily in a guide book. If you search for a particular place, you will be shown the most relevant images for that location. Click on the big preview image and you will be taken to that photo's flickr page. Every photo is placed on a map (geotagged in geek speak) so that you can see where it was shot. On the photo's flickr page, scroll down until you see Additional Information in the right-hand column. Just under this you will find a map link; click on it to open a little map showing exactly where the photo was taken. You can narrow your search by looking for a place-particular thing. For instance, you could search for graffiti to find the best graffiti spots in a particular place. Most places have a flickr group related to them, so join that group and ask its users what the best things to shoot are. A quick search on flickr won't tell you about times and events—a little local knowledge always helps.

← **Left:**

Essaouira Fort
Getting up early to avoid the crowds is a good way to get pictures without other tourists in them. Next time you're on holiday get up early, or just stay out all night.

← **Far left:**

Curb Markings
Street markings and shop signs are often different from one town to another. They can make a big contribution to the overall character of a place.

↙ **Below left:**

Sleeping Carpet Salesman
In Morocco we were hassled to check people's wares all the time, so this salesman made a welcome change!

Shooting well-known landmarks

When you are photographing well-known attractions, it's always good to think about what else will be in your shot. Try either to exclude distracting elements or to work with them and make them a deliberate part of your picture. For me, getting a good photo is all about going the extra mile. Remember, in any place, the main tourist areas tend to be very small, so you don't have to move far to get out of them.

Focusing on details

It can also be good to pick up on little details that are unique to a place and that will make an intriguing set of photos. I did this recently when I was in San Francisco. I took shots of the curb markings, which interested me because they weren't familiar to me. In San Francisco's Chinatown I noticed that all the shoppers were carrying the same pink plastic bag. For me, the pink bags summed up the area, so that is what I shot.

It's always good to shoot the locals, and sometimes it's worth hanging around and waiting until there is no one around at all, tourists or locals, to get some uncluttered shots. If you're on holiday, you should have all the time in the world.

Polaroids
Your portable friends

Sunroof
I got in my car and noticed there were thousands of water droplets on the sunroof, so I moved in for a close-up shot using the manual focus.

The Idea

I have had a love affair with Polaroid since the late 1990s, walking the streets of New York City, finding beauty in the mundane. I find it a great tool for quick reference, to help build a visual diary, or to create a painterly, fine-art image. The fact that it collapses down flat makes it very portable and great for traveling. The simple controls are minimal, being just an exposure control and a focusing ring. And there is no need to keep a spare battery–there's one in every film pack.

The Ingredients

> Polaroid camera
> Polaroid film

The Process

The SX-70 Land Camera was invented in 1972 by Dr. Edwin Land and is generally regarded as one of the great inventions of the twentieth century. In an instant it revolutionized the way the public took and shared photos. Nothing was more compact, easy-to-use, and immediate. And despite the demise of Polaroid, the SX-70 continues to have a very large fan base and a list of devotees that has included such creative luminaries as Helmut Newton, Charles Eames, and Andy Warhol. They were all attracted to the brilliant saturated colors, the square aspect ratio, and the overall simplicity of the camera's design.

As a designer, I gravitate toward graphic, minimal, and architectural compositions. I love shooting with lots of negative space in my images, leaving some room for typography. I also love shooting expansive vistas, up-close portraits, and still-life shots with a shallow depth of field. The manual focus and exposure controls allow you enough control to cover all these various situations.

I have traveled the world with my Polaroid and have come to learn that it's a great way to disarm your photographic subject. Simply approach a stranger, ask them if you can take their portrait, and immediately hand over a Polaroid as a gift. Watch the amazement on their faces as the image appears in front of them. One Polaroid for my subject and one for me, and we have become instant friends. The reaction is always positive. Just make sure you have some extra packs of film–you may need them.

My camera of choice is the SLR 680, which was released in 1982. There are quite a number of these popping up at auctions and estate sales, and on eBay. The 680 looks very similar to the SX-70, but is a bit larger, and includes an additional Sonar Auto Focus and built-in flash. The other difference is that it uses 600 film, and this makes it more versatile than the original SX-70, which takes ISO 150 Time Zero Film. The 600 film leans toward warm hues and the Time Zero to cooler hues.

Both film types have been discontinued, but there is still a bunch of 600 film available on such sites as Amazon. The expiration date of the last batch of manufactured Polaroid film was October 9, 2009. But there has been some great news for Polaroid enthusiasts. The Impossible Project plans to start large-scale production and worldwide sale of its new integral film early in 2010, with a brand new black-and-white Instant Film. The first color films are due to follow during the course of 2010. During 2009 The Impossible Project created some buzz about Analog Instant Photography and the Polaroid licensee, The Summit Global Group, announced that they will relaunch some of the most famous Polaroid instant cameras. There really is something special about the fact that the original image is *it*, unlike a negative or a digital file. If you love your subject matter, take more than one shot.

The manual-focus control allows you to achieve beautiful bokeh—the quality of the blur in out-of-focus areas of an image. This is important in portraits and still lives where you want to achieve a shallow focus, allowing your subject to jump to the foreground. You can also deliberately throw an entire image out of focus, which gives some interesting results.

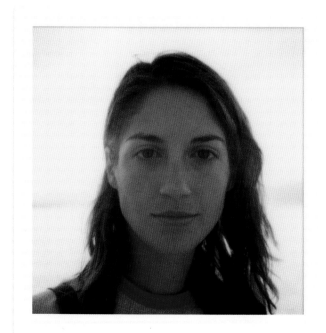

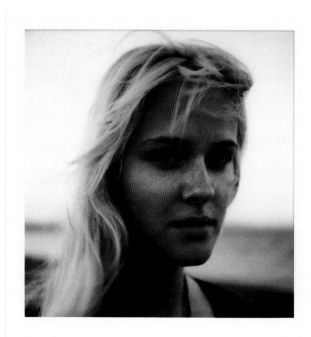

← **Facing page, clockwise from top left:**

Niterói Contemporary Art Museum
Shot on an overcast day. No tricks here, I just tried to make an interesting crop.

Window Washer
This image was shot through a frosted-glass window in my office on a sunny afternoon.

Sparkle
Shot from a footbridge over a busy avenue. The sun was bouncing off the chrome and glass of the cars, creating strong highlights. I used the manual focus to create a soft image, which turned the highlights into sparkles.

Park Avenue
This image was shot 47 floors up in Manhattan. This was the first time we ventured up to the rooftop at my old office and I was blown away by the graphic view.

↖ **Above left:**
Sarah
I positioned the sun behind Sarah's head to achieve a glow effect around her hair. She was completely backlit and in shadow, so I turned the exposure dial all the way open.

↖ **Above right:**
Natalie
Shot right before dusk, the wind added a nice dreamy movement to Natalie's hair.

The Polaroid SX-70 and SLR 680 both have a tripod mount on the bottom. I recommend trying out some long exposures at night: a busy street corner or cityscape would yield some cool light streaks from passing cars. Since exposure is controlled by the electric eye, covering the light sensor leads to longer exposure times, with a maximum of 30 seconds to 1 minute. You can manipulate the photographic dyes in the film before they harden to create a number of different effects and then further alter the image either with handcoloring or using a variety of digital applications. I tend to be more of a purist, straying away from any manipulation. I simply scan the image into Photoshop to remove any dust and scratches.

Pinhole
Extreme depth of field

Pin (Hole) Oak
The shorter the focal length, the more of a wide-angle look the photo will have. Extremely short focal lengths can yield interesting results.

The Idea

Experiment with pinhole photography by going back to basics and photographing without a lens. Pinhole photography opens up a new world of possibilities. What makes a pinhole photo different? The depth of field is extreme. All parts of the image–near to far–are in focus. However, depending on factors such as the size of the hole, there is often a soft, ethereal quality to the photos. The longer exposures required can show movement, and the characteristic heavy vignetting often gives magical results. No other camera can achieve quite the same effect. Pinhole cameras can be as basic as a cereal box with a hole poked in it or as high-tech as a digital SLR with a pinhole body cap in place of a lens. Pinhole photography is fun. Try it and see for yourself.

The Ingredients

> Pinhole camera or pinhole body cap for SLR
> Tripod or beanbag (optional)
> Cable or remote release (optional)
> Your imagination (required)

The Process

There are many options for anyone interested in getting started–the variety of pinhole cameras is incredible. Just about any enclosed space can be made into a pinhole camera: a hollowed-out pumpkin, a matchbox, an airplane hangar–even a cupped hand. These, and even crazier ideas, have been successful. You can convert a lens camera into a pinhole model or buy a ready-made pinhole camera; you can even make or buy a pinhole body cap for use on an SLR camera–film or digital.

Exposure

To determine the exposure time, you need to take a number of factors into consideration: the pinhole diameter, the focal length (the distance from the pinhole to the film or sensor), the speed of the film or the ISO setting of the camera, and the shooting conditions. Exposure times can vary dramatically depending on this last variable. The homemade pinhole camera I use most (working with ISO 100 film) requires a 1-second exposure in bright sun, a 9-second exposure on an overcast day, and an exposure of around 100 seconds indoors.

To estimate the exposure times required for your pinhole camera, you first need to determine its f-stop. The f-stop of a pinhole camera equals the focal length divided by the pinhole diameter. For my homemade pinhole camera, for example, the focal length (distance from the pinhole to the film) is 21mm and the diameter of the pinhole is 0.2mm, so the f-stop is f/105 (21 ÷ 0.2 = 105).

Formulas and exposure calculators to help you figure out the times for your specific pinhole camera are available online, but here are a couple of examples.

f/105 (my homemade pinhole camera)

	ISO 100	ISO 400
Bright sun	1 sec	< 1 sec
Overcast	9 sec	2 sec
Dawn/Dusk	21 sec	4 sec
Indoors	97 sec	17 sec

f/235 (Zero Image 6 × 9 pinhole camera)

	ISO 100	ISO 400
Bright sun	4 sec	< 1 sec
Overcast	66 sec	12 sec
Dawn/Dusk	157 sec	28 sec
Indoors	729 sec	128 sec

It's a good idea to tape an exposure chart to the back of your camera for easy reference. Also, keep track of your exposures the first few times you use your pinhole camera; this will help you to fine-tune your exposures. It is easier than you might think. Negative film is very forgiving, and if you use a pinhole body cap on a digital SLR camera, you'll be able to see your results and make adjustments immediately.

Accessories

Not much light gets through a tiny pinhole, so exposure times are usually very long. This means you'll probably need a tripod or some other means of securing your camera.

You can simply set the camera on the ground or a table, or you can set it on a beanbag to make positioning easier. How about tape? I've used duct tape to secure my pinhole camera to various objects. If you do use a tripod, make sure it can handle the weight of your camera. Another useful accessory is a level. Try gluing a small line level to the top of your

camera. Because most pinhole cameras don't have viewfinders, it can be difficult to get straight horizons in your images without one.

A light source is also a good tool for pinhole photography. This can be a camera flash or even just a flashlight. It isn't only pinhole photography that gives you the opportunity to paint with light—any long-exposure situation gives you the chance to use flash or other types of lighting to manipulate the exposure. The process is simple: during exposure, fire a flash or shine a light on a part of the subject. This can serve to add light to an area that would otherwise be underexposed, or it can serve as a creative tool to draw attention to a specific part of the image.

Capturing motion

Whether it's the subject moving, the camera moving, or both, pinhole photography is a great way to highlight motion. The long exposures of pinhole photography will enable you to show moving stars, moving water, or the effect of wind on things such as flags or fields of wheat. Set up your camera next to a road to capture the lights of passing cars.

Another fun technique is to move the camera during exposure. Secure your camera to something like a bicycle or a baseball bat, for example. Be sure to get part of the object in your camera's field of view, then begin the exposure and slowly move the object. The result will be an object in sharp focus with a completely blurred background. Give it a try. Experiment.

Moving objects can also be eliminated from a scene through long exposures. One photographer set up her pinhole camera, using extremely long exposures, at New York intersections. Busy all day with cars and people, they look empty in the photos; only the roads and buildings show because no person or car was in one place long enough to show up on the image.

Composition

Owing to the heavy vignetting of pinhole photography, centering the subject can often have dramatic effects. Also, try getting close—very close. The incredible depth of field allows this, and the results can be interesting.

And don't be afraid to shoot into the sun or other light sources. The tiny pinhole diffracts light, creating interesting patterns. To line up backlit shots, look to see how the shadows fall on the face of your camera. Lining up the pinhole with the edge of a shadow will result in the light source peaking out from the subject.

← Left:
A close-up of my homemade pinhole camera, made from wood, brass, and a variety of screws and other parts found around the house.

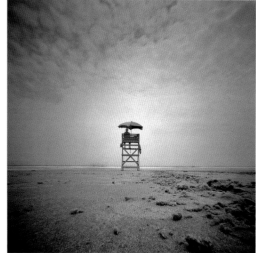

← Clockwise from top left:

Veering Left
I taped the pinhole camera to the side of my bike using duct tape, and exposed for about five seconds while slowly walking the bike in a semicircle. The horizontal white streak is the sun.

At the Beach
A pinhole camera is perfect for the beach because sand, sun, and surf won't hurt it—much.

Pinhole Pier
Because of the tiny aperture, pinhole photographs have tremendous depth of field.

Lighthouse One
Pinhole photography often results in heavy vignetting, so centering the subject can have dramatic effects.

Extras

Much has been written about the history of the camera obscura and the art of pinhole photography. Put simply, a camera obscura is an enclosed space such as a box, with a hole in one side to let light in. Light enters the hole, and an inverse image of the scene outside projects on the surface opposite the hole. Generally, the smaller the hole, the sharper the image. This is the basic principle behind pinhole photography. Film or a camera sensor is positioned opposite the hole to capture the projected image.

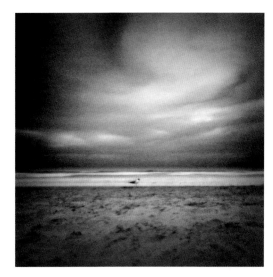

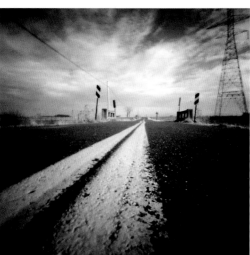

← Facing page, clockwise from top left:

Seagull
This image of a seagull in Wildwood Crest, New Jersey, is one of the first pinhole images I ever shot. I used a plastic Holga that I had converted.

Warp Speed
The colorful streaks are the result of heavy diffraction.

On the Road
You don't always need a tripod. I placed my camera on the ground in the middle of the road for this shot.

Sun Screen
When you're using a pinhole camera, try shooting into the sun.

Liquid Light
Light filtered through the trees and into my camera. The angle of the sun created a little diffraction, which gives this underwater look.

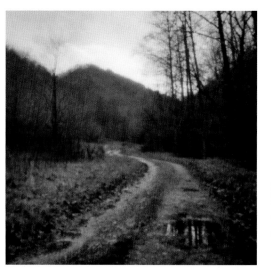

← Far left:
Appalachia
Many pinhole images, like this one taken in West Virginia, have a soft, diffuse quality.

← Left:
Off Duty
Another example of a pinhole photo showing motion. Myrtle Beach, South Carolina.

↙ Below left:
Lifeguard Chair
Not all pinhole images are soft—they can have sharp detail.

For a similar effect ...

Can you get pinhole images without a pinhole camera? No. Nothing can take the place of a pinhole camera. But you can achieve somewhat similar effects using a regular SLR or DSLR with a lens. Try closing down the aperture as far as it will go (to something like f/22 or f/32). This will give you a bit of the light diffraction that is common with pinhole photography. It will also give you extreme depth of field and require long exposures. Use a low ISO setting and a neutral density filter to further increase the exposure time. This technique won't result in pinhole images, but the look will be similar. Add a little vignetting with your image-editing program to complete the effect.

Off-camera flash

Get creative

Adam Bronkhorst

Wedding: Bride and Groom Waving
I had a few minutes with the bride and groom after I had taken their group shots, so we decided to have a bit of fun. I used two flashes to pick out the two chairs in this scene. You can use flashes to highlight certain areas of shots; don't limit yourself to lighting the whole image.

The Idea

What's so great about off-camera flash then? Well, for a start, it can give you the look of expensive studio lights and offer up a whole host of creative options that you just don't get with on-camera flash. On top of that, chances are you have already invested in the most expensive bit of kit–the flashgun.

The Ingredients

› Any camera
› A flashgun, or two, or three ...

The Process

Think about lighting and where it is coming from. I probably spend too much time thinking about lighting; I can't watch a film now or look at a picture in a magazine without trying to work out where the lighting is coming from. It could be the sun, a ceiling light, or some other source, but generally it's from above or to one side. Now, this is very important when it comes to flash and how we light subjects. The flash on your camera lights people from the front, smacking them in the face with bright light. Ever heard the expression "like a rabbit caught in the headlights?" Think about your on-camera flash photos. Do they have someone really brightly lit, looking a little startled and with a bit of red eye while the rest of the shot is dark?

What can you do about this? You can try bouncing your flash off the white ceiling, which should improve things a lot. But what happens if there isn't a convenient white ceiling just above you, or if the only surface you can bounce your flash off is a lime-green wall? Starting to see the problem?

To improve your photography, what you need to do is take the flashgun that's sitting snugly on top of your camera off your camera. You can do this with any flashgun for which you can change the power manually. Put it up high, put it to the left, to the right, below your subject, or even behind. You're getting the picture—you can put your light wherever you want it. This way *you* control the light and the way it hits your subject. You're making the picture, you dictate where the light comes from. The possibilities are endless.

Now, there are various ways of firing your flash when it is not connected to your camera. You could do this with your camera's own built-in system, you could trigger it with expensive dedicated wireless electronics, or you could do it with cheap radio triggers, which you can get on eBay. I'm not going to go into these here as you can find endless debates over the pros and cons of each system on the Internet. What I want to inspire you with is the creative aspects of off-camera flash and how simple it can be. When you take a picture with off-camera flash, use the back of your digital camera to get a feel for the shot. If it looks too bright, turn the flash down or reduce the amount of light coming into your camera another way. If it looks too dark, turn the flash up. It really is that simple.

One of the great things about off-camera flash is that, once you have set up your lights where you want them and your subject isn't going to move around too much, your shot will stay correctly exposed. It doesn't matter where you move with your camera—the amount of light on your subject will remain constant. If you keep your settings the same, you can shoot your subject from the left, the right, up close, or from far away. The set-up of your lights won't change so your exposure requirements won't change. If your flash were on the camera, every time you moved, your flash would move with you and the exposure required would change. Having your flash off-camera frees you up to move about, get more creative, and have fun.

→ **Far right:**
Officer Brownhorse
This shot was taken in the same place as *Where I Do My Stuff*; you can see the kind of image that can be taken with a very simple set-up and limited space.

→ **Center right:**
James Bond Tribute
I'm a massive James Bond fan and I wanted to shoot an image inspired by the dark tone of the new movies. For this shot I used three flashes. I started with one in front of me to light my face and body, and a second behind me to add a highlight down my face and shoulder on the right of the shot. Looking at the results on the camera back, the martini glass wasn't showing up as much as I wanted, so I added a third flash to highlight it subtly.

→ **Right:**
Where I Do My Stuff
This is where I did a lot of my self-portraits for the 365 project (see pages 28–33). You can see that I was working with very little space and used just one flash, one stand, and one umbrella.

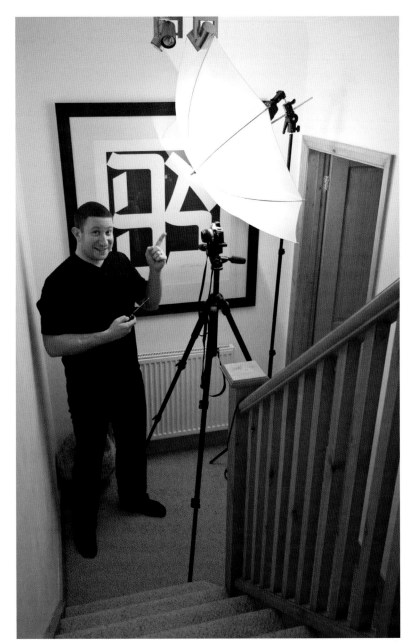

Something else you can do with your flash is change the color of it. Yep, that's right. Why does your light have to be white? Look at the lights around you. What color are they? Chances are they might be a bit yellow, orange, or even a tiny bit green. If you take a picture of someone with your white flash and you can see a lot of yellow light in the background, your picture will have two different colored lights in the shot. The different colors of these lights are often referred to as different color temperatures. What works really well is "warming up" the light from your flash by putting a yellow gel in front of it. This will make your picture look more natural. But you don't have to use yellow gel. Why not try red or blue; why not put a flash on either side with a different colored gel on each? See what you're doing? You're getting more creative.

Another way to change the light from your basic flashgun is to make it hard or soft. Bear with me on this one. It may sound quite technical, but it isn't difficult to grasp.

Imagine your shadows on a really bright sunny day; they have a nice crisp, hard edge to them. This is the effect of hard light. Now think of a cloudy day and the effect that has on your shadows—they tend to be all soft-edged and a bit fuzzy. Guess what, this is known as soft light. That's a very basic description, but I hope you get the idea.

So how does this affect your flashes? Have you seen big umbrellas on photographers' lights? Now that your flash is off-camera, you can put an umbrella or other "light-modifying" device in front of your flash. Try putting an umbrella in front of your flash when it's on-camera and you won't be able to see anything. The umbrella will diffuse the light from your flash, creating a bigger surface of light and making it nice and soft. There are other devices you can use to make the light surface smaller or make a pattern on your light. They

→ **Far right:**
Self-Portrait
All the walls in my house are white, but for this shot I wanted a blue background, so I put a blue gel on the flash and aimed it toward the wall. It was a lot easier than painting the wall.

→ **Center right:**
Professor Kev
For this a portrait of Lomokev I wanted to show him looking like a professor. I used two flashes to make the background look a brighter white, and a third with an umbrella to give an even, soft light across the whole frame.

↗ **Above right:**
Wedding: First Dance
I include off-camera flash for a lot of the weddings I shoot as it is very quick and easy to use. I combined a few techniques to get this image. I included a flash with a red gel on it out of shot to give a bit of atmosphere.

→ **Right:**
Wedding: Dramatic Daylight
For this shot I wanted to create something a bit different from what the wedding guests would be shooting themselves. It was taken in broad daylight. I put a flash on a stand out of frame and underexposed the daylight to make the scene quite dark. I then increased the power from the flash so that the couple were correctly exposed, but the general scene had a sense of drama.

all have funny names, like grids, snoots, barn-doors, and softboxes. Basically, you can get as creative with the appearance of your light as you want. To me, the whole point of getting your flash off-camera is to get more creative. Think about your shot and what you

want the light to do. Where do you want it to be? What color do you want? What quality do you want it to have? Most importantly, what do you want to say with the image? Go out there, get your flash off-camera, and start experimenting with your flash photography.

Animals

A pet's-eye view

Dog and Fish
Getting eye contact with an animal is often a matter of patience, or clicking your fingers.

The Idea

This section is not a guide to shooting wild animals, more the domestic kind. Photographing animals can be tricky as they are not very good at taking direction. That said, some humans are not very good at taking direction, but at least animals have the excuse of not understanding!

The Ingredients

▷ Any camera
▷ A pet—yours or someone else's

The Process

My top tip for shooting animals, above all else, is to shoot from their perspective. This one thing will get you images that feel more real. We are used to looking down on most animals, so if you shoot images from their height, you will present the viewer with something unique.

If you want an animal to look at you, but you don't want to call for its attention in case it runs off, it's probably best to get it in shot, get focus lock, and wait until it looks at you. With luck it will turn to look at the camera, and when it does you will have your shot—you just need to be patient.

An animal shot doesn't have to include the whole subject—you can focus on just one part, such as the ears or nose. In *Wild Donkey*, on page 111, I decided to show only the out-of-focus nose and legs. Such a crop can give some insight into the character of the animal, in this case the donkey's inquisitive nature.

If you are going to photograph your pets, it's always best to shoot them in natural light as this avoids the use of flash. Cats and certain other animals have a reflective layer inside their eyes, which helps them see in the dark. If the light from a flash hits this, you can get bright white eyes rather than the red eyes

that are a problem with human subjects. Another downside of using a flash is that it can freak animals out. If you want to get a photo of your pet looking calm, it is best to shoot when they are tired or when they have just woken up as at these times they are more likely to stay in one place.

It is always important to have the eyes of your subject in focus: the viewer will be drawn straight to the eyes in a photo, so out-of-focus eyes will be obvious. This is easier said than done when your subject doesn't understand that they have to sit still. If you are shooting digitally, you're best off firing loads of shots and finding what works once you are done.

Cats can be tricky because they are very easily spooked, especially if they are not yours. I like getting them at their level, so for *Wild Cat*, I held the camera very close to the ground and moved slowly forward. I was using a Lomo LC-A, a zone-focus camera, which meant I had to set the distance from my camera to the cat. In this case, I set the focus to 80cm (c. 2½ft) and moved toward the cat very slowly so as not to scare him. Once I thought I was 80cm from the cat, I took my shot. Luckily I estimated the distance spot on. If you are using an autofocus camera for this type of shot, be mindful of keeping your subject in the center of the frame so that the autofocus is pointing at your subject. This can be tricky if you are not looking through the viewfinder. When you are taking photos for which you have to use a little guesswork regarding the focus, it's a good idea to close the aperture down so you have a wider depth of field; this will result in more of the image being in focus, so you have more chance of getting your subject sharp. (You can read more about depth of field on page 285.)

→ **Right:**
Wild Cat
For all intents and purposes, this shot is of a wild animal. I took it when I was on holiday in Morocco—there were a lot of very wild-looking cats knocking about.

↘ **Below right:**
White Terrier
This terrier was particularly tricky to photograph, as I had to move around with him, shooting blindly, hoping that he would be in shot and in focus.

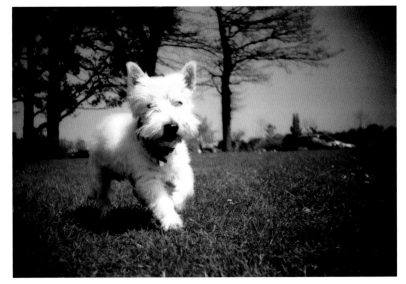

↑ Above:

Shetland Pony

I don't know why, but I find my horse shots always turn out a little amusing. I shot this pony from low down so her belly was set against the sky as a background to exaggerate her fatness.

↗ Above right:

Focused Dog

I tried to get this dog to look at me, but he was not playing along. In any case, this profile shot worked out well because he is looking into the empty space in the frame.

→ Right:

Wild Donkey

I decided not to include the whole animal; this image shows more character than if I had shot the full donkey.

My approach to shooting animals might seem a little slapdash, and you might ask yourself "Why not get a zoom lens and shoot them from a distance?" I believe that by using a wider lens, you capture an image that is closer to what the human eye sees, so the image seems more natural. Also, by being closer to the animals when you shoot them, you get a chance to interact with them and capture their reactions to you.

Long exposures: night
Capturing motion

Underground Tunnel
I took this from inside
a moving vehicle to capture
the forward movment.

The Idea

As a photographer you will probably spend a lot
of time trying to avoid camera shake and motion blur
in your shots, but when you know how to harness
motion blur, you can create stunning photos that
show more about the way the world moves than
the fine detail of a scene.

The Ingredients

> Any camera with a slowest shutter speed
of less than 1/2 sec
> Tripod (optional)
> Cable release (optional)
> Neutral density filters (optional)

The Process

A shutter speed below 1/60 sec will usually be slow
enough to capture something of the motion trails
of moving subjects, but to get their full impact you
have to slow the shutter speed right down. Many
modern DSLRs and digital compacts will allow you
to shoot with exposures as slow as 30 seconds, and
sometimes the lower limit can be a lot slower. If you
want to shoot slower than your camera's slowest
shutter speed, you can use Bulb mode, if your camera
has it. This is usually indicated by B on the shutter-
speed scale. When you are in Bulb mode, the exposure
begins when you press the shutter and is finished
when you release it. If you want a really long exposure
you can use a cable release, which will usually allow
you to lock the shutter button so that you can do
something else while the exposure is being taken.
If you want to capture the motion in a scene, but
to keep the background perfectly still, you will
need to use a tripod.

A great way of showing motion in a photograph is to
pan the camera with a subject while they are passing
you so that the background is blurred, but your main
subject is not. For my photograph of the cyclist on
page 275, I had the camera set up on a tripod. This isn't
necessary, but it can make it easier to keep your subject
sharp; you can loosen the tripod to allow movement
only in the horizontal plane. If your camera has image
stabilization you will need to turn this off as it will try
to cancel out some of the motion blur. Some cameras
have three image-stabilization modes: one will cancel
out all movement and the others will cancel out either
horizontal or vertical shake. If you are panning from

19

Kevin Meredith

left to right you will want the camera to cancel just the vertical shake. Unfortunately, these modes are not referred to as H and V for horizontal and vertical, but as A and B, or 1 and 2. To find out which is which on your camera, check the manual.

When you capture movement, it doesn't have to be of people or objects moving past you. Shots taken from inside moving vehicles can produce stunning images. If you are taking this type of shot and it is dark outside, you are more likely to see reflections in the windows of the vehicle. To avoid this, press the camera right up against the glass (this will also help to steady it) and then cover it with something like a jacket so that light from the inside of the train/car/bus cannot reflect off the glass and spoil the picture.

If you are shooting in low light and you can't use a tripod or flash, you can turn camera shake to your advantage to get dreamlike images.

What if you want to get motion blur during the day? Even if you closed your aperture down to its smallest— for example, f/22 with ISO 100 on a bright day—you are still not going to get speeds slow enough to capture motion blur. To get around this you can use a neutral density filter. There are lots of different filters that cut out different wavelengths of light. Neutral density filters cut out all light equally and allow you to open up your aperture and take shots with longer shutter speeds without overexposing them. Think of neutral density filters as sunglasses for your camera. They come in different strengths: ND2, ND4, and ND8. If your correct exposure is 1/250 sec at f/11, using an ND2 will allow you to stop down your shutter speed by 2 stops, to 1/60 sec; with an ND8 you could stop down 8 stops to the point where you can shoot a 1-second exposure in the day.

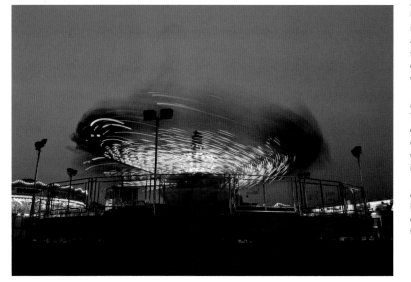

← **Left:**
Cyclist
I shot this on a shutter speed of 1/15 sec. As the cyclist came toward me, I looked through the viewfinder and panned to keep him in the same position in the frame as I was taking the shot.

↙ **Below left:**
Fairground Ride
Anything with lights that also moves makes a good subject for a long exposure at night.

→ **Facing page, clockwise from top left:**
New York in Passing
This was taken out of the window of a moving cab.

London Buses
Unlike the motorway images, this was shot with an exposure of about 1/2 sec, so you don't just get streaks of light—you can see the vehicles too.

Emergency Vehicle
This road shot has something extra—I captured a police car with flashing lights, which have been turned into a staggered blue line.

Motorway Traffic
For this I used a long enough exposure to turn the cars into trails of light.

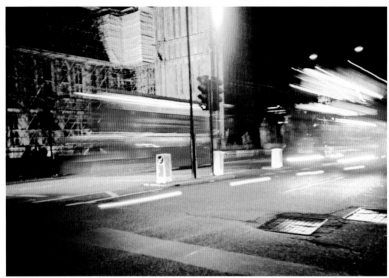

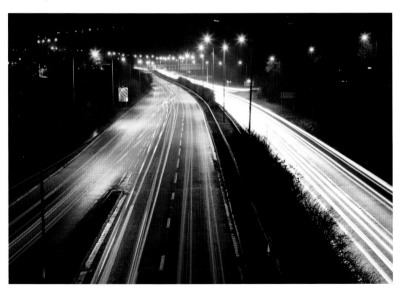

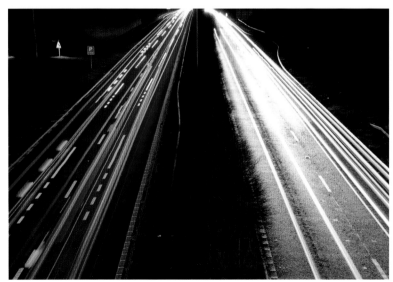

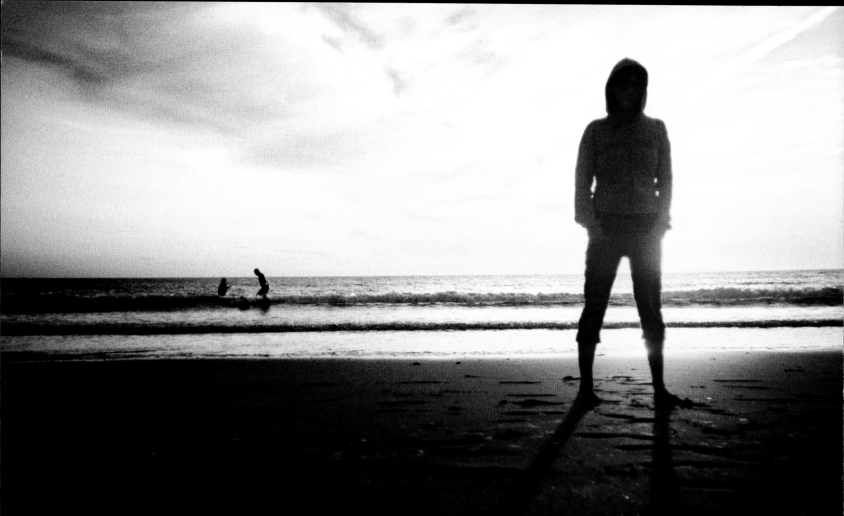

Silhouettes
Striking black

Devon Sunset
Sunset is a wonderful time for silhouettes—because the sun is low in the sky, it is easy to place behind things.

The Idea

Silhouettes make really striking images. They are an interesting alternative for capturing recognizable landmarks or obscuring someone's identity. Silhouettes often make standout photographs because of their simplicity. Sometimes color and texture clutter an image–shooting someone or something in silhouette is a great way of stripping it back to the basics.

The Ingredients

▶ Any camera
▶ Strong light source

The Process

Silhouettes are all about composition and the high contrast between subject and background, which is all about getting the right exposure. Depending on the type of camera you have, this can be difficult. If you leave the exposure set to automatic, your camera might try to get a good exposure on what is in silhouette, or try to get a balance between the two. In doing this it will totally overexpose the background with the result that it is completely blown out. If you have automatic flash turn it off or the camera might think you are trying to expose what is in front of you.

The key to getting a really striking silhouette is to make the black part of an image really black. This is best achieved by setting your exposure to the background, whether that be the sky or an artificial light source. The easiest way to do this is to set your camera to Manual Exposure mode, if it has this option. Point the camera at your light source, making sure nothing is obstructing it. Adjust the shutter speed and aperture until you have a perfect exposure. Now you can recompose the shot with an object obscuring some of the light source; your camera might say that it is underexposed, but ignore this as you *want* part of the shot–your subject–to be underexposed.

Another quick way of ensuring you are underexposing is to use exposure compensation. To do this, let the camera set the exposure, but tell it to underexpose each shot. Play around with the exposure until you get really nice blacks and lots of depth in your background. On a film camera you can do this easily by setting the ISO to one rating higher than the film you

are using. With an ISO 100 film, set your ISO to 200; that way the shot will be underexposed by 1 stop. If your film camera sets the ISO automatically, it should have an exposure-compensation dial somewhere. Remember to set your exposure-compensation or ISO dial back to normal once you are done, otherwise you run the risk of overexposing the rest of your shots. This is not such a problem with digital, as you will notice pretty quickly when reviewing your images, but you could shoot a whole film without noticing.

You will probably want the outline of your silhouette to be in sharp focus. Depending on the lighting conditions, your camera might have trouble getting a focus lock on the subject because it could be too dark; try to focus on its outline, then recompose the shot using focus lock (see page 283).

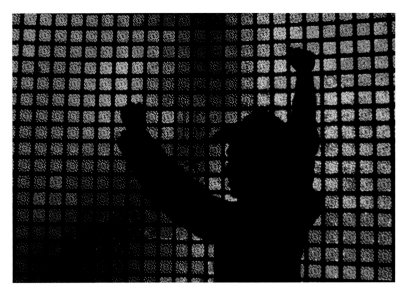

← **Left:**
Light Wall
Artificial light is very useful for making silhouettes.

↙ **Below left:**
Antony Gormley Look-Alike
Overcast days are good for shooting silhouettes, as you can face in any direction to get your shot.

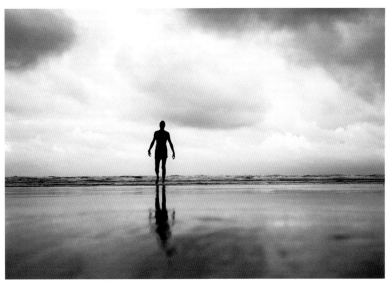

If you don't know your camera that well, the things you need to look up in your manual are "exposure compensation" and "exposure lock."

Dusk and daybreak are times of day when you are sometimes forced to capture silhouettes because, without a flash or tripod, you won't get much detail in your shot—the only thing you can get a decent exposure of is the sky. If the sun has gone down or is not even up yet, but there is still color in the sky, you will probably have to get down low to include lots of sky in your frame.

Overcast days can be great for silhouettes, as you get some moody backgrounds that really add atmosphere. The advantage of shooting on an overcast day is that you have quite a lot of freedom with the angle you can shoot from because the light is not coming from one specific direction. When it comes to direct sunlight, the opportunities for getting your shot become more interesting. One of the drawbacks is that, if it is the middle of the day, the sun will be high.

→ **Right:**
New Forest Ponies
Because cross-processing increases contrast, it can make silhouettes much more exciting.

↘ **Below right:**
Sun B
Letting the light source peek out from behind your subject can make light "bleed" into your silhouettes and add an extra dimension to them.

To get a good silhouette in these conditions you will need to point the camera upward so getting low down might be on the cards. When dealing with the sun, take variations of your shot, from having your light source totally obscuring your subject, to just peaking out behind it.

Wet surfaces, such as sand and tarmac, are great for silhouettes because they reflect the light, effectively doubling it. This makes it child's play to capture your subject in silhouette. I used this to good effect in my *Antony Gormley* shot. Remember, the shallower the angle at which you are viewing a wet surface, the more powerful the reflection is. If you are on a wet surface, just squat down and you will notice that more is being reflected. So, if you want to shoot a silhouette against this, you might have to get your knees wet!

It's not just natural light that is good for silhouettes. When you're in a city, look for illuminated billboards, bus hoardings, or giant TV screens–anything that puts out a lot of light is good. If you aren't in an urban setting, there is nothing a like a big old campfire for getting good silhouette shots.

Reflections
Puzzling perspective

Hospital Corridor
The reflections in this image help increase the sense of depth by doubling the number of perspective lines in the photo. These lines help draw your eye into the image.

The Idea

Including reflections in your images can help to add depth or create a warped sense of reality that arrests viewers as they try to work out what the photo is of or how it was taken. Reflections can be found everywhere; not just in mirrors, but also in shiny cars, wet surfaces, and glass buildings.

The Ingredients

> Any camera
> A reflective surface

The Process

Once you start looking for reflective surfaces you will spot them everywhere. For a big expanse, look at the tiled floors of shopping malls, subway stations, and hospitals. With shiny surfaces such as polished floors, a view perpendicular to the surface will give you stronger reflections, as will holding the lens closer to it. The strength of the reflections on floors will also vary depending on how regularly the floor is polished.

As someone who has spent most of his life living on the coast I can tell you, you will never get tired of the reflective shooting opportunities that a wide expanse of wet sand offers. The farther out the sea, the more sand you will have to shoot on, so it's always a good idea to keep an eye on the tide times. These can be found online, and most surf or fishing stores sell local tide tables. To capture the best reflections you need to get down as low as possible, so it's advisable to wear shorts or, if it's winter, waterproof trousers. This will save you the discomfort of wet clothes when you kneel down to get your shot.

Buildings with an expanse of glass can be a joy for shooting reflections. If you don't want to see the reflection off glass, you can reduce the amount of reflective light in a photograph by using a circular polarizer. While this won't cut out the reflective light completely, it will reduce it enough to help you see through windows.

Kevin Meredith

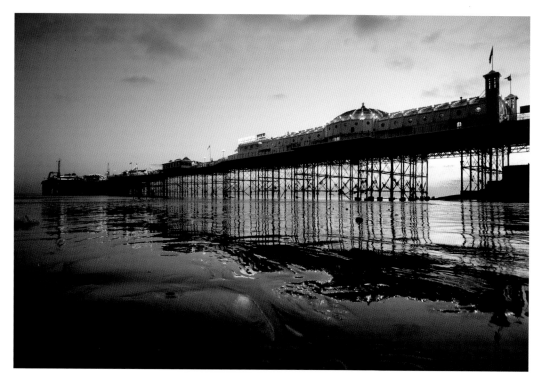

← Facing page, clockwise from top left:

Prague Office Block
With all the shiny materials used, modern architecture can be reflection heaven.

Beach Cyclist
When it comes to displaying reflections, I sometimes flip my images vertically so that, at first glance, the reflection looks like the real thing, but on closer inspection you will see the defects in the top image.

Rainy Phone Booth
Rain is no excuse to stay indoors; when they are wet, tarmac and concrete produce wonderful reflections where otherwise they would be a dull black or gray.

Subway Tunnel
In this shot the reflections are subtler, but they are still effective.

← Left:
Pier Reflections
A simple, but effective trick I use quite a lot is to shoot more of the reflection than of what is being reflected.

The most obvious place to find a reflection is in a mirror. They are perfect for getting self-portraits with your camera. If you are using a zone-focus camera such as a Lomo LC-A or an Olympus XA 1, remember not to judge the distance between yourself and the mirror–you need to double this distance because you are focusing on your reflection, not the mirror itself, and the light from your reflection travels from you to the mirror and back. If you are shooting yourself in a dirty mirror and you don't want the grime to show, you can simply open up the aperture to give yourself a narrow depth of field so that any grime and dust on the mirror will be out of focus and therefore less noticeable.

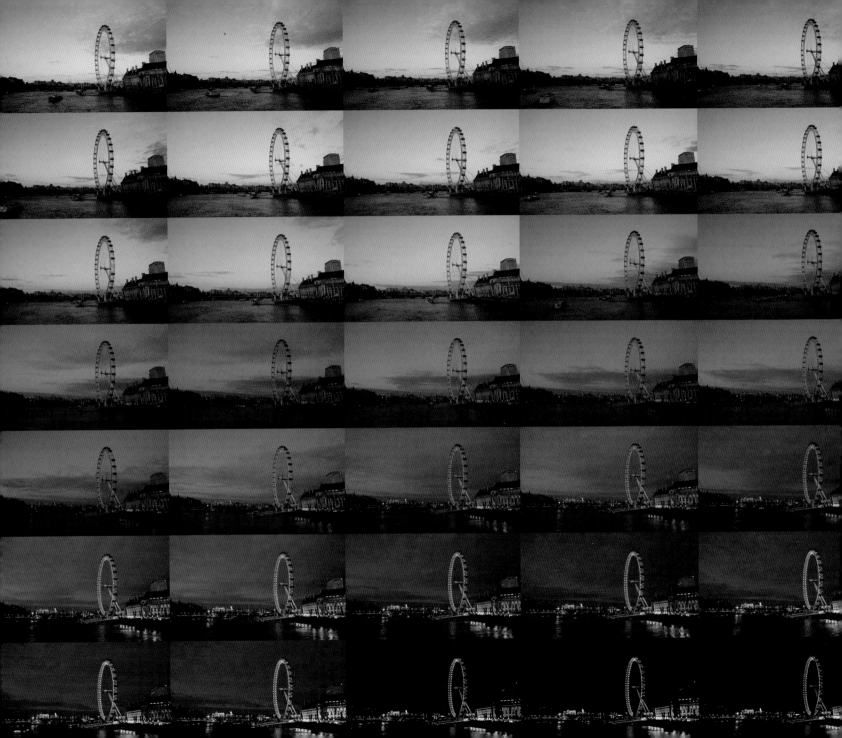

Time-lapse
Speeding life up

Kevin Meredith

London Eye
This was a perfect spot for a time-lapse. Even though there wasn't much cloud in the sky, there was plenty of hustle and bustle on the river, and the rotation of the London Eye looks amazing sped up.

The Idea

As photographers, we are used to freezing moments in time, but with time-lapse photography you can speed it up so that you watch things that usually happen too slowly for you to notice, like the tide coming in or the sun setting. Given the time-lapse treatment, even the simplest things can make for mesmerizing viewing. (To view any of the videos mentioned in this article, just go to www.lomokev.com/pages/tl.)

The Ingredients

> DSLR and timer cable release OR
> Camera with built-in time-lapse function
> Fast memory card of at least 2GB
> Spare batteries
> Tripod
> Calculator
> Intervalometer (a posh cable release)
> Fold-up chair

The Process

Before you start, you have to decide what time interval you are going to shoot at. This will depend on what frame rate you're going to play it back at, how long you want the final movie to be, and how long you want to shoot for.

Frame rates are measured in frames per second (fps). To give you an idea of how fast the fps needs to be for smooth video, TV plays at 25fps in Europe and 30fps in the USA, and the movies you see at the cinema run at 24fps. I usually stick to 30fps as this gives me the smoothest playback, although, depending on what you are capturing, 12fps can be fine to give you an illusion of motion.

As to video length, I tend to make mine between 20 and 90 seconds because I find that anything less than 20 seconds seems too short and anything over 90 seconds is not for casual Internet viewing. Also, the largest audience for viewing my videos is on flickr.com and flickr has a limit of 90 seconds for video.

I use the calculator on my phone to work out the time interval I need between shots. First you must multiply your fps by your desired video length, in seconds; this gives you the total number of frames, or pictures, you need to shoot. You then divide your shooting time, in seconds, by your total number of frames. If you know you are shooting for 30 minutes and you want to make a 20-second video to be played at 30fps, the calculations would be as follows.

Total number of frames to shoot:
30 × 20 = 600
(fps × video length in seconds)

Interval between frames:
1,800 (30 × 60) ÷ 600 = 3
(shooting time in seconds ÷ total number of frames):

For this example we would have to shoot a picture
every 3 seconds. If your result is not a whole number,
you will probably have to round it up or down–most
of the intervalometers I have used only allow time
to be entered in whole seconds.

What to shoot

As you're going to spend at least half an hour capturing
a time lapse, it's very important to consider what you
are going to shoot. If you want to film a landscape, set
yourself up when it's quite windy so there's a lot of
movement in the clouds; or shoot things that move
quite slowly, like cranes on a construction site or the
tide coming in. Take time to make sure you get your
composition bang on. Take lots of shots before you
start to ensure the composition you get is the best
it can be from the position you are in. Once you have
the shot you want, that is where you should set up
your tripod and, if you have one, a fold-up chair–you're
going to be hanging around for quite some time!

Image resolution

I am a great evangelist for shooting RAW, as many
photographers are, but when it comes to time-lapse
photography, thousands of images are involved, and
handling such a vast number of RAW images is not
much fun. I set my camera capture to the smallest
JPEG it offers; the resulting image is 2,496 × 1,664
pixels. When you consider that high-definition (HD)
TV is 1,920 × 1,080, you can see there is no point
shooting at a higher resolution. If you have an older
camera, check the pixel dimensions of the quality
settings and use one that is at least 1,920 × 1,080.

Triggering your exposures

If you have a camera that you can plug a cable release
into, you might be able to get what is called a remote
control or timer remote. This bit of kit is sometimes
referred to as an intervalometer. These are one step
up from a cable release as they allow you to set the
interval at which your photos are shot. If you have
a Nikon D3, D200, D300, D700, or D5000 you are in
luck as they have timers built in. If your camera does
not have a built-in intervalometer and you don't have
a timer, you can still make a time-lapse video, you just
need a hell of a lot of patience and a good sense of
timing as you have to trigger each exposure manually.

Camera settings

Your camera will be in action for a long time so it's best
to implement some power-saving measures. Turn off
the picture review option. With this on, every time
you take a picture it is shown on your LCD screen;
repeated thousands of times, this uses a lot of energy
and will shorten your camera's battery life considerably.
Set the focus to Manual: set to Auto, the camera will

try to refocus with each shot. This will use extra power,
and, if something passes in front of the camera while
the shot is being taken, the camera will sometimes
shift its focus. This will make the background pop out
of focus for one frame, which is quite distracting for
anyone watching the video.

Set the exposure manually. If you have exposure
set to automatic and the light levels change slightly,
perhaps because a small wisp of cloud passes over
the sun, there will be a noticeable flicker in your video
where the camera adjusted its exposure setting for
a few frames. The potential problem with a manual
setting, which I encountered with my 90 minutes on
Woolacombe Beach video, is that if a cloud obscures
the sun, your video will be darker for that period.
To moderate this, I tend to overexpose my shot by
½ stop if I am setting the exposure when the sun is
out. This means that, if a cloud does obscure it, the
shot will be slightly overexposed and won't appear
too dark. If you are setting your exposure when there
is cloud cover, you should set it to underexpose slightly.

→ **Right:**

*Ninety-Five Minutes
on Woolacombe Beach*
High winds and clouds can
look amazing with time-lapse.
The faster the wind, the
better, as there will be more
movement in the final video.

← **Far left:**

Even if there wasn't much
cloud in the sky, the wheel
would always be turning.

← **Left:**

My intervalometer. I use
one of the cheaper versions.
(My first one did wear out
pretty quickly.)

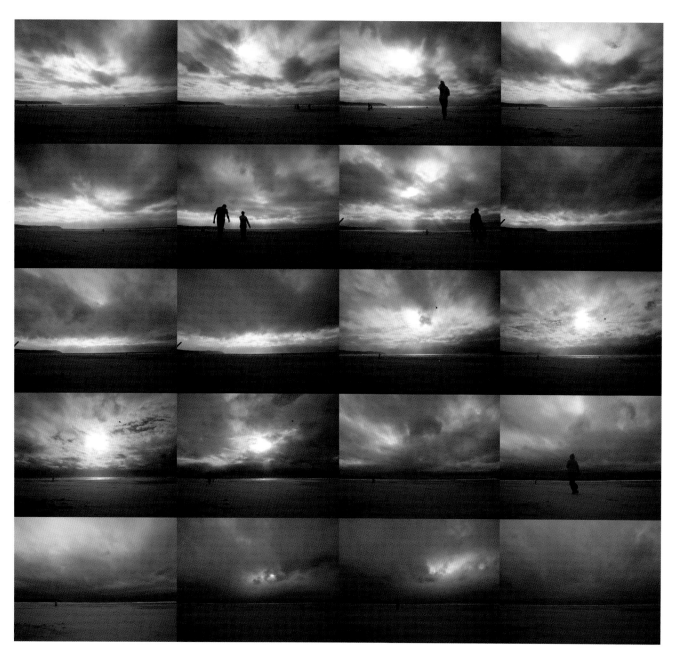

If you are shooting when the sun is going down and you have set the exposure manually, as the scene darkens so will your pictures until, eventually, they go black. This will give you a nice fade-to-black effect. If, however, you want to continue capturing detail as it gets dark, you will have to change the exposure. I find the best way to do this is to make small adjustments to the exposure every minute so that the changes will not be noticeable in the final video. As it gets darker, I change not only my shutter speed and aperture, but also my ISO setting. For my Sandcastle video I started shooting at ISO 200 and finished at ISO 3200. Using

a high ISO rating will usually introduce noise into the image, but with the lower-resolution settings used for videos this will barely be noticeable. If you change your camera settings you must take care not to move the camera at all–there will be a noticeable "jump" in your video if you do. You can leave Auto exposure on if you prefer. This is easier, and many people like the "flicker effect" for its film-like quality. Make sure the White Balance is not set to Auto; if it is, each frame might appear a slightly different color, which will look terrible in the final film. If it is cloudy, set it to cloudy, and if it is sunny, set it to sunny–it's all common sense.

Making your movie

Once you have all your images on your computer, you can create your video, but before you do this, you might want to make some color corrections and/or crop them. For this task I use Adobe Lightroom, which was made for working with large numbers of images. When you are dealing with time-lapse images, make sure they are in their own folder in your image library. Make adjustments to one image and, once you happy with it, switch to the Library Module and press G to enter Grid View. Select all the images in your time-lapse by going to Edit > Select All and then click on the image you have adjusted. To apply the changes to all images, select Sync Settings by pressing Command + Shift + S (on a Mac) or Control + Shift + S (on a PC). With the images still selected, you need to export them as a batch by going to File > Export; in the export dialog window tick Resize to Fit and enter your desired size for the finished movie. The most important thing is to resize your images to a more TV- and Internet-friendly size. I make my videos at 1,280 × 720 pixels (width by height). This is a high definition–it is the maximum that most video-sharing websites accept–but it is not true HD. You can go one step further and up your

↓ **Below:**
Dusk at Brighton Pier
Because the camera was set on a manual exposure, there is a natural fade to black as the scene gets darker and darker.

resolution to 1,920 × 1,080, which is true HD. Any true HD video upload to a video site will be downsized to 1,280 × 720. Both 1,280 × 720 and 1,920 × 1,080 have an aspect ratio of 16:9 whereas the pictures that come from digital cameras have a ratio of either 3:2 or 4:2; you have to crop them slightly to make them 16:9. Your videos can be in any aspect ratio you want; this ratio just makes them look more film-like.

Once you have made your adjustments, export your images into a new folder. These are the images that you will turn into a video.

If you don't have Lightroom, don't worry–you can use JPEG images straight from your camera. The simplest way to make your video is to use QuickTime Pro (Mac and PC). If you don't have the Pro version, you will need to upgrade to unlock its special features. If you are using a Mac and your operating system is Snow Leopard (10.6) you will have to use the older version of QuickTime–QuickTime version 7–which is located in the Utilities folder, in the Applications Folder. In QuickTime go to File > Open Image Sequence and select the first image in your time-lapse sequence. You will then be prompted to set your frame rate.

Once you have imported your images into QuickTime, you can play your video. You will need to export it as a movie file; simply saving it will not do, as a raw QuickTime file is large and will only be playable on a computer with QuickTime. Go to File > Export. On the dialog box that pops up, make sure Video is ticked, then click Settings. Select H.264 for your compression type and make sure that Frame Rate is set to Current. I always set Quality to Best, but if you want a smaller file size, set it lower. When you're done, click OK. If you didn't resize your images in Lightroom, click Size in the Movie Settings dialog box and enter

your desired image size, then click OK and your video will start to render. Depending on the speed of your computer and the length of your video, this will take anywhere from a few minutes to a few hours.

↓ **Below:**
Sand-Castle Building
A time-lapse of something being built can be effective. Anything that can be finished within a couple of hours can make an interesting subject. Next time you put up a tent or mow the lawn, think about shooting a time-lapse of it.

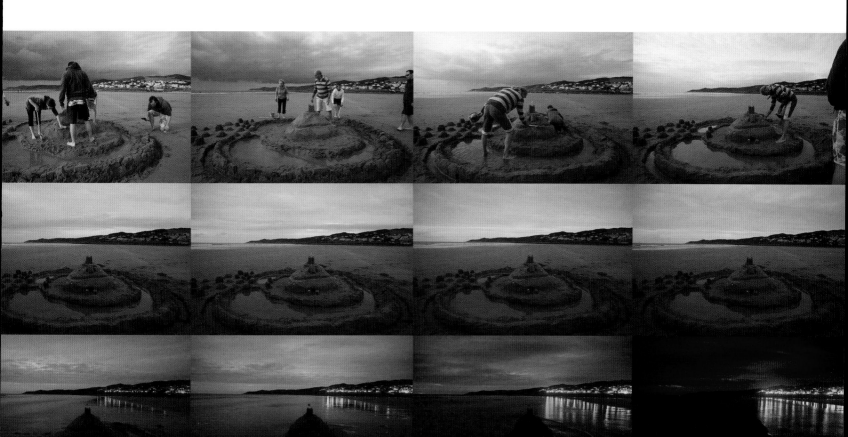

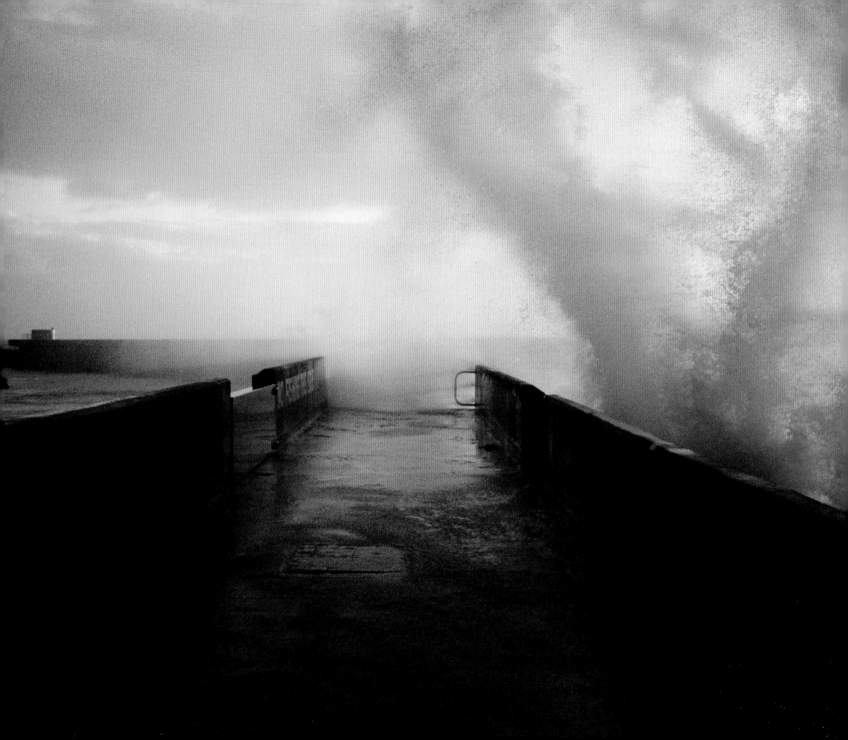

Getting the right light

It's all in the timing

Crashing Wave
You can see the yellow light characteristic of the golden hour in this photo.

The Idea

Photography is all about collecting light and projecting it onto film or a digital sensor. Without light there would be no photograph. It is important to consider the lighting conditions under which you are shooting. If you are using natural light, the time of day has a huge effect on what your final picture will look like, so think about when you will shoot when you are making plans.

The Ingredients

> Any camera
> Watch

The Process
Direction of light

It's not just the softness or hardness of light you have to consider, but also the direction from which the light is coming. It is tricky to take a portrait in the middle of the day, with no cloud cover, as the sunlight will be hitting the top of your subject's head rather than their face. This could also mean that their face will be in shadow. Even if the light is hitting their face, it will be hard light, which will produce strong shadows. You can get around this by using a reflector. Reflectors are usually circles of white material with a ridged frame. They fold down so that they can fit in a camera bag, and the best part is they are cheap. Some people prefer to use fill flash (a mix of natural light and flash light), but that means fiddling around with a flash to get the right settings, and you also have to worry about the different color temperatures of sunlight and flash light. If you are using a reflector, you can just angle it to direct light onto your subject and use the in-camera metering to get a good exposure. The only drawback is that you need someone to hold the reflector.

I am a big fan of shooting on overcast days as this produces really soft light, and soft light produces shadows with soft edges, giving a gentle gradation of tones in an image. If you want that soft look and it's not an overcast day, you can always shoot in the shadows.

Nice and bright and sunny doesn't make the best conditions for photos. Unfortunately, for the ideal light, you need to be up really early.

The golden hour

Most photographers agree that the best times of day to shoot are around sunset and sunrise. The period around sunset and sunrise is often referred to as "the golden hour" or "the magic hour." Although it is called the "hour," in reality there is a period of around 15 minutes when the light is incredibly golden just before the sun dips below or rises above the horizon. This light can give you wonderful portraits, but as the sun is so low, it can be tricky to keep your shadow out of the photos. The color of light can vary wildly depending on weather conditions and on where you are in the world. It can range from yellow to red. If you plan to shoot during the golden hour, make sure you get to where you want to shoot in plenty of time—it can be frustrating to still be in transit as everything is turning golden. Sunset and sunrise times change by a few minutes each day, so remember to check them. Weather websites usually list these times.

← **Left:**
Work Hard, Play Hard
Photos taken an hour before sunset will have really soft light, but it can be tricky keeping your own shadow out of the shot.

↓ **Below:**
Golden Hour, Just More Golden
This shot shows just why the golden hour is called the golden hour. The yellow tint is made stronger through the use of cross-processing.

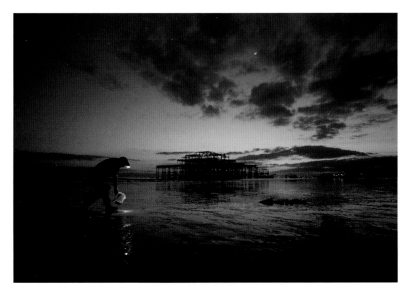

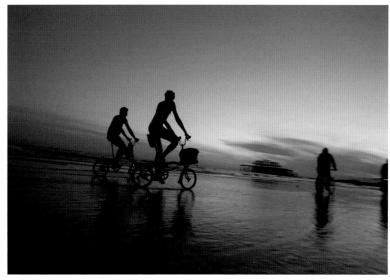

↗ **Above and above right:**
Blue Hour
On a clear day the quality of light during the blue hour can help you capture amazing landscapes. You might have to shoot using a tripod to avoid camera shake, but this shot was taken on a Canon EOS 5D, which is pretty good in low light.

→ **Right:**
New York Skyscraper
Sometimes the color effect will be red, which can make a really strong contrast with a deep blue sky.

The blue hour

This refers to the twilight period in the morning and evening, when it is neither fully light, nor yet in complete darkness. You are best off using a tripod at these times, but, depending on your camera, you can get away with shooting hand-held. When I shoot in the blue hour, I shoot on Shutter Priority mode, on the lowest speed I can use without camera shake. (See Shooting mode on page 286.) If you are shooting in the evening, as it gets darker, your shots will become underexposed. When this happens, I turn up my ISO sensitivity, but once you are at your maximum, it will soon be game over and too dark to shoot hand-held.

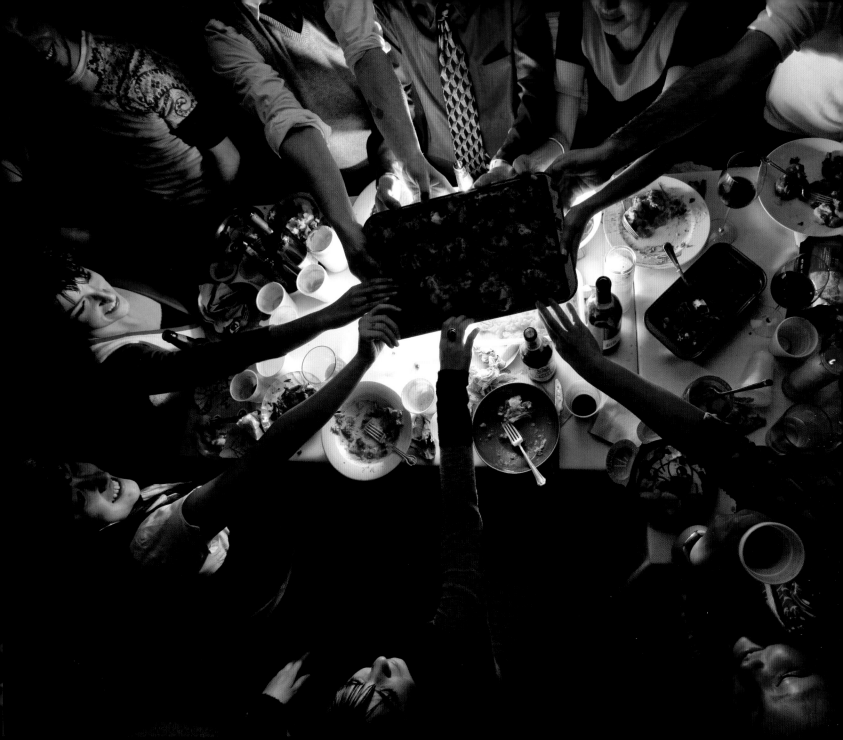

Events
Storytelling through pictures

Gather Round
"Everyone grab at the food again the way you were just doing!" Coax friends and party guests into the perfect storytelling shot with a little art direction.

The Idea

Parties, sporting events, gatherings, celebrations: with so much going on at such events, deciding how to tackle capturing it all can seem overwhelming. The answers to what equipment to use, how to direct participants (or not), where to be, and what to shoot can all be found by concentrating on a single objective– telling a story through pictures. Photographing events involves more than just waiting for guests and revelers to stop and pose for the camera; it's about the retelling of an occasion through a visual medium. Similar to the way in which a good storyteller will captivate an audience by manipulating their voice, deciding which details to include, and building suspense, the manner in which an event is photographed dictates the way people will remember it later on.

The Ingredients

› Any camera
› An occasion
› A crowd
› A post-event audience

The Process

The task of an event photographer (whether self-appointed, assigned, or hired) is to capture the essence of an occasion in a way that communicates a narrative, articulates the mood and atmosphere, and gives an idea as to the reason for the occasion. The stories that your photos tell will serve a dual purpose: they will shape the future memories of anyone in attendance, and they will give a sense of what happened to those who weren't. Either way, viewers of the photo will be seeing and experiencing the event through your eyes (or lens).

There can be many ways to reveal the story of an event. By identifying the main "characters" and capturing them candidly in action, with background details that reveal additional information (such as the location, time of day, size of crowd, or anything else that might be relevant), you can successfully convey a story in a single frame. Discovering that one "single shot" can be tough, and it often requires a skillful blending of creativity with patience, stealth, art direction, familiarity with your equipment, good editing, and luck.

Sometimes the clearest tale is so obvious, you'll want to ignore it and work to develop your own unique angle. A sought-after frame from an urban marathon might be the moment the winner triumphantly crosses the finish line. Presumably, there will be many other photographers who have come to the same conclusion. Concentrating on the story of thousands of runners from all over the world united by their shared experience of the race might be an angle that could make your retelling of the event unique.

The most significant point of the day can also be a relatively small moment or detail that most people never see: a chef placing the final garnish on the entrée for a grand dinner, or performers stretching backstage and getting into costume. Avoid overlooking these chapters of the story by getting too caught up in the big picture.

If the final outcome or presentation of your photos will be a series, you'll have the opportunity to tell a story with more than just one frame. Going through the exercise of summing it up in one capture can still be a worthwhile pursuit, but don't forget to concentrate on ways to support this shot in order to create a narrative with more depth. When all the images are viewed together, close-in details combined with wider scenes that show more of the action will give a great overall impression of everything that went into an occasion.

Art direction

For some types of events, the story you aim to tell will be clear from the start. With others, you might have to seek out or construct the narrative yourself. An event photographer is often tasked with the impossible mission of being everywhere at once, but rarely afforded the luxury of having time to spend waiting for the quintessential moment to happen right before their eyes. A little art direction can go a long way toward helping you shape the perfect frame. If you've managed to locate the ideal setting for a storytelling shot, with stellar light and interesting details, a spark of action is all that is needed to complete the scene. It could be as simple as having someone by the bar turn to look at you as they sip a fresh cocktail, or encouraging revelers near the DJ booth to dance a little harder for the camera.

→ **Right:**
Chase
Forgo the obvious and sought-after frames altogether and find your own unique angle for telling the story.

↘ **Below right:**
Pinch of Salt
Sometimes small moments can be the most significant.

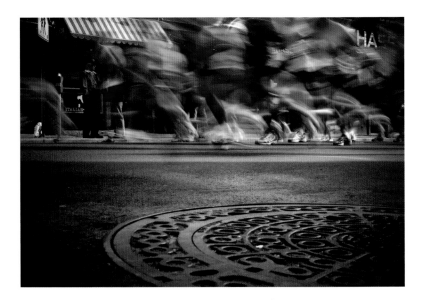

Equipment

Try to get as much information about the event as you can in advance. Particulars regarding the type and amount of ambient light, the style and rules of the venue, the number and demographic of attendees, and the overall mood of the day will dictate the type of equipment you'll want to bring along. A rowdy crowd at a late-night party might influence you to bring a smaller setup so that you can keep all your gear on you and avoid any "mysterious disappearances." It will also give you a more streamlined system, which will ease your navigation through the crushing mob. If the space is indoors and dimly lit, you'll probably want to bring along a different lens from the one you would choose if it were outdoors in broad daylight. Keep in mind that during performances, the use of flash can not only be distracting and potentially dangerous for performers, it can also be annoying to the audience. Take the type of performance into account in order to capture it tactfully. For gatherings with fast-paced action and the potential for wildly varying light, consider using two camera bodies, each with a different type of lens attached. This way you won't miss a beat while switching lenses.

Participation

As described in the scientific theory of the "observer effect," the mere act of watching a phenomenon can actually result in unintended changes to the phenomenon itself. Similarly, the mere presence of photographers can influence the nature of an event. How you choose to be involved in the occasions you shoot is up to you, and can be indicative of your style of photography. In the strictest sense, photographing an event will mean that you are more of a passive observer than an active participant. Occasionally, the presence of snapping photographers jockeying for position can be so overwhelming, it hinders the involvement of the participants themselves.

→ **Right:**
Acrobat
The reactions of the audience can say a lot about the mood of an event.

↘ **Below right:**
Firespinning
Keep in mind that a gaggle of photographers can influence the event itself. Always be aware of your presence.

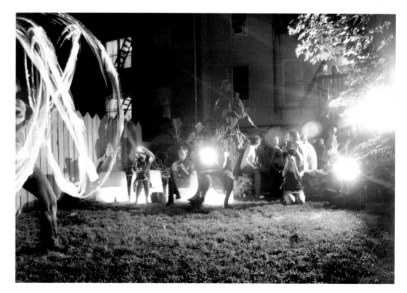

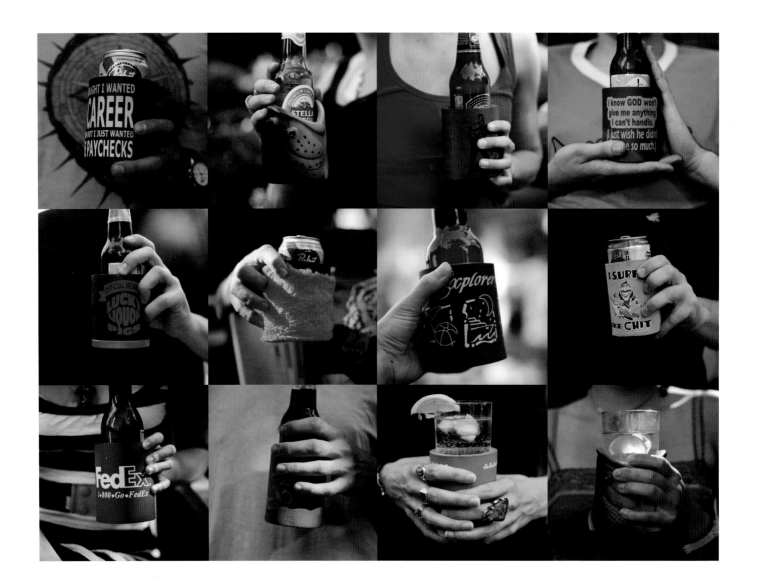

← **Facing page:**
Cozy Collection
Plan a presentation that will suit your collection of images.

← **Left:**
No Pants Subway Ride
Try stepping back from the action or shooting very discreetly so as not to disrupt it.

↙ **Below left:**
Santacon
Not content to merely stand back and observe? Join in the fun and become an active participant.

Consider stepping away from the action so that you are capturing it without interfering. Use a telephoto lens to put a greater distance between yourself and the crowd or gathering, and try to make yourself as invisible as possible to capture truly candid moments that weren't influenced by the presence of the camera. Alternatively, if you can't beat 'em, join 'em (the event participants, that is). Instead of shooting a parade from your tippy toes through the crowds at the sidelines, dress up and join in the fun yourself. You'll get greater access to interesting photo opportunities, and you will add to the atmosphere rather than taking away from it. Mastering the art of documenting while participating will mean you'll have a great time and take away energetic shots.

Presentation

People don't like to see pictures of themselves, they LOVE to see pictures of themselves. If you are planning to shoot an event, be prepared to be assaulted with "Can you send me that photo?" and "Where can we see the pictures?" Whether the attendees consist of your family and friends or complete strangers, develop a strategy for a presentation afterwards. If you have your own website or a page on a photo-sharing site, consider giving out cards detailing where the photos can be found. With enough forethought, you can even create a set or album in advance so that you'll be able to give out the exact URL. If you're not quite sure where you'll display the photos, come prepared to gather contact information from those who inquire. Seek out the host or organizer and ask whether they'd send a link to your photos to their guest list.

When preparing your gallery, don't lose sight of the intent to tell a story. Even if every snap of the shutter was stunning, if you include too many images, you will lose your audience. Half the battle with event photography is a keen eye for editing. Try to view your work objectively, and attempt to assemble the shots that have the most to say.

Tilt-shift
A different perspective

Laura
I prefocused on the point at which I wanted to capture the model when she walked down the slope.

Mona T. Brooks

The Idea

Cameras are made so that their lenses are positioned perpendicular to the film and camera body, and with the majority of lenses it stays that way. With a tilt-shift or perspective-control lens, however, you can adjust the angle and position of the lens, giving you greater control over the content of your photos and your angle of view. Such lenses will not only change the perspective in your images, they will change your whole perspective on photography. The only downside of these lenses is their price–they are not cheap. However, many rental houses offer a variety of Canon tilt-shift and Nikon perspective-control lenses. Canon offers four lenses, ranging from 17mm to 90mm, and Nikon offers three, ranging from 24mm to 85mm. Unfortunately, all have manual focus only.

The Ingredients

> Any camera with a lens mount
> Tripod (optional)
> Tilt-shift lens OR
> Lensbaby

The Process

Tilt-shift lenses are made to mimic view and large-format cameras. Shifting the lens allows you to include the whole of a tall building or tree, for example, without it appearing distorted; it allows you to get a wide depth of field and still keep the whole subject in focus. Tilting also creates a soft vignette out from your choice of focus, which draws the viewer to your intended subject.

Tilt-shift lenses are mainly used for photographing fine art, architecture, and landscapes. A tripod is key for such subjects. Where you need everything to be in focus, a small f-stop–f/22 or f/16–is required, so you will need to let more light into the camera by setting a slower shutter speed, and therefore, you will need to keep the camera very steady to avoid camera shake.

For photographing architecture, the shift function comes into its own. Rather than tilting your whole camera up to include an entire building in the frame, shift the lens sideways, up, or down. When you change the angle of your camera in order to include a whole building, as you have to do with a 35mm camera, the top half of the building will appear smaller than the bottom half. A tilt-shift lens corrects this distortion by keeping the plane of the camera parallel to the subject.

To accommodate horizontal compositions, make use of the tilt-shift lens' ability to rotate. When you are using a digital camera, shoot one frame straight on, one that is rotated left, and another that is rotated to the right. You can then stitch these frames together in postproduction to make the image more panoramic. If you are shooting film, you can do this by scanning your images and then using the imaging software in the same way.

As you tilt a tilt-shift lens, you are also tilting the focus plane; just a small tilt of the lens will create a big tilt of the focus plane, which means that you can have both the flowers in your foreground and the mountains in the distance in focus. If you want everything except your subject out of focus, a shallow depth-of-field effect of f/1.8 can be achieved at f/22 with a simple tilt. The instant feathering this creates is an eye-catching result that makes the subject really stand out. As tilt-shift lenses have only manual focus, previsualizing your idea generally makes for a better shot. For instance, if the subject is moving, prefocus so that you are ready to shoot when the subject comes into the perfect spot in your frame.

While tilt-shift lenses are not made for making objects in the foreground appear miniature, you can achieve this effect by focusing on the foreground, with the subject around one-tenth smaller than the background, then using the shift to get the feathered vignette look.

← **Left:**

1000 Marina
This image was composited, using three shots taken with the Canon TS-E 24mm lens, and retouched in Photoshop.

↙ **Below left:**
The Canon TS-E 24mm lens.

→ **Right:**

BBQ Back Bend Layover
Flare from the sunlight adds another dimension to this image.

Lensbaby

A Lensbaby is a cheaper alternative to a tilt-shift lens– usually around a third of the price. With a Lensbaby your "sweet spot" will be reduced, but I think this gives the images they produce a more artsy look. (Most lenses have a sweet spot–a range in their aperture settings within which they produce the sharpest images.) Lensbabies can't be shifted, but they can be extended and retracted. As a general rule of thumb, their natural focusing distance is 2ft (60cm); macro focus is achieved by extending the lens and infinity focus is obtained by retracting it. Keep in mind that having a Lensbaby is like having a fisheye lens; it looks cool, but if you only shoot with one odd lens, you must consider the gimmick factor. The good news is that you can save money by finding pre-owned lenses online.

No amount of reading will make you an expert in tilt-shift photography. I suggest you practice, practice, practice, and experiment!

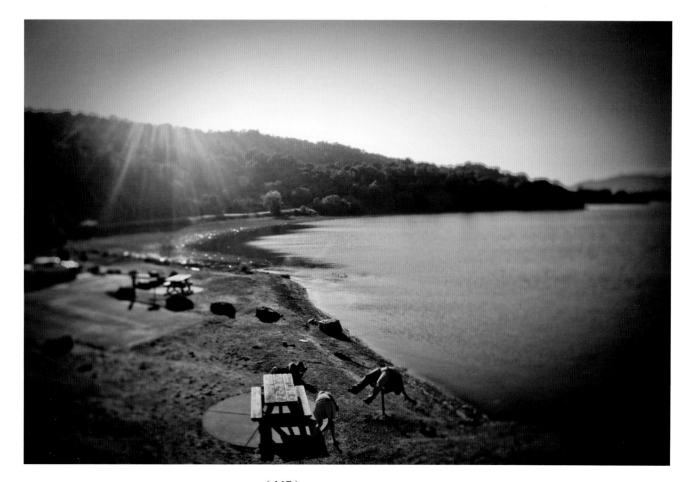

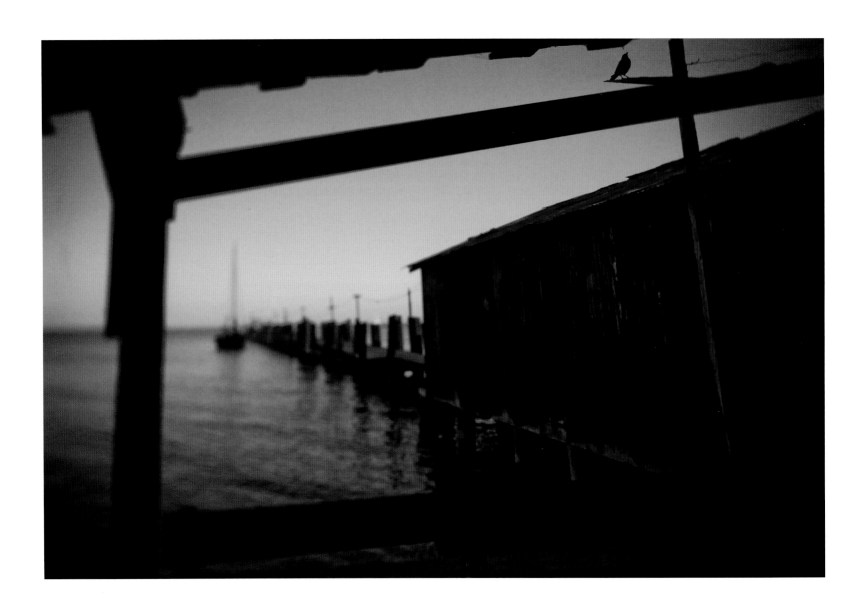

For a similar effect ...

You can use Photoshop or other image-manipulating software to achieve the "poor man's tilt shift." A limited depth of field can make objects in an image look like miniature models. To imitate this effect, think of a train set. More than likely, you will be looking down on the toy. Keep that image in mind as you follow these steps.

1. Choose an image that was taken from above your subject. The subjects in your frame must already be small in order to make the scale believable. The further the subject from the camera, the better. If you take a photo specifically for this treatment, try taking it from the second floor of a building or higher.

2. In Photoshop go to Filter > Blur > Lens Blur or Gaussian Blur. Experiment with the blur amounts and radius. Increase the contrast and saturation of the image to make it pop.

3. Under Layers, click on Masking. Feather the brush to 15 or higher. Change the brush size and lower the opacity level, if desired.

4. Unmask the subject and most of the bottom half of the image, but leave the top portion of the image alone.

← **Left:**
Pier at China Camp
I waited patiently until the bird gave me a straight profile of himself.

→ **Right:**
Old Shack
By focusing on the bench, I was able to create the illusion that the bench is much smaller than the shack.

Cross-processing
Super-saturated color

Hot Air Balloon
The darkened edges in this image are due to an effect called lens vignetting. The increased contrast you get with cross-processing strengthens this effect.

The Idea

Cross-processing, or xpro for short, is a great way of giving photos taken on a film camera more impact. You shoot film as you normally would, then you get it processed in chemicals intended for another film type. You can shoot negative film and get it processed as slide film and vice versa. I cross-process slide film to give my images a super-saturated high-contrast look. This effect can make the most mundane images really interesting.

The Ingredients

> Film camera
> Film

The Process

Cross-processing, as the name implies, is all about processing. When slide film is processed in the usual way, the film that was in your camera gets turned into a color positive. When you ask the lab to cross-process slide film, the lab technicians will develop it as though it were a negative film and instead of a slide you will get a very dense-looking negative. If you ask for a negative film to be cross-processed you will get a negative with very muted colors—almost the opposite of the effect you get when you cross-process slide film.

Film choice

When you are shooting film to be cross-processed, your choice of film is really important as certain types of film give specific, different effects. Some films produce a red, green, or yellow cast over the entire image. This isn't linked to brands; different speeds of the same film type can give different color shifts. Try all the options so you can make an informed choice. I prefer something a little more subtle than a huge color shift. The film I use for cross-processing is AgfaPhoto CT precisa. As a slide film it's not the best there is, but when cross-processed it is the king. Rather than putting a color tint over an image, it increases the contrast and saturation.

Subject choice

When you are shooting film to be cross-processed, you also need to think about what you are going to capture in order to avoid disappointment later–cross-processing might not work for your image. For this reason I carry a camera loaded with slide film that I am going to cross-process and a camera loaded with negative film so that I have an alternative if I think my subject won't work well with the cross-processed touch. As you shoot with cross-processed film you will start to realize what works for you and what doesn't. I tend to avoid taking pictures of people and objects in bright, direct sunshine because the shadows will be underexposed and the highlights will be overexposed.

Lighting

My favorite conditions for shooting slide film for cross-processing are overcast days, in the shade on a sunny day, and during the golden hour.

Overcast days are great for shooting because of the diffused light. Instead of light coming from one source–the sun–the sunlight is diffused by the clouds and light comes from the whole sky. This means there will be no strong shadows in your photos and also that tones and textures will be very subtle.

Shooting in the shade on a sunny day will give your image the same effects as shooting on an overcast day. If I am taking someone's portrait on a bright sunny day I will always ask them to move into the shade, if there is any shade nearby. You have to be careful that everything in your picture is in the shade; bright elements in the background will affect your exposure and might leave your main subject underexposed.

→ **Right:**
Heather and Me
This was taken in direct sunlight. You can see the really harsh shadows, which were increased by the use of cross-processing.

↘ **Below right:**
Me at Arm's Length
In this shot, you can see that cross-processing is far more flattering with the more even light of an overcast day than with direct light, as in the image above.

The golden hour refers to the first and the last hour of light in the day. When the sun is lower in the sky, light coming from it has to travel through more of the atmosphere. This reduces its intensity, which has the effect of making shadows less harsh.

Just because I like shooting my cross-processed film early in the morning and on overcast days, shooting in the middle of a sunny day isn't out of the question. Midday sun can be perfect for capturing silhouettes, which are particularly well suited to cross-processing because the extra contrast it gives means that any object in silhouette is virtually guaranteed to be black.

When you shoot under artificial light, your pictures might have a very distinctive color cast. This is because different types of lightbulb produce light at different color temperatures. Under these conditions, with a slide film that is going to be cross-processed, keep in mind that your images will be very red, very yellow, very green, or very blue: by pushing up the saturation through cross-processing, you are turning up the color.

↑ **Above:**
Beachcombing
Cross-processing has really helped give this image a striking sky. Without it, the sky would have been a dull, flat gray.

↖ **Above left:**
Munich Carrots
Brightly colored things can really pop out from the background with the effect of cross-processing.

← **Left:**
Afternoon at a Festival
Cross-processing can add oomph to images that might otherwise appear a little dull.

Processing

With your film shot you are only halfway there; you still need the all-important processing. When choosing a lab for cross-processing, you have to be a bit picky: the prints or scans the lab makes for you might not be what you expected. The problem is not in the chemical process–this is standardized so it is the same everywhere. The problem lies in the scanning from cross-processed negatives. Even if you are just getting prints, most labs scan the negative digitally so that they can print it. Different film types have different color profiles, which the lab's machines are set up to allow for. However, the scanners are not programmed to accommodate a cross-processed negative and will try to make adjustments for a negative's contrast, brightness, color saturation, etc. They will try to "fix" what is "wrong" with your pictures with the result that they mess them up. It can be tricky to find a decent local lab that scans cross-processed negatives well. Some refuse to cross-process altogether, and I have heard of labs charging three times their normal processing price as they say it shortens the life of the

↖ **Above and above left:**
Paris Big Wheel
These images were both taken at the same time: the left on a digital camera, the right on a Lomo LC-A with cross-processed slide film. You can see how cross-processing beefs up the contrast, especially in the sky.

← **Left:**
Snapping a Phone Pic
This image was shot under warm lighting, which gives an orange/yellow color cast.

chemicals. You can trick a lab into cross-processing, if necessary, by removing the film's label and telling them it is negative film. However, there is no real problem as there are labs that do good cross-processing that offer a postal service, including USA Color Lab in New York, USA (www.uscolorlab.com/), and Spectrum Imaging based in Newcastle, UK (www.spectrumimaging.co.uk/).

Extras

The codes for the most common types of processing are C41 and E6. C41 is the process used for developing negative film and E6 the process used for developing slides. Production of Agfa Precisa ceased briefly in 2006, but as it had reached cult status in the cross-processing community, a new company–AgfaPhoto–bought the rights to make and sell the film and it's now back under the name AgfaPhoto CT precisa.

← **Left:**
New York Subway
Another photo taken in artificial light; this time the image has been given a green cast.

Minimal
Stripping back the clutter

Garage Forecourt
In this particular case, the rule of thirds did not win out—instead, I used a corner of the roof to create a triangle.

The Idea

Minimal photography involves stripping back the detail in an image until you are left with a few perfectly balanced, zen-like elements. Let's face it, the world can be a pretty cluttered place, and that means photos of your environment can be loaded with too much visual information for the viewer to take in. If you strip back this clutter, your images can become easier on the eye and more appealing. You can achieve this by concentrating on a small aspect of a larger scene, or by making sure you don't include distracting elements in a photo. There are varying degrees to which you can take minimal photography, from photographing just color to framing objects in a way that obscures what they are.

The Ingredients

> Any camera
> An eye for detail

The Process

The composition of a minimal photograph will really make or break the image. It's best to keep in mind the rule of thirds (which you can read more about under Composition on page 282). You can find inspiration in simple things, like a gas station forecourt. I tried a lot of different compositions for this shot. When you are shooting, try to make different shapes and forms out of objects; you can also split the image up into different parts by creating forms through your framing.

Backgrounds are key to minimal photography. In fact, I would say you should think about your background as much as your main subject for every photograph you take, but backgrounds are especially important when you are creating minimal images. Look for contrasting colors between subject and background, and for plain backgrounds, which will help draw your eye to the subject.

Shooting lights in the dark can be a good way of creating striking images with high contrast. When compared with the background, the lights are much brighter, so, if the image is exposed for the lights, the background will come out a really deep black. If your camera has spot metering, use it to take a meter reading from the light so that the light is not overexposed. You can take this idea further by silhouetting objects in front of the light. (Read more about exposure and metering on pages 283 and 284.)

Kevin Meredith

Perspective is another useful element in creating a minimal composition as it helps draw the viewer's eye into the image. By isolating a subject and concentrating on one aspect of it, in this case perspective, you can make a striking image from something really simple. This image of the shutter works because of the geometry of the corrugations. A wide shot of the whole shutter would not have the same impact.

↖ Above left:
Bicycle Lock
In this photo, the background and foreground are both really plain, which helps draw your eye to the man locking his bicycle.

↑ Above:
Red Car
Even though this image is all about the car, it only fills a very small part of it. Red is a powerful color, so you don't have to include much of it to give a photo impact.

← Left:
Shutters
I made sure you can't see the end of the shutters in order to give a false sense of perspective and trick you into thinking that the lines go on for a long way. In fact, they stop just out of the frame.

↖ **Above left and above:**
Lights in the Dark
I used cross-processed slide film for these images to increase the contrast between the light and the dark background.

← **Left:**
Parking Cone
I created a striking contrast between the colors of the cone and the background for this image. It would not have worked as well if I had shot it looking the other way, with a busy background full of cars.

Architecture
A considered approach

Kevin Meredith

Regency Square
I have the gentle curve of the building running corner to corner to lead the viewer's eye through the image.

The Idea

Photographing buildings should be easy as they don't move, but there is a lot to think about when shooting them. And lessons learnt photographing architecture aren't just good for shooting buildings; they apply to all sorts of man-made objects, like bridges and large monuments.

The Ingredients

> Any camera
> Any man-made structure

The Process

The time of day at which you shoot can have a huge effect on the way your architectural shots turn out, and which side of the building you shoot from can totally change the feel of an image. If you shoot with the sun hitting your building straight on, this can flatten some of its details. It is better if the light comes in at an angle; in this case you get shadows picking out the details. If you are shooting a building with the sun behind it, it can be tricky to get a balanced exposure between the sky behind the building and the part of the building that is in shadow. If you want to capture any detail, you will have to come back at a time when the sun is hitting it from a different direction. You can use the situation to your advantage and shoot a silhouette, but this will only work well if the building has an interesting outline.

Dusk can be a good time to shoot as it is possible to get a balanced exposure between the natural light illuminating the outside of the building and the artificial lights inside the building. You can see this in my photo of the San Francisco skyline on page 162.

You can get wonderful results shooting architecture at night: some buildings really come alive when it gets dark because of the way they are lit. If you are going to shoot at night, you will need a tripod to avoid camera shake, though you can sometimes get away with resting your camera on the ground.

If you are shooting buildings from ground level, especially big buildings, it can be hard to get them without perspective distortion.

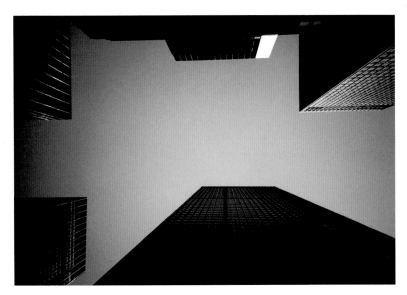

In *San Francisco Skyline*, the buildings appear to lean toward the center of the frame–this is caused by lens distortion. You *can* avoid this by using a longer lens and moving further away, or by shooting the building from a higher vantage point, but such options aren't always practical. For this image, I would have been in the bay if I was any further back. You can try to fix distortion in Photoshop through the Lens Distortion option. In Photoshop go to Filter > Distort > Lens Correction; in Photoshop Elements go to Filter > Correct Camera Distortion. Tweak the Vertical Perspective and Remove Distortion sliders until you have made your leaning vertical lines a little more vertical–it's not always possible to remove all distortion. Professional architecture photographers use tilt-shift lenses, which avoids the problem in the first place.

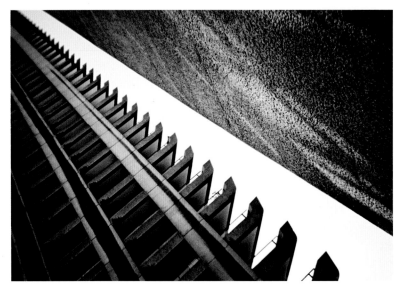

↑ Above:
San Francisco Skyline
I shot this skyline at dusk. It would have been impossible to expose for the interior lighting in the middle of the day, as the natural light would be too bright in comparison.

↖ Above left:
New York Skyscrapers
The multiple perspective lines in this image give it a huge sense of height.

← Left:
The Barbican Centre, London
I shot this picture at an angle in order to include the maximum number of balconies and give the picture a greater sense of scale.

Architectural photography doesn't have to be about the whole building, and often it's hard to get the whole thing in. Try isolating particular details. You can also play with the angle at which you shoot your pictures to include more or less of a particular element.

If you are going to shoot the interior of a building, you will need a wide-angle lens. Without this, you might find it tricky fitting everything in your shot— you won't always be able to take a step backward in order to fit more in as there might be a wall behind you. You could, of course, shoot multiple shots and stitch them together in a panorama (see page 259).

If you are trying to show the scale of the building, including people in the photo, or other objects that viewers can relate to, is good as this will give them an idea of the relative size of all the elements in the scene.

↑ **Above:**
The British Museum
A wide-angle lens is ideal for capturing interior shots.

↖ **Above left:**
The Gherkin
This is an abstract view of the Gherkin, a London landmark, shot from the base looking up.

← **Left:**
Lloyd's of London
Seek out unusual architecture to get unique images. This is an office block in London, but at first glance you might think it was an oil refinery.

Cut-outs in-camera
There's something in my Holga

Retirement
Including a little lens flare in this image enhances the silhouette effect.

The Idea

Modify your Holga with some tiny visitors! Place tiny paper shapes inside your Holga to create a silhouette on each photo. The Holga is a simple, and cheap, medium-format plastic camera (120mm roll film) hailing from China. Given that the Holga is built almost entirely from plastic, it produces a very distinctive lo-fi photograph. You can expect blurring, sharpness, vignetting, and light leaks. Hooray!

The Ingredients

> Any camera
> Holga with 6 × 6cm mask (or similar plastic camera that you don't mind messing with)
> 120mm, medium-format roll film
> Thick paper (c. 180gsm)
> Computer and printer, or pencil and crafty drawing skills
> Scalpel and cutting board
> Superglue
> Patience

The Process

Open the back of your Holga and remove the 6 × 6cm mask. This is what you have to work with, so get an idea of how big it is. Once you have an idea of what size your cut-outs need to be you can let your imagination go nuts!

The shape(s) you choose to cut out will be transposed onto the film and appear in each photo as a silhouette. Choose a shape, some letters, a figure, an animal— whatever you want. I used some vector graphics which I opened in Illustrator, but you could draw your own and cut them out. You can create a "signature" on each photo by printing or writing your name on transparent film (the type you would use with an overhead projector). You need to ensure that your shape(s) is the right size; about 3cm ($1^3/_{16}$in) tall is a good place to start. It needs to fit in the mask, without being so big that it covers up too much of the photo.

Alternatively, you might want to make a textured "frame" for each photo. This is dead simple. You can cut a frame about 1cm ($^3/_8$in) wide to fit inside the 12cm mask, which will give each image a nice outline. Toilet paper can work well, as it is slightly transparent.

Print or draw your shape onto thick paper or thin card (180gsm is good). Cut out with a scalpel, leaving a tab at one edge to glue the item into the Holga. It is important that you leave enough extra paper to attach the shape; this won't show up on the photo. When you position the shape in the mask remember that all cameras take a flipped image, so things placed on the right will appear on the left, and things at the

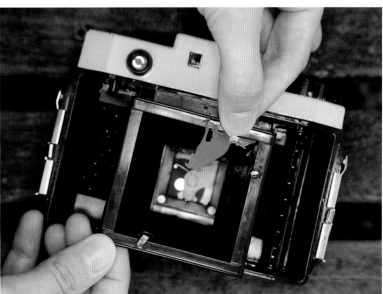

← Facing page, clockwise from top left:
His Master's Voice / Cornwallis Under Fire / We Go Walking / Mirror
To get the best results, think about where your shapes are when you're composing your photos. Old ladies might like to watch people or take it easy down at the seaside; dogs like to chase cats (and they love the piano too); planes like a nice blue sky ...

← Far left:
Plane, duck, and dog shapes.

↙ Left and below left:
Sticking shapes in the Holga.

top of the mask will appear at the bottom of the image. If you stick people top right so that they hang down inside the mask, they will appear to stand at the bottom left of the image when you see the finished picture. Similarly, if you want to write something, use a transparent film and stick it in back-to-front. It's best if you superglue the tab to the plastic mask so that it doesn't move inside the camera. Wait for the glue to dry properly. You don't want superglue snagging on the film–trust me! Put the mask back into the Holga as usual, load your film, and set out on your photo safari. Finally, develop your film and squeal with delight at the results.

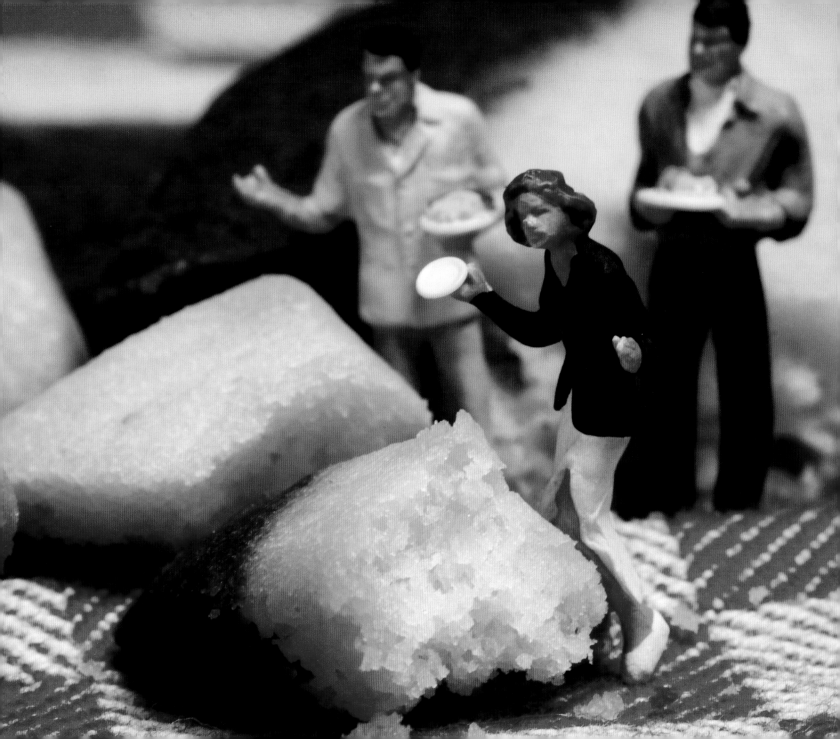

Macro
My Lilliput

Nice Day For a Picnic
Sometimes even a piece
of cake can make your photo
look different...

The Idea

If you love macro photography like I do, and take close-up shots of everything possible with a 1:1 ratio and at a really close range, you probably have a hard disk full of stunning images of bees, flies, and other bad-looking insects; flowers, petals, blossoms, and shots of water drops... A little boring in the long term, isn't it? Well, if you want to spice up your macro portfolio with some really different subjects, follow me in this project.

I will show you how to build dreamlike and humorous scenes with very little effort, a few model figures, and a lot of fun! What if model figures come to life? What if their life happens around us, in the real world? The idea here is to let these figures interact with real-life objects on a totally different scale from them in order to build funny and surreal scenes that will keep your friends saying "oooooh" and "aaaaaah" for a long time.

The Ingredients

> Digital SLR with dedicated macro lens
> Tripod
> Remote switch/cable release (optional)
> Light reflector (optional)
> Colored paper
> Backdrop (whatever your creativity suggests—
 a flower, a fruit, a cheese, a ball ...)
> Set of model railroad figures

The Process

I often come up with an idea while shopping at the local supermarket, maybe discovering a new, strange-looking vegetable, or a bad-looking fish. Other times it can come from the news I read, a scene I watch on TV, or a stranger I meet down the street ...

The secret lies in letting your fantasy flow. Identify a situation/phrase/pun/concept you want to represent and then arrange your prop(s) and miniature(s) to deliver the final shot. Once you have fixed the concept and collected all the elements that will make up your scene, the production steps are very simple and straightforward.

I use the sun to light my shots—it is, after all, a cheaper and easier option than using flash or modeling lights. Find a place in your home where you can get good sidelight through a window. It is best if the window has white or transparent curtains as this will help you achieve softer shadows on your scene. Place a table, or anything solid enough to hold your set in place, perpendicular to the window, then cover it with colored paper, if necessary. Place your objects of choice on the table, then play with the position of your figure in the scene until it fits your intended composition. Remember that the figure will always be the focal point of the image, so careful positioning is one of the most important steps.

Now place your tripod in front of the scene, always perpendicular to the light source, and compose your shot. Use the following settings as a kick start:

ISO: 100
Aperture: Priority Mode
Lens: macro, open from f/2.8 to f/5.6

Always remember, the larger your aperture, the shallower your depth of field, and the smaller the area of your shot in sharp focus. Focus is the most important part of a macro shot: you need to have part of the figure in focus and a very shallow depth of field to give the image the characteristic dream-like effect. If you have a light reflector (golden is the best color to choose here), use it to counter-balance the sidelight coming through the window and reduce any harsh shadows being cast.

↖ **Above left:**
Fashion Photography
A jacket cuff can offer you a hint for a shoot!

↑ **Above:**
Looking Forward to Your Reply
By highlighting a single detail you can give new meaning to everyday things.

← **Left:**
Wildlife Photography
The unusual perspective and juxtaposition make this shot unique and captivating.

Place it on the side of your scene opposite the window and be sure to direct the bouncing light onto the figure. Now it's time to program your Self-Timer mode, or use the remote switch if you have one, and shoot the scene! I usually bump up saturation and contrast in Photoshop to enhance the surreal effect, and that's it.

Extras

Model railroad figures are tiny plastic people (available in HO (1:87), N (1:160), and Z (1:220) scales) used to decorate model train scenes, or architectural scale models. I usually work with HO, but have shot scenes made with N-scale figures. HO scale is the best if you want to avoid working with magnifying glasses and claws! The most popular manufacturers are Preiser, Noch, and Hornby. Google any of those brand names plus "miniature" and you will discover hundreds of online resellers around the world—and there are thousands of characters from which to choose!

↖ **Above left:**
Bad News
A newspaper and a figurine speak of financial crisis better than a thousand words, right?

↑ **Above:**
Flirtin' at the Beach
Everything can be reused to create a mood ... even a mussel shell.

← **Left:**
A Quiet Afternoon at Cabbage Hill
I used a printed sky for the background here to give the illusion of an open-air shot.

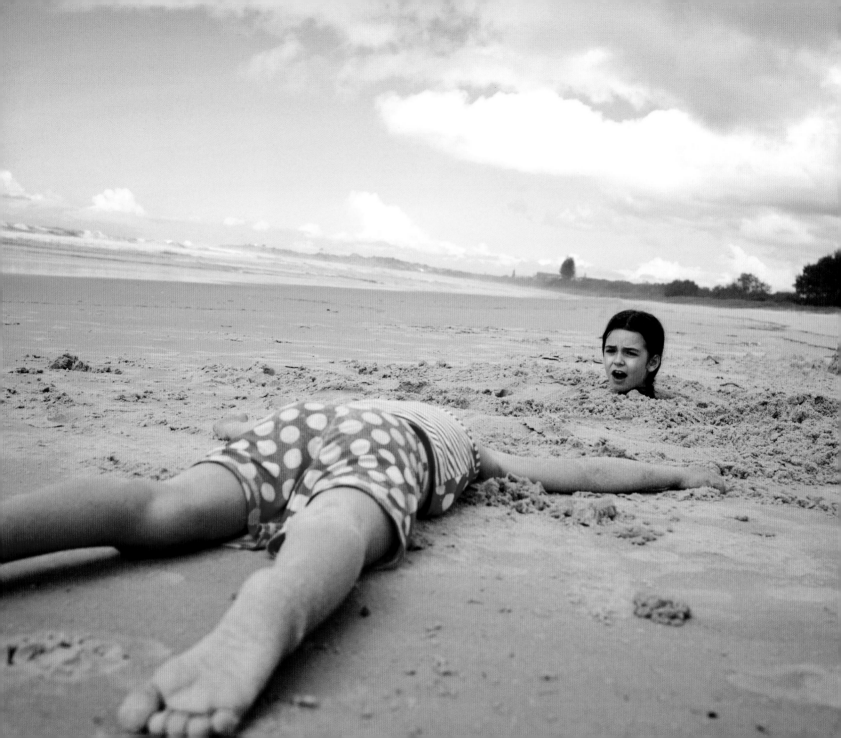

Children
Carefree play and a natural smile

Head Off
It's all in the perspective.

The Idea

Take photos of kids that are fun and real and make you smile. Remind yourself what it's like to be a kid and have that carefree spirit. Play with photography and play with the subject. Capture kids in their natural guise–being kids!

The Ingredients

> Any camera
> Children
> Sense of fun

The Process

Photographing kids can be very tricky. This is usually because children simply don't want to sit and look at the camera. I have one daughter who *loves* to model and one daughter who has a serious case of "ants in her pants." This has given me an enormous amount of practice experimenting with different ways to get kids to come alive and be photographed–and you do need different techniques for different kids. Even if you are lucky enough to photograph a child who is happy to model and do everything you say, the photos can sometimes feel very stiff and posed. I don't get much of a thrill from this type of image. My adrenalin rush comes from capturing a true moment of childhood happiness and delight.

For digital photography my approach is "just keep shooting." For shooting with film my motto is "always be prepared." Shoot outside wherever possible, and always set your camera to autofocus! I know this isn't very "professional," but when you're running and not even looking through the viewfinder you will need it.

If you are shooting with an SLR, set your camera to AI Servo (focus mode). This means that the focus, once locked, will follow the child as he or she moves away from or toward the camera. You will also need to set the ISO, which should be either 200 or 400, depending on the light. Switch the Continuous Shooting mode to ON so that you can hold down the shutter button and shoot more as the action happens. I always shoot with either a fixed 35mm lens or a 24-70mm lens. Using a wide-angle lens will allow you to get in close and capture as much expression as possible.

Hailey Bartholomew

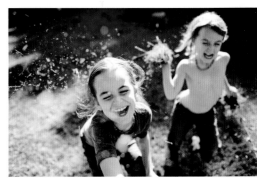

It helps if you make photography a game. Show the kids that having your photo taken is fun. I chase them with the camera and I get them to chase me. This can make shooting tricky, but don't feel bad if you get six shots with the bush *behind* the child in focus rather than their giant grin. Keep going. Try to keep a similar distance between you and the child. If you're patient you will manage to get some great images that capture the joy of childhood. Play is the way to go–and it will keep you very fit.

When you shoot children in digital, you have the luxury of shooting as many experimental frames as you like–and you should! Play, experiment, and take your time, without boring the children!

Babies

Simple peekaboo, popping out from behind the camera, works a treat with little ones from around six months to one year old. I sometimes sit their favorite toy on top of my lens: when I bring my camera in they make a grab for it and often smile or laugh. At this age many children are very attached to their parents and it can be difficult to get them to warm to you. Getting mom or dad to pop their face next to your lens can help.

Babies are also easy to photograph when you put them into something they love; a small basin of water or a baby swing for example. Ask the parents what their child's favorite thing is and photograph them doing that, if possible.

Toddlers

Very few toddlers are camera shy and it's easy to engage little kids. Just get them to show you bubbles, or their tea set, or how well they can kick a ball.

However! I once spent a whole shoot chasing a toddler. When they want to run they can really move. I could *not* get her to keep still at all. Not once. Framing is hard work when there is no down time. This is when you bring out "rolling on the grass," "race to the camera," "jump on the chalk cross," or "how high can you go?" Anything to slow them down just a little. Then all you have to do is get in among the action and photograph them doing what they are doing. This is also the best way to capture a little of their personality.

You *can* get very shy toddlers who take some time to warm to you or the camera. Showing them what you're doing can help, and with digital that is super easy. Getting them busy doing something they love is a good way to get them to forget you're there. Get them in a sandpit, on a swing, or playing chasing... Whatever it is, play it. Get your lens down low on their level; be fun and silly.

A little bucket or chair is an excellent prop for this age-group; sitting on something cute and colorful helps them relax and gives you time to snap away. If you want a toddler to look at you, wait until your framing is just right, play heaps, and just shoot them mucking around. Find other ways to get them to look at the camera. "What am I doing?" "Can you see my eyeball in the camera?" "Can you see yourself in the camera?" Whatever you do, do not wear out the words "Look at me!" Keep this as a last resort. Toddlers love farty sounds and squeeking like a mouse ... make any noise that sparks that child's imagination.

Children

When kids reach the age of about six or seven it is trickier to get natural responses from them, and the fake smile is a killer in any photograph. I love the challenge of finding a way to crack this age-group.

Again, getting them caught up in something they are doing or getting them to do something they're interested in is a way to keep them off guard. You could ask them to show you their very best surprised face, angry face, happy, scared, and so on. This is often hilarious and can make for a fun series. If you know good jokes, pull them out.

If you are photographing a child you don't know, be confident when you meet them and try to tune in to how they are feeling to get an idea of what you can do to help them enjoy the process. Don't be worried if what you do doesn't work first time–try something else.

← Facing page, clockwise from top left:

Winks
The bonus of always carrying a camera is little moments like these.

Spin Me Right Round
Use movement and low light to create dreamlike images.

Swinging
The girl looking over her shoulder to see if she would hit me is one of the wonderful things about this shot.

Grass Play
When I run with the camera I don't look through the lens.

Zen Teddy
Choosing your background and ensuring there is good natural light is half the battle in taking a good image.

Strike
This boy *needs* to be active. Putting myself in the firing line made this shot work.

↗ Above right:
Sunny LOMO
I framed this to have the sun flaring into the lens just above the girl's head. This adds to the soft vintage feel.

→ Right:
Sisters
Asking the little girl to give her sister a big sloppy kiss made a great moment!

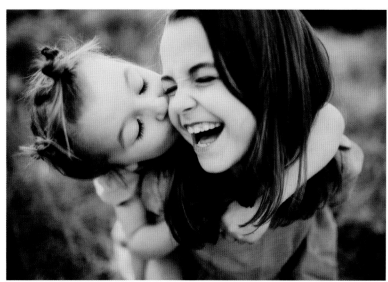

The beauty of digital is that you can take loads of images and it is no big deal. You only use the ones you like. Shoot plenty, get in among the fun, and just go with the flow. The best shots are often child-directed.

My favorite film images are from my Lomo and Polaroid cameras. Lomography has a magic quality that makes everything seem richer and more fun. Polaroid is much the same; there are many situations that just strike me as Polaroid moments. However, the cost and hit-and-miss nature of film photography means it doesn't lend itself so well to lots of work with children. If you are documenting a moment, it's best to have the children keep doing what they are doing while you snap around them rather than asking them to hold a pose. One of the problems of shooting with a Polaroid camera is the time it takes to focus properly, but being able to see the printed image so quickly provides a fun payoff for the kids.

Locations

Finally, choose your locations well. Find places that have lots of color and possibilities for fun, and from there you will be able to create amazing images that sparkle with creativity and life.

→ **Right:**
Children's Party
This shot was taken at a very big children's party. I framed up the image as the birthday boy walked off toward the bouncy castle, then, choosing my words carefully, called out to him and snapped away before waiting to see what he did. He turned and smiled, which was what I hoped for!

→ **Facing page, clockwise from top left:**
Chickens / Candy Cane / Sweet Treats / Cousin Itt / Sleepy / Bike Riding
All these images work well because they are not set-up moments, but are to do with having your camera handy at perfect childhood moments.

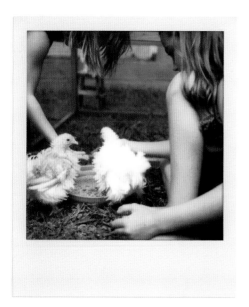
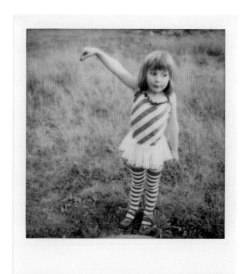

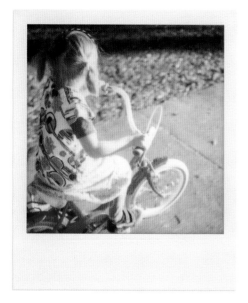

Double exposures
A different view

Carousel
In this mirror-image double exposure there was "something" in most of the frame, so overlaying the second image created a ghostly look. However, because this was shot at dusk and the carousel's lights were on, the shapes are strong enough to stand out.

The Idea

Go to Paris and it's a fair bet you'll take a photo of the Eiffel Tower. And why shouldn't you? It's an iconic landmark after all. It's also a fair bet that your photos will look very similar to those taken by millions of other tourists. If you'd rather have something different as a memento, there is a really easy way of producing more creative and interesting photos–double exposures.

Finding a different angle or waiting for unusual lighting conditions are good options for a more singular image, but they may not be viable if you haven't got much time or can only take the shot from one position. The beauty of double exposures is that you take two pictures from the same spot, but you end up with something far more interesting than the standard shot.

The Ingredients

❯ Any camera
❯ Splitzer (optional)

The Process

I use a Lomo LC-A+ (a 35mm film camera) as it makes it particularly simple to take double exposures. On the underside of the camera is a very handy switch; if you flick this after taking a photo, it allows you to take another without advancing the film.

You don't need an LC-A+ to take double exposures. Many old film cameras, such as the Lubitel 166B, allow you to make multiple exposures without advancing the film. There are also some modern film cameras that allow you to do this, including the Holga. However, many film cameras will "helpfully" not allow you to take double exposures, so you have to trick them into it. If the shutter-cocking mechanism is linked to the film-advance mechanism this is easy. After taking the first shot, hold down the rewind button and turn the film advance lever until you hear the shutter cock. Holding the rewind button down means that the film doesn't actually get wound on, so you overlay your second shot on top of the first, then wind on as normal.

Some digital cameras have a multiple exposure setting built in, but it's often buried within the features menus so you might have to read through your instruction manual to find it.

Framing the shot

As you're framing the shot, remember that you need to fit two of what you're shooting into the frame. Visualize a line running through the frame, cutting it in half, and position the bulk of the subject to fill one section. Most of the time I like to create mirror-image double exposures of buildings. It's not always possible to fit the whole of the subject in, so pick an interesting

part of it. For structures that are more square in shape, photographing just a corner creates a dynamic composition. Tall or thin structures work best if you place them following the long edge of the frame, or side by side.

Taking the shots

If you're using a film camera, you'll need to take a bit of care in order to get the two exposures to line up. As you can't see what you've done, you'll need a good memory. When you take the first shot, make a mental note of what position your arms are in and how you're holding the camera. Take note also of what part of the structure touches the corners or edges of the frame. As you can't take the two shots one after the other– you have to move to rewind the film–it's easiest to keep a simple pose, so keep your elbows tucked in and don't walk about in between shots! For mirror images, turn the camera upside down and take the second shot from the same position and using the same framing. Don't change the side of the frame you shoot on; turning the camera upside down means that if you shoot on the same side it will actually appear on the opposite side. If you are worried about lining the shots up, you could draw a simple grid or mark the center point on a piece of clear acrylic and stick this over the front of the viewfinder to use as a guide.

Technical info

To avoid overexposing your shots, rate your film at twice what it should be, for example, if you're using ISO 100 film, tell your camera it's using ISO 200. This means that each individual shot will be slightly underexposed, but the combination of the two will be bright enough.

Try to avoid shooting subjects against very bright sunny skies because cameras like the Lomo LC-A+ will expose the film for the sky, leaving the subject itself underexposed.

→ **Center right:**
Eiffel Tower
The contrast and unusual color of this image was created by shooting the tower against a very bright sky and cross-processing the film. Positioning the two images so that they fill the frame and touch each other creates a unique view.

→ **Right:**
Louvre Sky
Choosing a slightly different perspective for the second shot creates a dynamic composition. Dramatic skies against reflective surfaces always look good.

↘ **Below right:**
Brighton Pier
Using the Splitzer's ability to mask off a portion of the frame, I was able to overlay the pier sign onto the sky. The combination of two totally different views gives this image more interest than a straight shot.

To keep as much color as possible in the photo, choose a film that is known for high color saturation. I nearly always use Agfa Precisa 100, a slide film, and get it cross-processed.

Splitzer

You can create a different double-exposure effect by using a nifty piece of equipment called a Splitzer. It's a simple plastic device designed to slide onto the front of an LC-A+. (There is also a Splitzer variation available for the Holga.) It works by covering part of the lens and therefore masking a portion of the frame. It has two semicircular panels that can be moved around to adjust which part of the lens is covered and which left clear. Remember to move the panels around between shots or you'll end up with half of your photo black. As the masked part of the frame in each shot is not exposed, the images will overlap only a little, if at all; instead, they will appear to join up. This technique is good for combining different parts of the same scene or combining totally different images.

For a similar effect ...

You can always combine a couple of shots (or more) in a program like Photoshop, but that's not half as much fun as shooting on film and waiting to see what you've got.

You can replicate the Splitzer effect without buying a Splitzer; just get crafty. Cut a piece of stiff black card big enough to cover as much of the lens as you want to mask, and tape it in position on your camera. You'll have to fiddle about with re-taping it every time you move it, but it is cheap.

↑ **Above:**

Pavilion Spires
Shooting on a bright day with a very blue sky and then cross-processing the film gave this shot its rich color. The second shot overlaps, but as it is fainter, it doesn't clash with the first. You tend to get a more ghosted second shot when you shoot in very bright conditions, and when the images are overlaid onto plain areas such as sky.

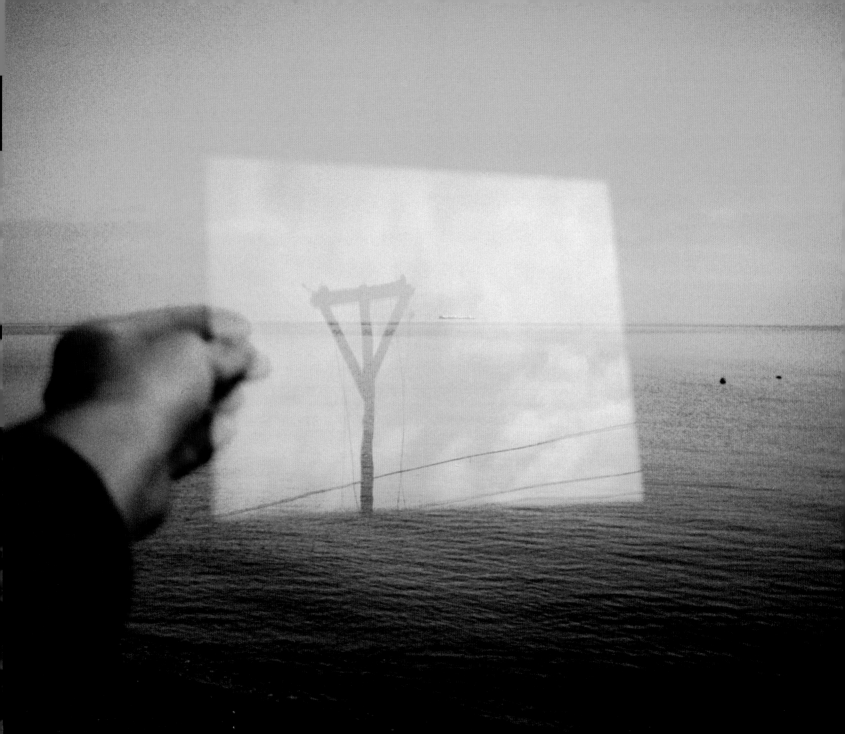

Perspex reflections
Two pictures in one

Seaside Telegraph Pole
Objects in silhouette make excellent reflections and produce striking images.

The Idea

There is so much you can do with Photoshop, but sometimes it's nice to do a bit of real-world image manipulation. I find people are more impressed by effects achieved without software. This technique uses a reflective surface to superimpose one image on another–all you need is a small piece of Perspex or Plexiglas.

The Ingredients

> Any camera
> Small piece of Perspex or Plexiglas

The Process

This may be a simple technique, but the results can look really stunning. I won't claim that I came up with it ... I was at the photography workshop Phoot Camp with a gathering of photographers and fellow Phoot Camper Derek Wood handed me a piece of Perspex with the idea of shooting the reflection in it. Before I even took a shot I knew it was a great idea. My first attempt turned out really nice and ever since, I've been hooked.

You can get your Perspex cut to order in a plastics suppliers. The size you need depends on the lens you're going to be shooting with. If it's a wide-angle lens, you want a bigger piece, if you're using a narrow lens (zoom) you want a smaller piece, as you don't want the Perspex filling the frame. I take my Perspex reflections on my Lomo L-CA, which has a 32mm lens, and I find that a piece 30 × 20cm (c. 12 × 8in) looks good. I like my Perspex to have the same aspect ratio as my photo so that it fits in the frame nicely. If you are shooting 32mm film, or with a DSLR, the aspect ratio will be 3:2; if you are using a digital camera other than a DSLR, the ratio is usually 4:3. It's quite hard to keep Perspex free from scratches, and the more scratched and scuffed it gets, the less reflective it will be. I carry mine wrapped up in a T-shirt, but at the end of the day, it's not expensive and you can easily replace a scratched piece.

With your Perspex at arm's length, change the angle at which you are holding it. If you have it so that the reflective face is straight toward you, you will be shooting your own reflection. You might have to angle

it quite a bit not to have yourself in the shot. Set your focus on what is in the reflection, *not* on the Perspex itself. If you are using a camera with autofocus, it is probably best to focus manually as the camera might focus on the Perspex. To make the edge of the Perspex really soft (out of focus), open your aperture up to its widest.

Subjects

It can be quite tricky to get nice compositions because you have to think about what you are shooting in the reflection as well as what is directly in front of the camera. I find that neutral backgrounds work well. If you are focusing on infinity to get clouds in your reflection, consider moving the Perspex quite close to what is in your background–when you focus on infinity, the closer you get to the background, the more out of focus it will be.

↖ **Above left:**
Me and Victorian Lamppost
Including other objects in your reflection can give clues as to your environment.

↑ **Above:**
Ripply Reflection
The ripples in this reflection add an extra dimension.

← **Left:**
Gray Days
On an overcast day your image will be more about background as the reflection will just be white.

I find that simple things work best in the reflection. Silhouettes work really well if you are shooting on an overcast day—trees with no leaves on them can be good. Broken cloud can work well, but remember, it will be fighting with the background. As you walk around holding your Perspex you will start to get a feel of what works and what doesn't, even if you look a bit odd in the process.

One thing you have to look out for is double camera shake. With any photography you must hold your camera steady to avoid camera shake, and with this technique you must also hold your Perspex still— a shaking piece of Perspex will result in a blurred image. You don't need much wind before it's shaking around all over the place—if it's really windy, you're best off trying another day.

↖ **Above left:**
Trees and Tarmac
To get a good contrast, the simpler your background, the more complex you should make your reflection.

↑ **Above:**
Sunset Reflection
A colorful sky at sunset provides a great opportunity to capture a reflection.

← **Left:**
Chimney Row
Architectural details are a good subject for this technique.

TtV: through the viewfinder
Doubling up

50 Cents
Using a macro lens on the top camera allows you to get extremely close to subjects.

The Idea

Through the viewfinder (TtV) photography is, essentially, taking a picture of any subject through the viewfinder of any camera with *another* camera. I first came across a TtV photo back in April 2006, taken by Carrie Musgrave. Carrie's picture of a rusted out, abandoned streetcar had toy-camera qualities that film aficionados love–dark corners, blurred edges, and grunge–but it was taken with a digital camera through the ground-glass viewfinder of an old Yashica-A.

The Ingredients

‣ Two cameras
‣ Light-blocking "contraption"

The Process

There are a number of ways to guarantee your success with this technique. Here are some guidelines to what I consider the optimal method for making TtV photos.

Bottom camera

The cool thing about TtV is that any camera can be used on either end, but the camera most frequently used for the "bottom camera" (the camera whose screen you shoot through) is the Kodak Duaflex, a twin-lens reflex (TLR).

Other cameras enjoying renewed life as TtV bottom cameras include the Kodak Brownie Starflex, Argus 75, Brownie Reflex, Anscoflex, and Ensign Ful-Vue. The reason for their popularity is the quality of their view-finding optics. All of these cameras have bubble-glass top-viewing lenses (which make the largest, clearest images), and, as with any TLR, everything you see and shoot through them is recorded backward. Flipping the image in post-processing is optional, but many photographers prefer to leave their images as they are.

Some TtVers shoot through a Holga, a Polaroid, or a film SLR. The viewfinder lenses on these cameras are typically small and rectangular. They work, but the resulting image is very, very small. The bubble-glass lenses are about $1\frac{1}{2}$in (38mm) square–nice and big!

Top camera and lens

Any camera can be used as a "top camera" (the camera that does the recording) to shoot TtV, but most folks use digital, and the majority use DSLRs. The object is to make as big an image of the top of your bottom camera's viewfinder as possible, which means getting close. The most common methods include using a close-up filter, a macro lens, or a macro setting on the top camera. Experiment to find what works best for you. The best way to start is to look in your camera bag–you probably have a lens or camera that will work just fine. I'm using an "old" Pentax *ist D with a Sigma 28-135mm zoom and a 130mm macro.

Blocking light

In order to eliminate glare and reflection from your TtV pictures, you'll need some way to block out light between your two cameras. I use a "contraption" made from black artboard held together with gaffer tape. (Templates for this contraption are available for download from my website: www.russmorris.com/ttv/myContraption-v2.pdf and www.russmorris.com/ttv/starflex_contraption_v1.pdf.)

My first attempts at creating a device for blocking light were very basic. Using an 11 × 14in (c. 280 × 355mm) piece of black construction paper, I made a fold every 3in (c. 76mm) to form a tall, square channel. I wrapped it around the Duaflex and made marks around the front viewing lens in order to cut a viewing hole through the paper, then secured everything with gaffer tape. I've seen some pretty wild contraptions, made from a variety of materials: cereal boxes, mailing tubes, plastic tubing, rubber parts from the plumbing section of a housewares store, cigar boxes, and shoeboxes. Be creative!

← Far left:
Camelia
Flowers are a favorite subject among TtV photographers. Post-processing with Urban Acid really makes the color in this shot pop.

← Left:
Reflection
Car shows offer opportunities for reflection shots. All that chrome and glossy paint are TtV magnets!

Taking the picture

While cradling the bottom of the Duaflex with my left hand, I slip the contraption over the Duaflex and hold the channel in place with my index finger, just below the taking lens. When shooting TtV, the taking lens on the bottom camera isn't used; my finger naturally found the shape and placement of the lens to be a convenient way to get a good grip on the bottom camera and the contraption. Next, I hold my digital camera with my right hand, then stick the macro lens down the channel, bring the camera to my face, look through the DSLR viewfinder, and frame up the shot. I stand or stoop, just like I do with TLRs and any other camera I use. Nothing is different about this part of the process. I let the camera take care of autofocus, pressing the shutter release slightly until I hear the beep that lets me know I have focus lock, and then shoot. I fire off multiple shots, just for insurance, all the while checking the composition and framing. Autofocus can be tricky, but manual focus is extremely difficult, so be warned.

← Far left:
I put this contraption together using cereal boxes rescued from recycling bins in my neighborhood. Traps can be made from mailing tubes, cracker boxes—even plastic tubing.

← Left:
Diana
Low-light TtVs can be tricky, as the on-camera flash is normally pointing at the ground, not the subject. One solution is to use white artboard for the front panels of the trap—these can then act as reflectors for the flip-up flash.

↙ Below left:
Wood
A low angle and contrasting subject/background combine to give a compelling image. Friends are natural models, even with TtV.

Digital darkroom

Since the digital images being taken are rectangular and most TtV shots are square-ish, the pictures you take need to be made square and true. This can be done with image-editing software like Photoshop. Film users, just scan your shots in and crop the digital results.

The fun doesn't end there. Early pioneers in TtV added a touch of funky brilliance by running their shots through an Action in Photoshop that simulates the effect of cross-processing film. The most commonly used and freely available Action is Urban Acid. With a simple Internet search you will find relevant downloads. Every one of my TtV shots are touched by Photoshop. I try to recreate the moment as I envisioned it and post-processing helps me to achieve that goal.

What to shoot

Any subject is suitable, but toys, children, cars, people, and flowers seem most popular. And because there's a fair amount of space between the two cameras, you'll find that your shots will have a very low point of view. Simple, yet complicated; old and new,

TtV photography is consuming, addictive, and totally fun. Curious people will stop me in the street to ask about the strange chimney-shaped thing I'm carrying, and with a quick explanation and demo, they'll let out "Ah-ha! Now, that's a great idea." I couldn't agree more.

← Far left:

17 Wheels

One benefit of using the Duaflex as a bottom camera is that its square, bubble-glass viewfinder produces shots that mimic medium-format cameras.

← Left:

Bones

In this candid moment I was able to capture the action of this game of dominos with a low angle that's natural for TtV.

→ Right:

Action

Caught in the act! This is what me shooting TtV looks like, with the top camera, contraption, and bottom camera all stacked up. Don't forget to look up every once in a while.

Backgrounds
Emphasis, scale, and meaning

Green Wall
Between shots, I snapped this photo of my wife. It has a natural feel because she was fiddling with her scarf.

The Idea

A photograph is nothing without a subject, but how that subject is viewed is dependent on a lot of things, not least its background. There is nothing worse than having a great subject lost in a really busy or distracting background. Often, when people see something interesting, they take a picture of it without considering what is behind it. My philosophy is to think as much about what is behind your subject as about the subject itself.

The Ingredients

> Any camera
> A subject and background

The Process

It's easy to spot what you want to take a picture of, but that's only the first step in successful photography. The next is to decide what you want to shoot it against. Unless what you are shooting fills the entire frame, always think about your background. The way you approach this depends entirely upon your subject, but in most situations, the one thing you want to avoid is shooting your subject on a background that has a similar tone, color, or texture, because your subject will be lost.

People

When shooting people, it's important to move them in front of a neutral background rather than just shoot them where they stand. Keep an eye out for pattern and texture as well as color. If you want to shoot street portraits of strangers, it's always a good idea to consider your location carefully so that you don't inconvenience your subjects too much by asking them to move too far out of their way.

Sometimes you just need to capture a moment as it is. If your subject has a distracting background, you could blur it with a shallow depth of field to soften it up and have only the subject in focus. You can achieve this if you are able to open up your aperture wide. Typically, point-and-shoot cameras won't allow you to have a depth of field as shallow as this; you need an SLR camera and, usually, the better quality the lens, the wider the aperture will open. (You can read more about aperture and depth of field on page 285.)

Kevin Meredith

Still life

When I shoot still-life images I always make sure there are no distracting elements in the frame. Before I took this photo of strawberries I removed a receipt from the table. Once I had the image developed, I cropped out the top as the end of the tablecloth was visible. This is similar to a situation in which I shot an image of an abandoned glove on a mailbox. I moved the glove toward me slightly because otherwise it would have been intersecting with the edge of the mailbox and I wanted the glove to be framed by the top of the box. Technically, the mailbox and the gingham cloth are not backgrounds in these images, but the same principles apply.

↖ **Above left:**
Abandoned Glove
Move your subject around in a shot until you are pleased with the framing.

↑ **Above:**
American Flag
What I wanted in this shot was the background, but I needed something else in it to give the image a sense of scale. I had to wait for this pedestrian to walk into my frame.

← **Left:**
Strawberries
Don't be afraid of having a little tidy-up even if it is someone else's market stall!

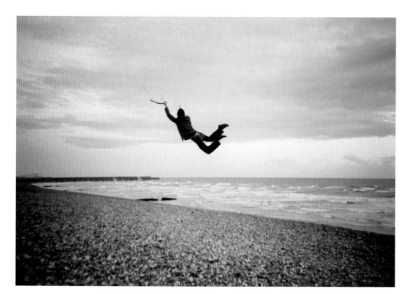

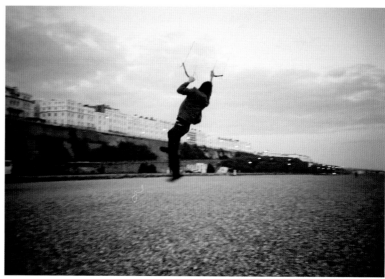

Background first

Sometimes you will find an amazing background that you know will work really well in an image, but you need to shoot something with it to give the image a sense of scale or meaning. In a way this is working backward, as you find a background first and then think of something to put in front of it. If I had shot the image of the stars and stripes without the pedestrian in it, the viewer would have no idea how big the flag is. Before taking it, I got down low and waited, looking through my viewfinder, for someone to walk into the shot. I was in a similar situation when I found the fantastic green wall in the photo on the previous page. I stood in front of it for a while, shooting people as they walked past, but none was quite right, so I decided to get my wife to model in front of it.

↖ **Above left:**
Extreme Kite Flier
I made sure I shot my kite flier using the sea and sky as a backdrop, as this made him stand out.

↑ **Above:**
Extreme Kite Flier 2
This doesn't have the same impact because the kite flier is lost in the busy background.

← **Left:**
Leo
Although Leo is standing in front of shutters that share the tones of his clothes, he stands out because of the strong horizontal lines.

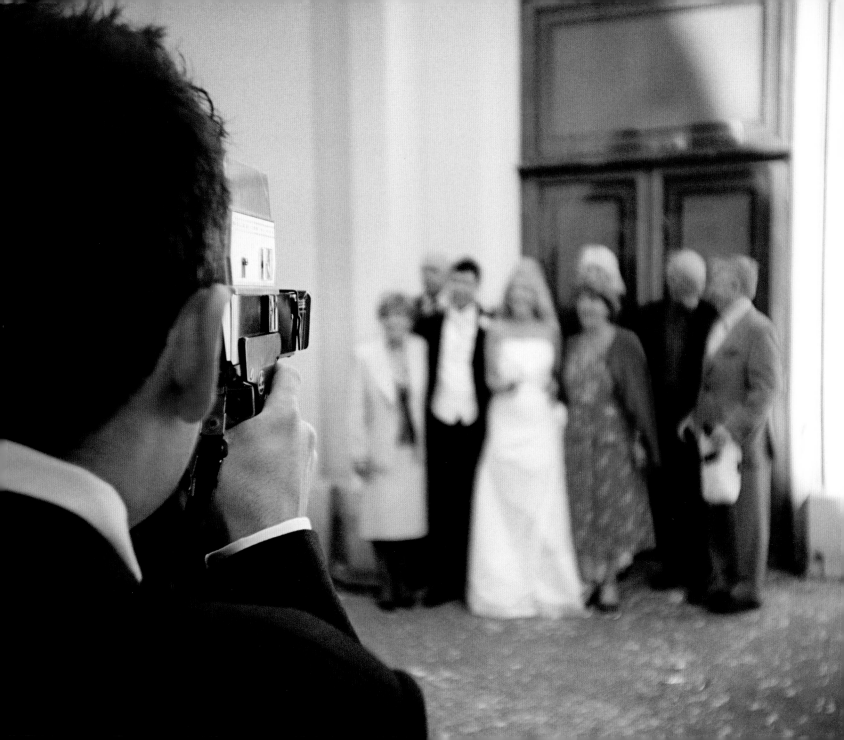

Shallow depth of field

Isolating your subject

Wedding Day Cinematographer
Using a shallow depth of field is good for drawing the viewer's eye away from what would usually be the most important part of an image—it shifts the focus.

The Idea

An understanding of depth of field (DOF) gives you much greater control over the appearance of your photos. You can use it to isolate your subject from its surroundings, to create dreamy images, and to quieten down noisy backgrounds. You can also use it simply to give an unusual view of something. One of the reasons an image can become more visually appealing with a shallow DOF is because it is different from what people are used to seeing.

The Ingredients

> Any camera
> A subject or view

The Process

DOF refers to how much of an image is in focus. If you have a wide DOF, more is in focus; if you have a narrow DOF, less is in focus. There are a few things that can affect the DOF in a picture, but the main one is aperture. When you buy a lens or camera you need to take note of its widest aperture, and remember, the wider the aperture, the shallower the DOF you can achieve.

If you open up the aperture, by selecting a low f-number (around f/2.8), you will get a shallow DOF. If you close down the aperture, by selecting a higher f-number (around f/11), more of your photo will be in focus. You can see this in the images of huts on page 200. I focused on the huts for both shots; the only difference between them is how I set my aperture. In the image with the blurry foreground I opened the aperture up whereas, in the sharper version, I closed it down.

If you are shooting digitally you have the advantage of being able to check the DOF on your LCD screen once you have taken your shot. It's a good idea to zoom in to a small part of the image on the back of the camera so you can see how much *is* in focus; there is nothing worse than finding out too much is out of focus when you don't have the option to reshoot. On a film SLR, and on most DSLRs, you can preview your DOF if you hold down the DOF preview button. This is usually located near the lens, but check your camera's manual.

Kevin Meredith

Manual control of aperture

You can set manual control of aperture on all SLR cameras, and on a lot of compact cameras, through the mode dial. On Canon cameras you need to turn the dial to Av and on Nikon cameras to A. (Other camera models will be similar; check your manual.)

Auto aperture

If you are using a camera that sets its own aperture (like a Lomo L-CA), you can judge what the DOF will be. If you are in bright conditions or are using a fast film, the camera will need less light so it will close down its aperture. If the aperture closes down you get a wide DOF. If it's an overcast day and you are using a slow film (around ISO 100), the camera's aperture will open up, giving you shallower DOFs. Put simply, if it's bright you will have a wide DOF; if it's night you will have a shallow DOF.

Distance of subject

Another factor that can affect DOF is how far your subject is from your lens. The closer the point of focus is to you, the shallower your DOF will be. The most extreme example of this is macro photography for which the DOF can be as little as a fraction of an inch. The vast majority of people who own a camera have a digital compact or a camera phone. It is always hard to get a shallow DOF with these cameras, but one thing you can do is try to move really close to your subject to get the DOF as shallow as possible.

↘ **Right and below right:**
Beach Hut
I focused on the hut for both of these shots; the only difference between them is how I set my aperture. In the image with the blurry foreground I opened the aperture up whereas, in the sharper version, I closed it down.

Focal length

Focal length has an affect on DOF as well: the longer the focal length of a lens, the shallower the DOF will be. A 200mm zoom lens will have a shallower DOF than a wide-angle lens. At the extreme end of wide-angle lenses you can get shots where virtually everything from a few centimeters to infinity can be in focus.

Effects

You can use DOF to create subtle effects and lead the viewer's eye to specific points. To exaggerate DOF, a simple trick is to have objects very close to the lens.

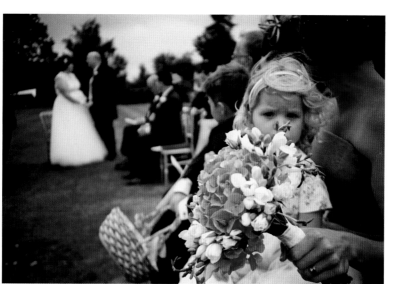

← **Left:**
Child's Bouquet
In most wedding photos your eye would wander to the bride and groom, but, because of the shallow depth of field, the focus is shifted to the child and the subject of the photo is changed.

↙ **Below left:**
Bride
I got the bride to point at the camera; her finger was only an inch from the lens, but it is totally out of focus, which gives the image a real sense of depth.

Portraits

If you have a lens that can open its aperture right up to f/1.4, there is a temptation always to shoot on f/1.4 to get really blurry backgrounds, but this can cause problems. If you take a portrait with a really open aperture, your subject need move only an inch away from or toward the camera and they will be out of focus. It's a good idea to focus on a person's eyes when taking a portrait—as long as the eyes are in focus, nothing else matters. This is because people looking at a picture of a person will always look at the eyes first. (For more on aperture, see page 285.)

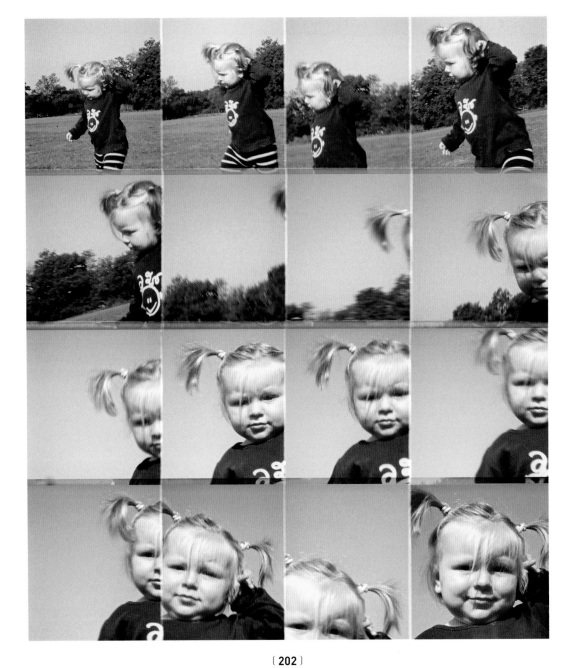

Action sampling
Sequenced images

Kevin Meredith

Playing Child
Action sampling shows the playful nature of children to great effect.

The Idea

When you take a photograph you are freezing a moment in time so you can preserve it forever, but what if you want to show movement? You could slow down your shutter speed, but then the subject will be motion-blurred and you will lose detail that you might have wanted to capture. You will also have to worry about tripods and camera shake. There is an easier way–action sampling. For action sampling you take a few photos over a period of time and display the resulting images together.

The Ingredients

> ActionSampler or similar camera
> Moving subject (or moving camera)

The Process

The reason I call this process action sampling is because the first camera I came across that enabled you to do it was called the ActionSampler. I don't know if there is an accepted term for this type of photography, but this is what I call it.

The original ActionSampler was brought to the world in the late 1990s by the Lomographic Society. It has four lenses arranged in a 2 × 2 grid. Each of the lenses has its own shutter, and when you press the shutter button they are set off in sequence over half a second. There are now quite a few variations on this type of camera.

In 2003, having successfully marketed the ActionSampler, the Lomographic Society decided to make their own model, which they called the SuperSampler. This model has four lenses stacked one on top of the other, which expose a single frame in slits. The drawback of both the ActionSampler and the SuperSampler is that they can't be used at night because they have fixed shutter speeds and apertures. But that changed with the ActionSampler Flash. In addition to its four lenses, it has four flashes that fire in time with the four shutters. You can place different colored gels over each of the flashes to turn your action sampling pictures into mini Andy Warhol compositions. My favorite ActionSampler camera, and the model I consider the Rolls-Royce of action-sampling cameras, is the Kalimar Action Shot 16. It has 16 lenses arranged in rows of eight and exposes two negatives with each shot to produce one long photograph. It also has a wonderful feature that

allows you to set off each of the shutters individually. You get the film developed in the normal way and put the photographs together later. Unfortunately, the Kalimar is really hard to get hold of because it was only made in limited numbers and has not been in production for 10 years. Another option is the Oktomat, which is half the camera that the Kalimar is—it has eight lenses arranged in two rows.

Shooting with these types of cameras could not be simpler, as most of them only have a shutter button. Some models also have a speed button, which allows you to set how quickly the shutters are set off. What you must remember is that either you or your subject has to be moving, otherwise you will be taking the same photo many times. Moving toward your subject as you shoot is a great way of getting really different shots for each frame, and spinning the camera as you shoot can produce interesting results. It can be tricky if you are pointing the camera forward, but if you are shooting upward you can just spin your whole body.

You can take it one step further and turn your action-sampled shots into small looping animations. The easiest way to do this is to make them GIF animations. The GIF format is designed for short animations displayed on the Internet. You can make these animations in Photoshop, and there are many free software applications; simply google "gif animation software" to find them.

→ **Facing page, top to bottom:**
Statue of Liberty
The individual shutter release of the Action Shot 16 meant that I could walk around the Statue of Liberty taking each shot as I wanted in order to make a montage of the statue from every angle.

Smokestack
To get this series, I spun the camera while I took the shots.

Stars and Stripes in the Breeze
Sometimes a subtle change in each frame is enough to make an interesting image; this flag flapping in a breeze is a good example.

→ **Right:**
Spinning Office Block
I held the camera at arm's length, pointed it toward the building, and twisted my arm as I took the picture to ensure that each frame was at a different angle.

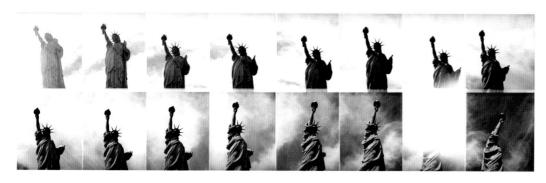

For a similar effect ...

If film is not your thing, you can create the same effect with a digital camera. Most digital cameras have a continuous shooting or Burst mode. If you hold down the shutter button in Burst mode, pictures will be taken in quick succession until you release it. If you don't have Burst mode on your camera you could select Sports mode–this will usually turn on continuous shooting. It's best to turn off autofocus when you're in Burst mode as this might cause some delay in photos being taken; this is down to the time it takes the camera to get focus lock.

Once you have the images on your computer, you will have to combine them in a montage to finish off the ActionSampler effect. It won't really matter if some of the shots are out of focus–this will simply add a low-fi SuperSampler feel to your final montage. If you want to emulate the ActionSampler aesthetic more closely, set your shutter speed to 1/60 sec or 1/30 sec so that your images have some motion blur in them.

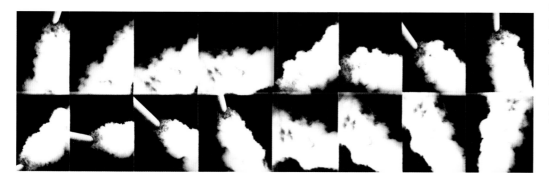

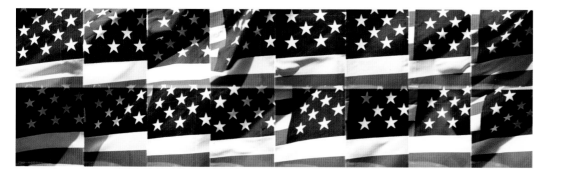

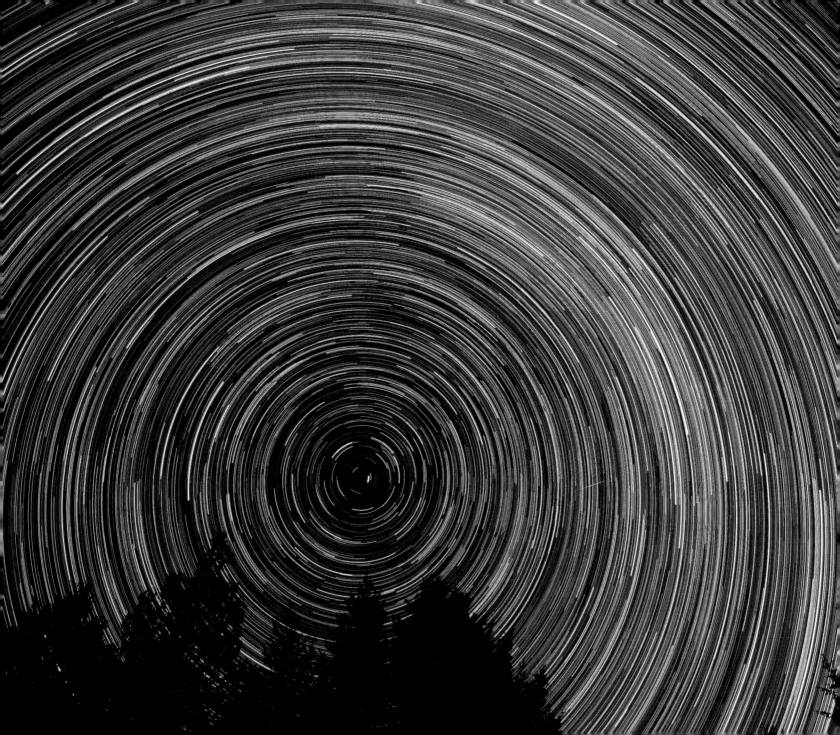

Star trails
Spinning space

The Milky Way
I exposed 300 shots at 30 seconds each for a total of 150 minutes of night sky. The Milky Way produces a very dense patch of trails.

The Idea

A lot of people mention that their love of photography comes from capturing that perfect moment in time. When shooting at night those "moments" become a little longer; when shooting star trails, those "moments" turn into hours. Capturing that perfect hour or two in time is what makes shooting star trails so fun for me. When I look at star-trail pictures, they remind me that this big rock we live on is spinning out in space. The plan here is to capture the stars over a long exposure so that they leave behind a "trail" or light stream. In fact, the stars are stationary—it is the rotation of the earth that causes the trails. Sounds cool, doesn't it? For such amazing-looking pictures, the technique is really quite simple.

The Ingredients

> Sturdy tripod
> Camera capable of shooting in Bulb mode
> Cable release or remote
> Location far from city lights

The Process

To begin, if you live in a city, I suggest you get into your car and drive far away from it. The number of visible stars will greatly increase the farther away you get from any town.

There are a few ways to go about shooting star trails. We will start with the basics, regardless of whether you are using a film or a digital camera. Before anything else, it is a good idea to set the focus. In the dark, it is not easy to get the autofocus to lock on to anything. I suggest trying to lock on one of the brighter stars in the sky, and if that doesn't work, try to focus on anything that is really far away. If that fails too, try to lock on your car headlights from at least 100m (100 yards) and if that fails, you will have to focus manually. If you do manage to get your camera to focus automatically, be sure to set it to MF (manual focus) before starting your exposure or it will focus again. Once you have set the focus, set up the camera on the tripod and compose your shot. Try to exclude any direct light sources, like streetlights, in the shot. One more thing to think about is white balance. I tend to shoot night skies with the white balance set to "tungsten," which gives a nice blue look. Warmer colors tend to give the sky a dirty look.

Film cameras

With film, the number of stars that will be picked up is determined by both the ISO rating of the film you are shooting with and the aperture value. A wider aperture and higher ISO will pick up more stars, but, in turn, will shorten the maximum exposure time. For film, my suggestion is to start with ISO 400 film

and an aperture of 3.5–4.0, depending on the lens. With this combination it should be possible to expose for around an hour or more, but this is also dependent on ambient light. Set the camera's time value to Bulb, dial in the aperture value, and start the exposure with the remote or cable release. Now all you have to do is kick back and relax while the camera does all the work.

Digital cameras

When shooting with a digital camera you have a few more options. There are things you can do to make it a little easier, including taking test shots, which will help you compose your shots. A 2–3-minute exposure is enough to show you in which direction the stars are moving and allow you to imagine what the final shot will look like. As to shooting options, you have two: you could choose to do it all in one shot or shoot multiple shots and "stack" them afterward, using computer software. Personally, I find that shooting multiple exposures and stacking them yields much nicer images than creating them all in one shot.

If you choose an all-in-one shot, your biggest concern should be noise. To avoid noise, you could use a narrower aperture and a lower ISO speed. While these settings tend not to pick up many stars, I would suggest at least trying it. Focus and compose the shot, set the shutter value to Bulb, the aperture to its widest value, and the ISO to 200; try for a 30-minute exposure with a wide aperture of 3.5–4.0. If there is too much noise, drop the ISO to 100 and either shorten the exposure time or try a narrower aperture.

Shooting this way will reduce the length of the trails that appear in the frame, due to the short exposure time, but there is something you can do to make them appear longer. The actual length of the trails is determined solely by time, but the appearance of the trail length is determined by the focal length you are shooting at. For example, star trails over a 30-minute

→ **Right:**
Odyssey
This was shot on Kodak ELITE Chrome slide film and cross-processed. The exposure time was 1 hour.

↘ **Below right:**
The Tower
I composed this shot so that the trails look like radio waves hitting the tower.

→ **Facing page, right:**
Focal Point
A longer focal point of 50mm created these trails in only 211 seconds.

→ **Facing page, far right:**
Explode
Expired film yields unpredictable results, but the images often have a cool, grainy, vintage look.

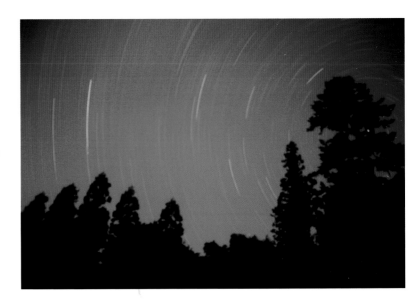

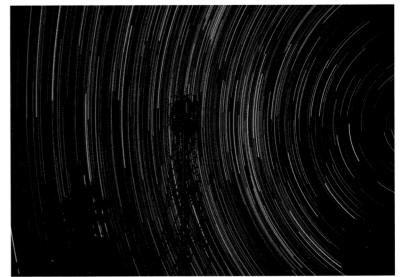

exposure would appear much longer in the frame at 50mm than they would at 10mm. If you find that you are limited to a shorter exposure time because of noise, or any other factor, try shooting at a longer focal length to increase the appearance of the star-trail length in relation to the frame.

Now to my preferred way of shooting, which is to take multiple shots to be stacked later. This method allows you to shoot with a wide aperture and a faster ISO, which will pick up many more stars than the previous method. You can do this because noise becomes much less of a factor. Noise increases with time; when you are shooting with 30-second exposures, noise won't be a problem even at ISO 800. There is even an option to include dark frames–frames shot with the lens cap on–so that even the tiny bit of noise from ISO 800 over 30 seconds will be removed. With the evil "noise" taken care of, the only thing limiting your exposure time is your battery life. For this method it is necessary to use a cable release and it is also important to make sure there is plenty of space on your memory card. To get started, set your focus and compose your shot. Set the aperture to its widest option and the ISO to 800. Dial in 30 seconds for the exposure time and set the drive to Continuous Shooting mode, which allows for nonstop shooting when the cable release is locked. I suggest doing a test shot first to see if it looks alright. If anything is too bright, dial the ISO down to 400.

Once you have taken your shots, you will need to stack them using software. I recommend freeware program Startrails (available from www. startrails.de). Simply import the pictures, hit the Build button, and wait for it to finish rendering. Don't forget to save it when it is finished as the there is no auto-save function built into this software. It is also possible to stack in Photoshop, and a quick Internet search will turn up several different methods. I find Startrails much simpler and more effective, but unfortunately it will only run in

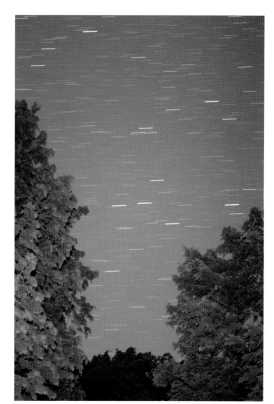
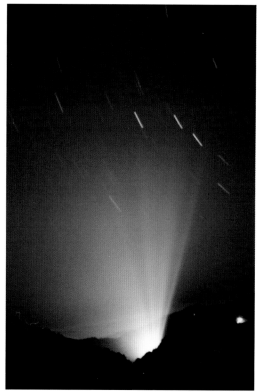

Windows, so Photoshop might be the only option for Mac users. One thing that may be of help to Mac users is that Startrails is a standalone program that does not require installation and can run off a USB memory stick, which means it can be used on any Windows machine, anywhere.

Foreground

To complete the shots, one idea is to include a foreground element, such as a structure or a tree, and light it with a torch or flash. I highly recommend testing how much light is needed before you lock that cable release. Too much light will distract from the beautiful star-filled sky you are about to create. If you are using the recommended tungsten white balance, use a warm color for the foreground lighting. If you use LED light with a white balance setting as cold as tungsten, you will find that objects in the foreground look very blue. To avoid this, you could apply an amber gel to a flash or use a tungsten light source, such as a torch, that has a regular light bulb as opposed to an LED bulb. I also suggest lighting the foreground at the beginning and again at the end of your exposure in case one of those is unsuitable for the final shot; you simply exclude the unwanted frames from the stack. If you light the foreground in the middle and make a mistake, leaving those frames unusable, you create a break in the trail, which will detract from the shot.

A final note for those with experience in night photography: keep in mind that you are now shooting wide open with your ISO bumped to 800, so adjust your lighting techniques to accommodate that with low-power flashes, or for less lighting time with a torch. All in all, this rather simple technique yields captivating results.

→ **Far right:**
Night Drive
A single 15-minute exposure aimed at the North Star.

→ **Center right:**
Temple Rain
Vertical trails look like rain falling on this temple.

→ **Right:**
Celestial Equator
A stack of 240 shots with a total exposure time of 2 hours. I aimed the camera at the celestial equator and lit the foreground with a torch.

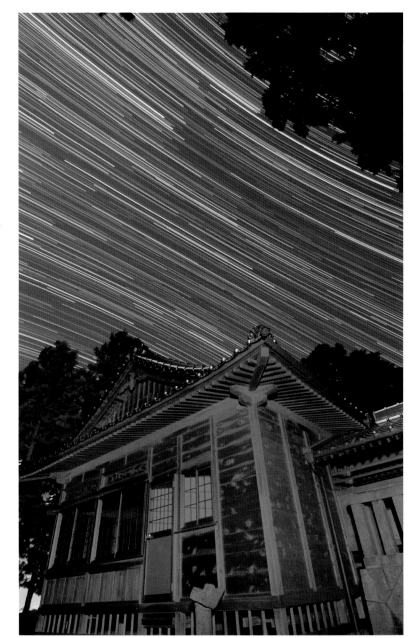

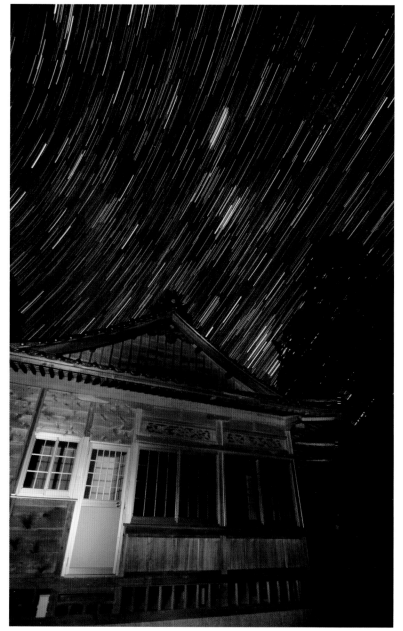

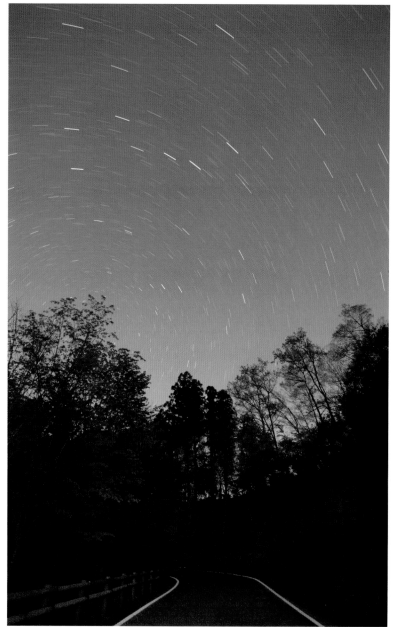

Concerts
Performance and display

Lady Gaga in Black-and-White
I waited for the moment her arm was perfectly aligned with her costume.

The Idea

Live music photography is fascinating–a perfect chance to take shots of people in their performance modes, displaying interesting character, high emotion, and energy–on top of which, gigs are great fun! With some preparation and experimentation, there is no reason why you can't get impressive results from less than high-end equipment.

The Ingredients

> Any camera
> Flashgun (optional)

The Process

So you have a ticket or a press pass to a gig, but what about the kit? Can't afford the expense of a camera such as a Canon EOS-1D or a Nikon D3X? Well, I still use my first SLR camera–the Canon EOS-350D–which came onto the market in 2005. I was lucky enough to get a press pass for Glastonbury Festival (the largest outdoor music and performing arts festival in the world). Astounded by the amount of equipment everyone had, I felt daunted among the mass of 30 or so other photographers in the pit, holding only my 350D. I tried to ignore the fact that I was also the shortest there and could barely see above the highly built stage. (Note to self: next time bring stepladder or stool like the others!) But I ended up with shots I was really proud of.

Preparation

Before the gig it's always worth researching the artist(s) or band(s). Look at their websites and listen to their music. Watch videos and view other photos of them. This way you'll learn more about your subject(s) and how they act on stage. For example, Lady Gaga is one of the ultimate performers, with a haute-couture, showgirl image. Her movements are expressive and frenetic. Having done my research, I understood that I needed to capture this essence in her performance, and I made sure her clothing was an important part of the image. It may seem obvious, but another good tip is always to bring spare batteries and memory cards. They are easy to carry, and it is extremely frustrating if you run out of memory or power and miss an interesting or insane moment on stage.

Ruby May Allcock

Three-song rule

Most venues and acts follow the three-song rule in the photo pit (three songs and you're out), so you have to be quick off the mark. Position yourself well, watch the performance for a moment, and try not to panic. Don't frantically take a photo every second possible in the hope of getting one good shot—wait for the right lighting and the right moment on stage. Vocalists are often stuck in front of the microphone, which can be uninteresting, so wait for them to move away slightly before you shoot, take a picture of another member of the band instead, or maybe even a crowd shot.

ISO/shutter speed/apertures

For concert photography it's best to go for an aperture of f/2.8 or lower to allow more light in so that you can shoot at faster shutter speeds. As band members tend to move and jump around a lot, this is a key point that will help you capture a sharp image rather than an out-of-focus shot. A good, affordable lens that is great in these situations is the Canon 50mm f/1.8. The aperture goes as low as you need, it doesn't weigh much, and it produces a really sharp image. The only slight problem is that it is a fixed focal length lens so, as you are not able to zoom with it, you need to get as close as possible to the performers. Set your ISO to 800 or 1600; this is best for low-light photography as it means you can use a faster shutter speed. However, sometimes using an ISO as high as 1600 will increase the digital noise/graininess of images, with color speckles appearing where there shouldn't be any. This is usually unavoidable, but again, it all depends on the available lighting. If there is a lot of light, you can set your ISO lower, resulting in less noise.

I normally take my photos on the Aperture Priority setting. With this you can set your desired aperture as well as the ISO, and the camera will automatically calculate the shutter speed. As using a low aperture is important for taking high-speed music photos, this mode makes the most sense to me. However, it can

→ Far right:
Lady Gaga
I shot Lady Gaga mid-movement to capture her stage presence.

→ Right:
Rob Swire, Pendulum
A flash action shot. The symmetry of Rob's arms aligned with the wings on his T-shirt.

↘ Below right:
Bruce Springsteen fans
I took this shot of Bruce Springsteen fans in the crowd while I was waiting for an act to come on stage.

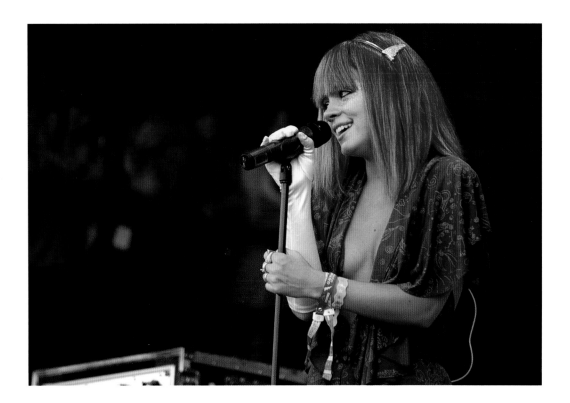

← Left

Lily Allen
This shot was taken during a daytime performance, using Shutter Priority mode. There was a lot of available light, so I could use a fast shutter speed.

→ Right:

Karen O, the Yeah Yeah Yeahs
To make the most of the atmospheric orange lighting, which complemented her costume, I shot without flash.

→ Far right:

Bloc Party
I used flash in this shot to reflect off and accentuate the white T-shirt of Kele Okereke, frontman of Bloc Party.

depend on what the stage lighting is like at the gig you are attending. For example, when I shot my photos at Glastonbury during the daytime, I didn't need the aperture to be low because there was a lot of light available. This meant I could use a faster shutter speed, so I set my camera to Shutter Priority instead. This allows you to set your desired shutter speed, and the camera calculates which aperture to use.

Flash

Some photographers dislike using flash, and it's usually best to keep it to a minimum–it can distract the performers and certain venues don't allow it. However, if the stage lighting isn't great and your photos aren't working for you, or if you don't own a lens with an aperture that is low enough, using flash can be a good way to solve these problems, and it can be really effective. I recommend investing in a flashgun rather than using your built-in flash, as this allows you to use a variety of settings to produce different effects. It also means you are in charge of how much light you let out to compensate for the level of the stage lighting.

So, just get stuck in and try it. Don't be embarrassed about your kit. You don't need the best technology to take a great photo. Preparation, a little technical knowledge, familiarity with your equipment, and a lot of front can get you fantastic images that will compete with those of the boys with the big lenses!

〔 **217** 〕

Camera phones
Observation and spontaneity

The Geisha on the Train
I was in the right place at the right time, and sneakily used my camera phone to capture a particular moment.

The Idea

I own a number of cameras, which I use for different events and in different situations, but the camera in my phone is always with me. As a result, I find myself using it a lot to capture the odd and interesting things I spot during my daily commute and in my everyday life. Since some of the most interesting things are unexpected, the camera in your cell phone might be the only camera you have to hand. Camera phones (camphones) can be very frustrating in terms of quality and available functionality, which makes it all the more important to know how to get the best from them.

The Ingredients

▷ Camera phone
▷ Image-processing software (optional)

The Process

The iPhone is now the most popular camera–not just the most popular camphone–on flickr. Other devices may provide greater functionality and quality, but sometimes convenience wins. I took *Geisha* with my Nokia 6230i on the train one afternoon. It simply couldn't have been captured in such a spontaneous way without a camphone. As so many of us are now carrying these low-res cameras in our pockets, here are a few tips for squeezing decent photos out of them. They apply mainly to phones which provide a rather feeble 1-2 megapixel camera with no focusing or zoom capabilities. While camphones that yield better resolution and functionality are now readily available, it's not all about the technology.

Embrace constraints

Your camphone is limited. Really limited. That being said, it can do *some* things well. The first thing to do is recognize and accept that you're never going to squeeze incredible shots out of it; at least, not every time. Take loads of photos until you figure out what it does well, then play with the strengths it has. For example:

○ Some camphones, including the iPhone, are very good at contrast–use that to your advantage.
○ On most camphones the focal point is a minimum of 12in (30cm) away, so concentrate on subjects at least this distance from you–don't bother trying to take close-ups.

○ It can take a couple of seconds for the exposure setting to settle down; let the image catch up before you click the shutter, or exploit this weakness to take photos with the foreground deliberately underexposed. (Poor exposure can sometimes be "reset" by pointing the lens at something dark and moving it gradually to the subject you want.)

Compose creatively

Camphones tend to cope poorly with strong, direct light. Bright, overcast skies will often bleed into the image or cause the rest of the shot to be underexposed or bleached out. This is often a problem when a bit of the sky is in shot, so counteract this by cutting the sky out of the frame entirely; compose your shot to fill the frame with something else. Play with patterns or strong colors.

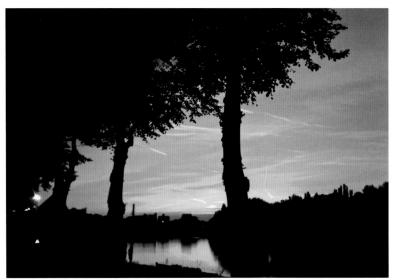

→ **Right:**
Pit Stop, English Style
Unexpected angles can yield striking results.

← **Left:**
Sunset on the Thames
Use your camera phone's poor handling of low light conditions to your advantage by combining bright skies with dark silhouettes.

↙ **Below left:**
Fallen Leaves on a Car Roof
Filling the frame cuts out interfering light sources and makes colors pop.

Cutting light sources out of the composition also forces you to use interesting angles, which can be a good way of isolating objects from their surroundings. Top-down shots work particularly well, but beware of shadows.

Camphone photos can also look distractingly cluttered or very flat because of their deep focal range–everything is in focus. If this is the case with your intended capture, the rules are the same as for old-school photography composition: look around to find something to place in the foreground of the image, use lines or objects to lead the eye into the scene, or isolate the subject by choosing a plain or uncluttered background.

Camera shake

A special tip for iPhone users: the placement and behavior of the in-screen shutter release button for the iPhone camera is, frankly, rubbish. There's no physical feedback, it's slow to react, and its location at the very bottom of the screen seems almost engineered to introduce camera shake. However, some of the worst of this can be compensated for with a very simple modification to how you take the photo. In fact, probably the most useful thing to know about the iPhone camera is that the capture doesn't happen when you press the button, but when you take your finger off it. By composing the shot while you have your finger on the shutter button, and then taking it off to capture, you're more likely to reduce camera shake when you take the photo, and more likely to capture the moment you want, bearing in mind that there's still a slight lag.

Rather than holding your iPhone one-handed in portrait format (which means the whole phone moves when the shutter is pressed because of the high center of gravity), try getting into the habit of holding it more like a games controller, landscape style. This is much more stable and also means that your right thumb can comfortably grip the shutter button until release.

Optimal conditions

One thing camphones do well, despite their other shortcomings, is color. Though the results are horrible in low light–grainy, dull, and pretty underwhelming–they come into their own in the right light. If it's too sunny, colors can bleach out and contrast is lost, so avoid taking photos of things in direct sunlight. If it's too dull or too late in the afternoon, it gets very grainy. The best conditions seem to be bright, damp days. Compositions that make the most of juicy, bright, saturated colors and strong contrast, together with interesting patterns or focal points, can make for a really striking shot.

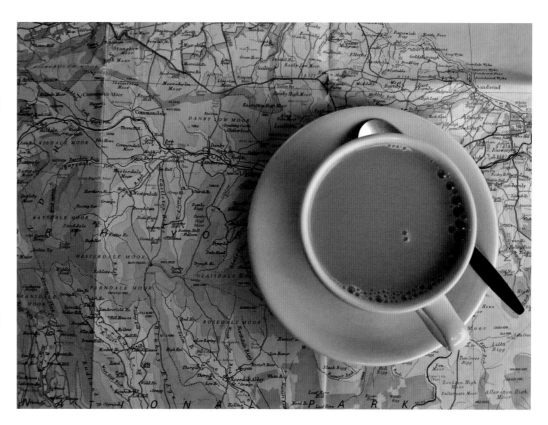

← **Left:**
Waiting at a Bus Stop
Strong colors in isolation
work particularly well
on damp days.

↓ **Below:**
Public Art
Use perspective and
foreground focal points
to add depth to an image.

Both of these examples inspire anyone with a camera
in their phone to become a collector of the interesting,
the absurd, the everyday, and the notable.

Cheat

If all else fails and the image on the phone screen
doesn't match the punch and promise of the image
in your head, you can cheat. Even the most incredible
software isn't going to rescue a dire, out-of-focus,
grainy camphone shot, but it's worth trying the
following to see if you can give your image a little
boost. On your computer, on your phone, or using one
of the web-based image manipulation applications:

Play

One of the best ways to get into the habit of taking
photos with your phone is to play a game. Set
challenges for yourself, like taking a photo every
five minutes when you're out for a walk, or capturing
interesting street signs, lost objects, or red things…
There are a few web-based games that encourage
players to observe the world around them and use
cameras to capture it, whether for kudos, to complete
a set, or for points. flickr is great for developing a
camphone discipline. Groups dedicated to snapping
things that look like faces, laughable cycle lanes, or
particular combinations of shapes mean that, if you
are in a receptive frame of mind, every foray into the
world will be filled with potential captures. Another
site, http://noticin.gs, uses flickr and geotagging to
turn random things people spot while they are out
and about into a social game—you get points for
noticing things in new places and near other players.
Once you start playing noticin.gs, it's very difficult
to stop noticing things.

- Increase saturation slightly, but be aware that a light touch is needed: too much saturation can leave a low-res image looking silly.
- Boost blacks or adjust levels to enhance shadows.
- Add a little fill-light or brightness to compensate for overall darkening of the image.
- If you can, adjust contrast/clarity to enhance edge detail.
- Try converting the image to black-and-white: sometimes removing the color can make an image feel less cluttered, and you can play more with tones and shadows.
- For iPhone users there are some great apps that are extremely helpful with turning average shots into really interesting or striking ones. My top recommendation is an app called Camerabag, which helps you to take or convert photos as though you are using a range of toy cameras. There are various filters, which do quite a good job of "holgafication" and "lomofication," among other mimicry. The results can be extremely effective. Another app, ColourMill, gives more granular control over color settings.

When post-processing camphone images, as when composing them, remember that if a technique works for lo-fi cameras, it will probably work for camphones. They are much the same in many ways: they both have fixed focus and limited functionality, are both prone to odd quirks, and with both your images will benefit from familiarity and ongoing experimentation.

And that's the biggest tip of all—keep trying new things. Armed with the tips above and a willingness to experiment, your everyday wanderings will suddenly become a playground for creative discovery.

→ **Right:**
Painted Arrow on a Shutter
Adding a strong vignette and playing with contrast and crop can turn a humdrum photo into a hot shot.

↘ **Below right:**
Fallen Leaves in London
Change your perspective— get down low to capture interesting details.

Aerial: plane shots

Just say no to the in-flight movie

Cloud Formation
Viewed from a plane, cloudscapes take on a very different aspect from our familiar land-based perspective.

The Idea

Taking a trip via commercial jet gives you an opportunity to create photographs that look like very few you've ever seen published. That's because almost all aerial photography is done from private planes and helicopters, which fly below the cloud cover–much lower than commercial airlines. In recent years we've also seen a lot of images of our earth shot from space, usually by satellites, but obviously, that point of view is from a much higher altitude than the one you'll have from your window seat.

The Ingredients

> Any camera (ideally, with a wide-angle to telephoto zoom lens)
> Ticket for a commercial flight

The Process

I travel a fair amount (mostly for work) and, being a big fan of both aerial and space images, I always take the time to look carefully at the view from my window, a view that is very beautiful in its own way. Obtaining worthwhile images by shooting from that window seat, however, requires some knowledge and preparation. It does involve technical issues, but mostly it takes patience, persistence, and luck. You can have nothing but solid cloud cover under you for long stretches of time, then a break will reveal something spectacular, but only for a few minutes, and sometimes only for a few seconds. To maximize your chances of getting a good shot, pass on the movies and video games. Read or listen to music instead, that way you can send a quick glance out the window every few minutes. Look not only for the wide view, but also for features to zoom in on, and stay open to different types of beauty: cloudscapes, landscapes, natural features, or man-made structures; or images that are enjoyable primarily for their abstract quality. Here are some tips and tricks I've learned over the years.

There are three types of technical issue you'll have to deal with. They relate to:

° the physical parameters of your location in the airplane;
° your optimal camera settings; and
° post-processing.

Alexis Gerard

Plane issues

Beyond the obvious—get a window seat—it matters which window seat you get. Of course, you don't want your view obstructed by the wing, but you'll also find that jet engines can leave a trail of air turbulence that causes distortion, so you will want to be seated ahead of them. If you really get into this, you'll find that the combination of what direction you're traveling in, which side of the plane you're on, and what time of day it is can make a difference. For instance, you generally don't want the sun facing your camera, so if you're flying north in the morning, you'll want to be on the right-hand side of the plane. There's also the fact that the window you're looking out of wasn't designed for photography, and very often wasn't cleaned properly. I carry alcohol wipes to clean the window, but if it's very badly scratched, or made of a material that bands, it's game over. Finally, you will be instructed to turn off "all electronic devices" for takeoff and landing, which is just when you can get some of the most interesting views. Hmmm ... no comment!

Camera issues

The objects you see from your plane window move *much* faster than they appear to. You'll have only a few seconds to get the framing you want. So, in the interest of speed, turn off your autofocus and set it to infinity. And since depth of field is not a consideration, but shutter speed is, go with Shutter Priority or, on point-and-shoots, Sport mode. I recommend these settings over full manual, because lighting conditions can vary dramatically very quickly. One big advantage of digital cameras for this type of shooting is that they allow you to compose on an LCD rather than a viewfinder. If your face is glued to the camera, your range of motion will be very reduced, particularly as you're already confined to a small space and can't move around freely. Holding the camera away from your face and composing with the LCD, especially if it tilts and/or swivels, will enable you to direct your lens with much more freedom.

→ **Right:**
Mesa Edge
A view that contrasts the orderly nature of man-made fields with fractal-like natural features reads as either landscape or abstract.

↘ **Below right:**
Golden Gate Bridge
One of the world's most famous landmarks viewed from a different perspective.

Post-processing issues

Be prepared for extremely low-contrast, bluish images that don't look like what you remember seeing. That's because your eye-brain system compensates to some degree for the poor optical qualities of your airplane window and for the atmospheric haze below it, but the camera doesn't. If you use automatic correction tools such as Auto Contrast or Auto Color to fix things, you're most likely going to get a pretty wild-looking result because the values in your file are quite different from those that these algorithms are designed to correct. Such images can be visually appealing, and you might find them to your liking. Personally, I prefer trying to recreate what I saw as closely as possible, which is a bit more work. If you want to go that route, you will give yourself the best odds if you start by shooting RAW, if your camera supports it. Your program's RAW processing tools should then give you the flexibility to obtain the result you want. If you're starting with a JPEG file, use your program's contrast, black level, and color-correction tools gradually and iteratively, rather than trying to get to the result you want in one step. With patience you should get to a fully rewarding image.

Happy flying and happy shooting!

← **Left:**
Ice Floes
Flying over the (north) polar ice cap reveals a landscape unlike any other, with striking abstract qualities.

Aerial: plane shots Just say no to the in-flight movie

↖ **Above left:**
Winter Farmland
An example of a landscape image that comes across first and foremost as abstract.

↑ **Above:**
Suburbia
Urban development viewed from above often brings to mind electronic circuits.

← **Left:**
Winter Landscape
Some of the most spectacular images are of landscapes partially covered by snow.

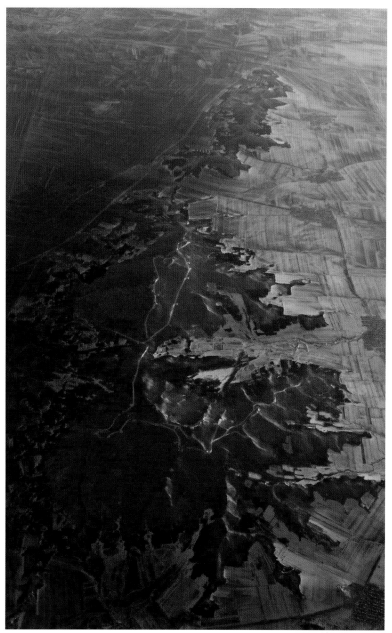

↑ **Above:**

Wyoming Lake
Look for patterns in
color as well as shape.

→ **Right:**

North China Dawn
Dawn and evening light
"rakes" the landscape at
a low angle, producing
some stunning effects.

← **Left:**

Peaks and Clouds
Cloud- and landscape
combined in a high-
contrast image.

Sprocket-hole

Take it to the edge

The Continental
I imagined the car framed by the sprocket holes while I was taking this picture, considering them part of the composition.

The Idea

The world of toy-camera photography is a vast one. With a little modification you can use your toy camera to create things it was never meant to create. The very nature of these cameras allows for a wide range of differing techniques to achieve unique and beautiful images that are "off the beaten track," so to speak.

The Ingredients

> Toy camera
> 35mm conversion kit OR
> Foam padding
> Cardboard or posterboard
> Gaffer tape or electrical tape

The Process

A few very simple additions or modifications to a plastic medium-format camera, such as a Holga or a Diana (and the countless clones thereof), will open up your opportunities for alternative techniques. One of the most intriguing of these is sprocket hole photography–shooting 35mm film in a camera meant for 120mm film–the result being an image that extends beyond the usual 24 × 36mm image size of standard 35mm film and "bleeds" onto the sprocket holes. The Holga and the Diana are the two cameras that I am most familiar with using for this technique, and they also happen to be the two most widely available toy cameras. However, most toy cameras work in more or less the same way, so don't worry if you have a different model.

Modifying your camera

Let's begin with what you'll need. The required materials are basic and few. First, and most obviously, you'll need your camera. Next, there are a couple of options to consider. You can purchase a 35mm conversion kit for both Holga and Diana cameras. These kits help hold the film canister in place as you shoot and keep the film from moving around too much. They also lack the clear viewing window that allows you to see the frame numbers on 120mm film, but which causes red or white "light burns" if you're shooting 35mm.

← **Left:**
Red's Cruiser
A multiple exposure shot on a sunny day, using ISO 100 film.

↓ **Below:**
Ghost
A macro shot using Lomo's Tunnel Vision lens, taken in bright sunlight.

Or you can use this lo-tech, but equally effective method of loading 35mm film into these cameras. Cut a few cents worth of foam padding to fit into the film spool space and hold the canister in place. Giving it a bit of a snug fit ensures that the film will advance properly and that your images will appear as you see them in the viewfinder (or very close to, at least). You'll also need to cut a small piece of cardboard or posterboard and tape it over the viewing window on the back of your camera with black gaffer or electrical tape. When you load the film cartridge, place it so that the film is as centered as possible in front of the lens. Use a piece of tape to secure the tongue of the film on the take-up spool. This is a very important step. I've had the film detach from the spool on more than a few occasions because I didn't make sure it was secure enough. Now put the back on, tape it up to avoid light leaks if necessary, and you're ready to shoot.

Holga Click Chart

Shot #	Load Film	1	2	3	4	5	6	7	8	9	10	11	12	13	14	15	16	17	18	19	20	21	22	23	24
Clicks	42	35	34	33	33	31	30	30	29	28	27	27	26	26	25	25	24	24	23	23	23	22	22	22	End

Diana Click Chart

Shot #	Load Film	1	2	3	4	5	6	7	8	9	10	11	12	13	14	15	16	17	18	19	20	21	22	23	24	25	26	27	28	29	30	31	32
Clicks	78	77	76	74	72	72	68	68	65	65	65	61	61	59	58	58	57	57	55	54	54	53	53	51	51	51	51	50	50	48	48	48	End

↙ **Below left:**
El Camino
This image was shot with high-speed film on an overcast day.

↓ **Below:**
Chapel of the Ferns
The center of the photo is in sharp focus with a blur radiating outward thanks to the Holga's plastic lens.

Taking your shots

Which film speed to use depends on where and when you'll be shooting. Just follow the usual rules of film speed selection based on lighting conditions, keeping in mind that most toy cameras have a shutter speed of roughly 1/100 sec. Since toy cameras are completely manual, you can shoot multiple exposures, panoramas, overlapping images ... the possibilities are limited only by your imagination. The more you shoot, the more intuitive the process will become. Don't be afraid to

experiment. Shoot a couple of test rolls to get a feel for the results. There really is no "right way" to take a sprocket hole photo, so don't think about it too much, just shoot!

At this point you'll need to become familiar with the "click" method of advancing the film in your camera. Since toy cameras offer no auto wind, you'll have to advance your film according to a very mathematical formula–counting the clicks of the winder as it turns.

The number of clicks is different for Holgas and Dianas. I've created a chart for each and I tape a copy to the back of my camera. This way I can simply check off each exposure as I shoot. Note that as you shoot and the film advances, fewer and fewer clicks are needed.

Developing your film

Developing your film can be tricky as many professional labs won't be able to scan the entire width of your sprocket hole film. Your best option is to scan them at home on a flatbed scanner. I've developed a system of taping the negative to a small piece of glass from a disused picture frame and laying it directly on the scanner bed. This ensures that the negative doesn't move around when you close the scanner lid, and it keeps the negative perfectly flat during the scan. You will need to adjust your scanner settings so that it can cope with the excess light it will detect through the sprocket holes. This is especially true if you are scanning cross-processed slide film or dense black-and-white negatives. But as with most things in photography, ultimately, it comes down to what results you are happy with. Find a method or system that works best for you, then perfect it.

→ **Right:**
King Joe
I shot this portrait on an overcast day, using ISO 200 film.

→ **Center right:**
Marin County Civic Center
This was taken in a dark environment with ISO 100 film and strong backlighting.

→ **Far right:**
Ocean View
The low-light environment with bright light source made for a moody image.

People montages

A composite view

Kevin Meredith

Montages
You can use software to blend the joins of the images, but if I'm showing a printed version, I prefer to stick prints together in the "flesh."

The Idea

Sometimes a subject can't be summed up in just one photo. This is where montages step in. Take a few photos and put them together later so that they tell a more complete story than a single image ever could. With montages of people you can record every detail about a person, from the look on their face and the slogan on their T-shirt to the type of shoes they wear. Such details can be lost if taken as a single image, especially on 35mm film or lower-resolution digital cameras.

The Ingredients

> Any camera
> A subject

The Process
Taking your shots

Hold your camera level, pointing it forward, and "scan" up the person, moving your camera higher as you go. Don't keep the camera in one position and change the angle at which it is pointing: if you do this, you will get a really odd perspective in your final piece. You have to start kneeling down and work your way up.

There are two reasons why I start at the bottom: it can be uncomfortable kneeling so it's good to get that over with; and if you start with the subject's feet, they will get used to what you are doing and be a little more relaxed by the time you get to their face. I always pay particular attention to the face because, if you get an unsatisfactory face shot, it can ruin the whole thing and waste all the shots you've taken. People often have a momentary funny look on their face, so I always shoot three head shots in order to have a pool to choose from. Generally, I take seven shots to cover a person: three for the face and four for the rest of them—sometimes three if they are short.

As you move up, make sure you get a good overlap between shots so it's easy to join them afterwards. When you take each shot, make a mental note of what is near the top of the frame. On the next shot, make sure what was at the top of the last frame is at the bottom of the next. Keep as constant a distance from the subject as you scan. Set your camera to manual focus and, for the first shot, focus as you normally would. For the rest of the shots, move the camera closer and further away from the subject until you achieve focus. That way you know all your shots be taken from the same distance.

Creating your montage

I use Photoshop to line up my photographs. Before you start, you need to have all the images you want to use in your montage in one Photoshop document, as separate layers. To do this, open all the photos you want to use in Photoshop or Photoshop Elements. Once you have your documents open, you have to copy all your images, one by one, to the file that will contain all the layers. This process is a whole lot faster if you are familiar with shortcut keys. In one of your

files select all (press command + A [Mac] or control + A [PC]), then copy (press command + C [Mac] or control + C [PC]), and then close the file you copied from (press command W [Mac] or control + W [PC]) as you don't need it anymore. Switch to the file you are going to copy all your images into. Hit command + V (Mac) or control + V (PC) to paste the copied images into it. Repeat this until you have all your images in the same document, then save the document with a new name. If you are a Lightroom user, there is a far quicker way

to open your files as layers in a Photoshop document. In the Library mode in Lightroom, select the files you want in your montage and right-click (PC) or Control + Left-click (Mac) to open up the Edit menu. Click on Edit > Open as Layers in Photoshop. Photoshop will then open and do all the hard work for you.

At this point all your photos are just stacked on top of each other, in one Photoshop file. The first thing you need to do is increase the pixel dimensions of your file.

In the File menu go to Image > Canvas size. Enter the height you want your image to be. I take the current height and multiply it by the amount of images I have so I know I will have enough room. I also increase the width by about 20% because I know some of my images won't line up vertically. To line up your images, select the Move tool from the very top of the Tool palette, making sure that Auto Select is ticked, and that Layer is selected in the drop-down next to it. If the Options palette is not open, go to Windows >

Options. You can now drag your images around until you are satisfied with the way they line up. Once you're done, you might want to make a new layer in the background and fill it with a color, or crop the image to get rid of any space you don't need. When I put my images together I don't worry that they aren't perfectly lined up—I like the rough look. If you want to go even rougher, you could print the individual images and lay them out by hand, á la David Hockney.

← **All images:**
Montages
I use a Lomo LC-A to create my people-montage shots because I like the rough look it gives the final piece; when the images are placed together they don't quite match up because of the characteristic Lomo vignetting.

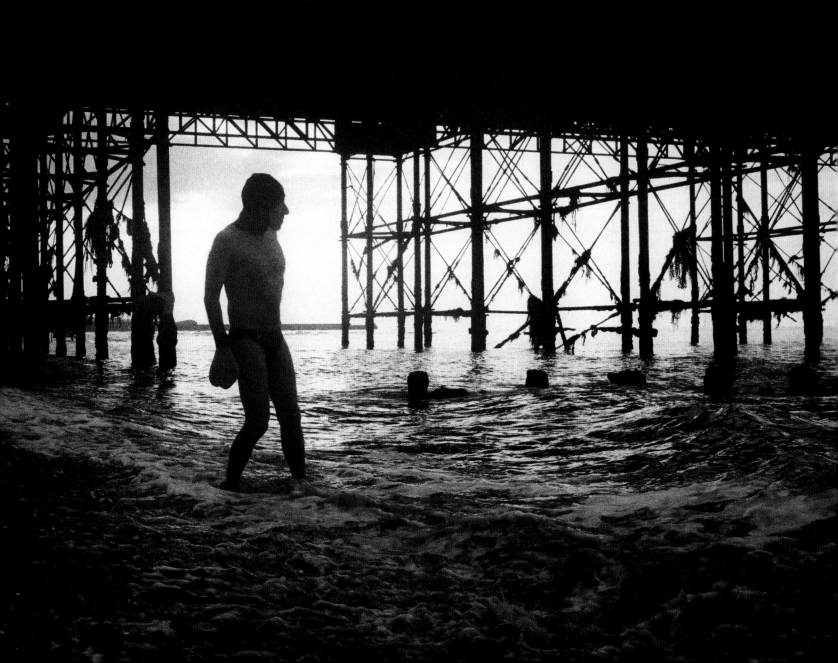

Black-and-white
Monochrome vision

Silhouette Swimmer
Black-and-white film is well suited to shooting silhouettes on dull, overcast days.

The Idea

It's good to simplify your images to make them easier for the viewer to digest. Sometimes stripping out color can have a dramatic effect. It used to be that anyone learning photography would start by shooting black-and-white, the idea being that you worked your way up to color. Another reason for starting with black-and-white was that it was cheaper than color photography. With the advent of digital, this is no longer true, but many photographers have a certain nostalgia for black-and-white.

The Ingredients

> Any camera
> Black-and-white film (if film camera)

The Process

Shooting black-and-white is quite a different discipline from shooting color. You have to learn to look out for different things. Clearly, looking for complementary or contrasting colors is out the window: contrasting colors like red and green will end up looking the same. When you are shooting in black-and-white the things to look out for are patterns and textures. Sometimes patterns are obscured by color, but reproduced in black-and-white they can really jump out. Silhouettes work beautifully in black-and-white, especially if you are shooting on an overcast day. A bold blue sky contrasting with a deep black silhouette looks fantastic, but when it's a dull gray day, a black-and-white image might be more striking if you boost the brightness in the sky. Strong contrasts and shadows also come out well in black-and white. One big advantage with digital black-and-white is that you don't have to worry about color temperatures and white balance so much. Color photography can be affected by the different color temperatures of artificial lights–photos shot under artificial light can have a color tint to them, which can be tricky to totally remove in post-processing. This is not the case when shooting black-and-white.

44

Kevin Meredith

Film photography

I don't like shooting color films with a speed of over ISO 400 because they tend to be very grainy (noisy) and to produce undersaturated color. If I am shooting film really early in the morning, or indoors, I use an ISO 1600 black-and-white. While this will be super-grainy, stylistically, black-and-white film grain looks much nicer than the graininess you get from high-ISO color film.

One of the drawbacks of traditional black-and-white film is getting it developed, as it requires a different chemical process from color negative film. Slide film and negative film have to be developed in chemicals specific to them; this is the same for black-and-white film. Most professional labs will develop black-and-white, but smaller labs tend not to offer the service, and if they do, they will have to send your film away and/or it might be expensive. The good news is that it is relatively easy to develop yourself—as long as you can measure liquid, test temperature, and read a clock, you're away. You can pick up all the kit you need relatively cheaply, including the chemicals, but it's only really worth it if you are going to develop a lot of film. An alternative to "real" black-and-white film is C-41 black-and-white film. This goes through the same chemical process as regular color film, which means you can get it developed anywhere.

One thing I would advise anyone who is serious about photography to do is take a class in black-and-white photography. There is nothing like developing your own film, watching your images appear on paper in the developing tray as if by magic. I love Adobe Lightroom, but for me nothing can replace the chemical smell of a real bricks-and-mortar darkroom.

Digital photography

If you want to shoot black-and-white, don't set the Black and White mode on your camera. All this does is strip out the color information. It is much better to shoot color and then convert to black-and-white on your computer. You will need color information so that you can control how each color is converted. You can shoot with the Black and White mode turned on *and* keep color information if you shoot in RAW, but not all cameras have the option of saving files as RAW instead of JPEG. The advantage of RAW is that you can turn on Black and White mode so that, when you take a shot, you will see it in black-and-white on the LCD screen. This will give you a better idea of how your monochrome compositions are looking.

Even though they are black-and-white, the RAW files will contain all the color information, and they can simply be resaturated in an image-editing program if you decide that the image works better in color.

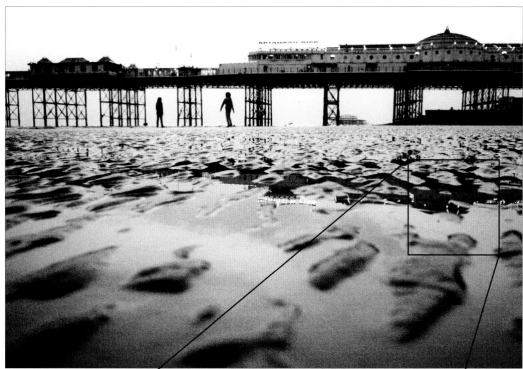

← **Left:**

Low Tide
Even a very grainy image can have a pleasing effect in black-and white.

↓ **Below:**

Borough Market
Peaked-out highlights tend to look better in black-and-white than they do in color.

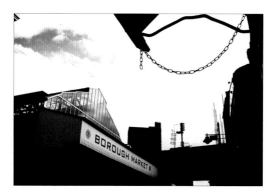

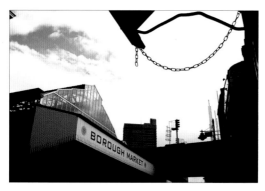

↖ **Facing page:**

Words of Wisdom
Clockwise from top left: the RAW image is very yellow because of the artificial light; the white balance has been corrected, but it still doesn't look quite right; a stage in the conversion to black-and-white—very flat and dull; the final version, with the contrast shadows tweaked.

↑ **Above:**
Photoshop palette.

→ **Right:**
Photoshop Elements palette.

→ **Far right:**
Adobe Lightroom palette.

Consider shooting black-and-white if your subject has very dark shadows and very bright highlights. As yet, digital cameras still have difficulty dealing with a big contrast and sometimes the highlights will be blown out (pure white). This doesn't look good in a color photo, but black-and-white tends to be more forgiving. As digital technology marches on, cameras are getting better and better. The Olympus Pen range of digital cameras has Fine Art modes, one of which is Black and White. The Pen's Black and White mode doesn't simply desaturate images, it beefs up the contrast and adds film grain to a point where it is hard to distinguish between a scan of a black-and-white negative and a digital image from the Pen. It has the added bonus that, if you choose to shoot RAW and JPEG, you have your high-contrast black-and-white JPEG image and your RAW color image, so you get the best of both worlds with a minimum of fuss.

Converting to black-and-white

Converting your digital pictures to black-and-white is not as simple as clicking a button, but it can be pretty easy. In Photoshop go to Image > Adjustments > Black and White and then slide the different color sliders to see how this will affect your image. For instance, if you were to adjust the blue slider you would see the contrast in the sky and other blue parts of the image change. In Photoshop Elements click Enhance > Convert to Black and White, and you can control how the red, green, and blue values are converted to black-and-white. I find that the method I use in Adobe Lightroom gives me the greatest control. In the Development panel, scroll down to HSL/Color/Grayscale, and click HSL. This stands for hue, saturation, and luminance. Click All and then slide all the saturation sliders to the left [1]. This will remove all color from the image. To fine-tune how different colors are converted to black-and-white, play with the relevant luminance sliders [2]. Lightroom takes it one step further with its Target Adjustment tool. You might want to adjust how the sky is converted to black-and-white, but the sky might be a mix of green and blue. Normally you have to the tweak the blue and green luminance sliders, but there is an easier way if you click on the Target Adjustment tool [3]. Simply click on the image area you want to adjust and drag up with the mouse button still held down. You will see all the colors for that image area being adjusted. It's a lot easier than tweaking three sliders or more.

Wide-angle

A bigger picture

Purple Mini
In this shot I had the camera set up on a tripod about a foot away from the car, with the aperture set to f/9. You can see that everything from a foot in front of the camera to infinity is in focus.

The Idea

Wide-angle photography allows you to capture a broader field of view. Photos taken with a wide-angle lens tend to look a little unnatural because they show a wider field of vision than the human eye can see. Wide-angle images put a unique spin on the world we see around us.

The Ingredients

> Any camera with a wide-angle lens or lens converter
> Full-frame camera with a lens that has a focal length of less than 35mm OR
> Non-full-frame DSLR with a lens that has a focal length of less than 20mm

The Process

The human eye's field of view ranges from around 120° to 140°, but if you don't include peripheral vision this comes down to about 60°. Photographs shot with a field of view of more than 60° will seem wider to us than what we normally see. If you are shooting with a film SLR or a full-frame DSLR (one that is fitted with a sensor that is the same size as a 35mm film frame), a lens with a focal length of 35mm will give you a "normal" 60° field of view; if you shoot with a focal length of anything less than 35mm, your images will start to look wide-angle. Because of the lens crop factor, if you are shooting on a camera with a smaller sensor, you will need a focal length of less than 20mm to take a wide-angle image.

Wide-angle lenses can make objects close to the lens seem larger than they are, while making objects in the background seem tiny, so they are good for showing detail in elements of the image that are close to the lens. Images shot on a wide-angle lens will have very strong lead-in lines because they are able to capture more of them. It is a common misconception that wide-angle lenses distort perspective–they don't. If you were to shoot a photo from the same spot with a narrower lens, you would see less of "the picture," but the perspective would be the same.

Being able to capture a wide field is very handy when you are trying to shoot something large, but don't have space to back away from it, so they are particularly handy for architectural photography.

If you are shooting an object or a person, make sure they are close to you, as a distance of even a few feet will make them seem much farther away than they actually are. If they are too far away you run the risk of losing them in the rest of the scene. You can have a lot of fun shooting people with wide-angle lenses. If you shoot them from above you can make them appear really short; if you shoot looking up from their feet they will appear huge. You could try shooting children from their feet to make them appear like giants. Keep in mind that sometimes shooting people with a wide-angle lens is not very flattering, as any features closer to the lens can appear bigger than they actually are. This suits some subjects, but I wouldn't use it for something like a wedding portrait when you want people to look their best.

Because of the wide field, shots taken with a wide-angle lens are less prone to camera shake than "normal" shots. This makes them ideal for low-light situations as it allows you to use a slower shutter speed without getting any blurring caused by camera shake.

Wide-angle lenses for SLRs can be expensive–not many are manufactured compared with standard lenses, so the cost of production is high. A good alternative is to buy a toy camera with a plastic lens. Lomography make the Lomo Fisheye, which has a field of view of almost 180°, and they also make a Fisheye Adaptor lens for the Lomo LC-A.

→ **Right:**
The Great Court
In my image of The British Museum's Great Court, I was able to capture a large section of the floor and ceiling using a 10mm lens on a Canon EOS 450D.

↘ **Below right:**
London Underground
By shooting wide-angle, I was able to set a 1/2-sec exposure and not get any camera shake. I balanced the camera on one of the steps and angled it upward, so I still had to hold it steady to make sure it didn't tip while the shot was being taken.

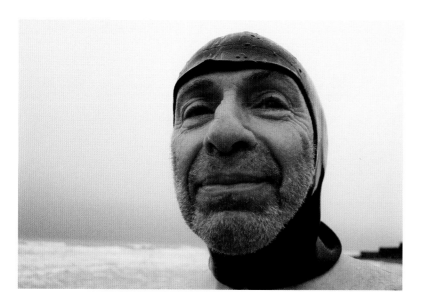

Some lenses have such a wide field of view that they start to see the edge of a lens filter, if you have one attached. This might appear as darkened corners in your images. If you really need to use a filter and you don't want this effect, try closing down your aperture–this will sometimes get rid of it.

As the glass element on a wide-angle lens can be quite bulbous, it is prone to glare and lens flare caused by strong light hitting the lens side on. Most wide-angle lenses come with a lens hood to prevent this. If you leave the lens hood at home or you have a Fisheye Adaptor, you can always try to block out this light by holding your hand or a piece of card just out of frame.

↑ **Above:**
Swimmer
Shot with a 20mm lens on a film SLR.

→ **Right:**
Fisheye Portrait
This shot was taken with a Lomo Fisheye, which produces a super-wide circular image. Even with my head in the center of the frame you can see my big toe.

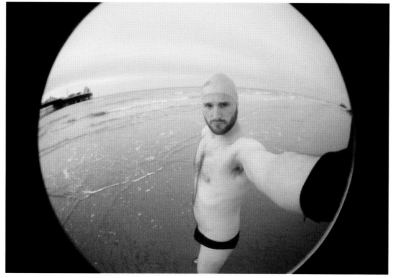

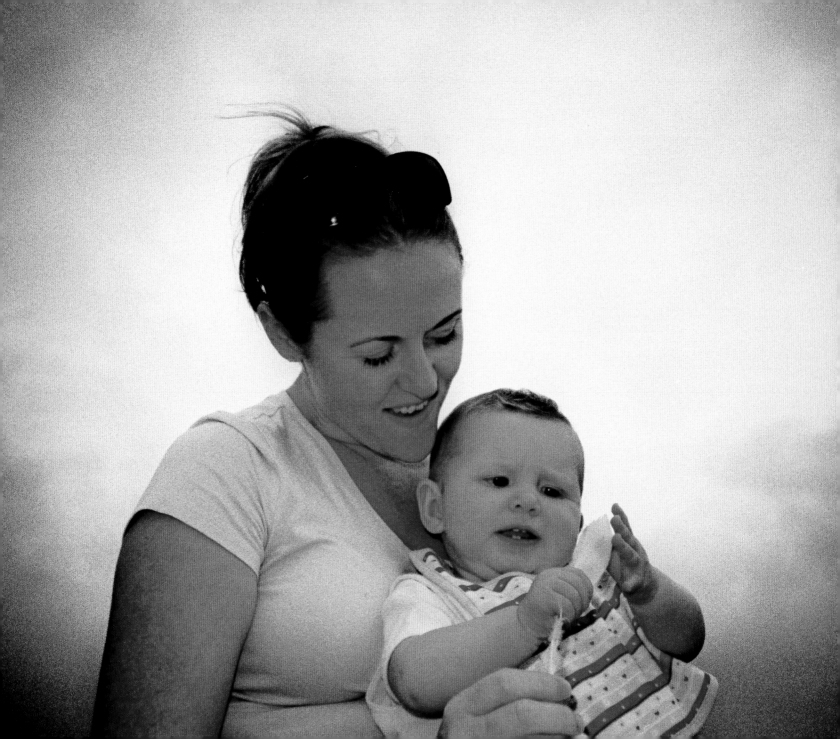

Colored flash
Brighten your world

Mother and Child
In this image, the mother and child are lit up with an even red because the sunlight was behind them.

The Idea

Sometimes the world can appear a little dull, but you can brighten up images with a colored flash. This technique is not just restricted to the nighttime—no matter what time of day it is, just pop a colored flash onto your camera and discover what can be done.

The Ingredients

> Any camera
> Colored plastic gels OR
> Colorsplash Flash

The Process

All you need do to start painting the world with super flash color is get some colored plastic gels. Place one over the flash so that, when it is triggered, it sends out a burst of colored light instead of plain white light. Colored gels are usually sold in square-foot sheets, but you won't need that much. I get my gels from a sample book as the sample-book size is just big enough to cover most flashes. You can usually get these free from shops that sell lighting equipment for theaters and clubs. Some shops have got wise to the fact that people are using them in this way and have started to charge, but even so, they aren't expensive.

Remember that your flash only has a certain range; if you have a colored gel on your flash, it has a stronger effect on objects closer to the flash than those farther away. The power of the light from a flash decreases with distance—this is referred to as fall-off.

You can get some quite bizarre effects if you use a colored flash during the day, as can be seen in Self-Portrait, on page 252. The sunlight was hitting the right side of my face while the left side was in shadow. Because I used colored flash, the shadows are filled in with red.

Kevin Meredith

Once you get the hang of using a colored flash, kick it up a notch and start using two or more. In the photo of Lee (central image in montage, right), one side is colored pink and the other green. I was only able to achieve this with Lee setting off the flashes himself, holding them in his outstretched arms, and it was only possible to set off the flashes manually because of the slow shutter speed on the camera. If you want to use a flash in brighter conditions, for which you won't be able to use such a slow shutter speed, you need to get some wireless flash triggers.

You *can* spend a lot of money on wireless flash triggers, but you don't need to—there are good-quality sets available at a reasonable price. They consist of a transmitter that slides into the hot shoe of a camera and, usually, two receivers that can be paired with two flashes.

If you don't want to fiddle around with colored gels, an easy solution is to get a dedicated flash for the job. Lomography make the Colorsplash Flash, which has four colored gels built in. If you want to change the color, all you have to do is roll the dial. You also get nine additional gels with the Colorsplash Flash, and these can be swapped with the built-in ones. Lomography also make a Colorsplash camera, which combines a Colorsplash Flash with a 35mm film camera.

→ **Right:**
Night Color
You can see how the range on a flash works in this picture; the ground is lit up pink, but at about 3m (c. 10ft) the color drops off and the effect of the flash can no longer be seen.

↘ **Below right:**
Self-Portrait
This shot works because the sunlight was much stronger than the light coming from my flash, so the flashlight had no effect on the parts of my face that were lit by the sun.

→ **Far right:**
Montage
Using a colored flash under artificial light can give you some wonderful results. Artificial light will sometimes give you a color cast—images can come out blue, yellow, or green. If you use colored flash in these conditions, you can get great contrasts.

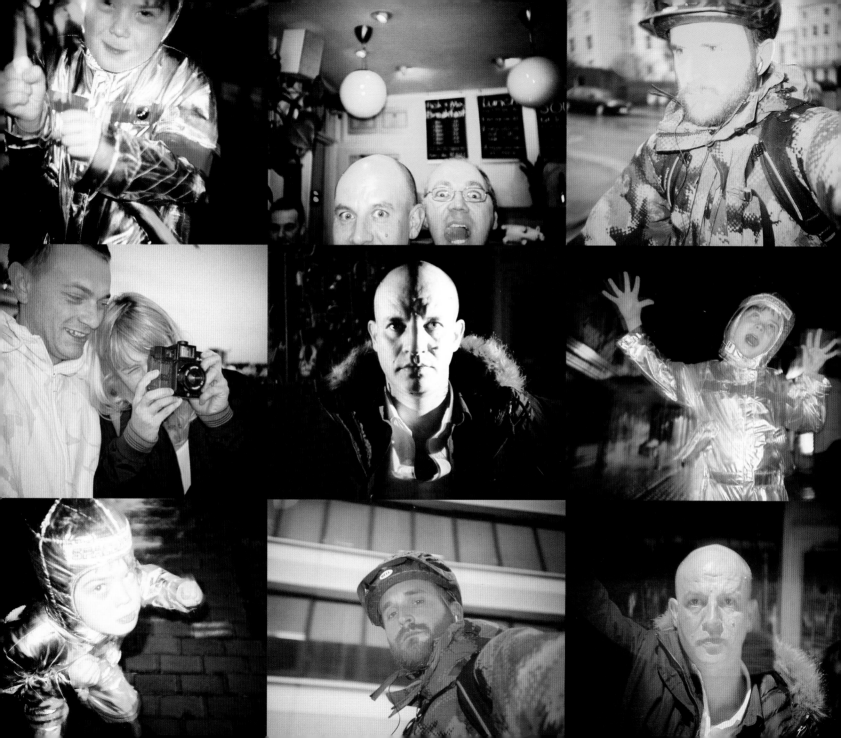

Full-moon lighting
An eerie quality

Cleft Cliff
A full moon creates very dramatic, strong shadows, much like the midday sun. It's perfect for simple, graphic compositions.

The Idea

Go out shooting under a full moon and you'll see the world in a totally new light. Moonlight can make an ordinary landscape look extraordinary. The cool crispness of the light and the dark shadows adds an eerie quality. Additionally, the long exposures needed for night photography can turn a stormy sea into a silky pond and the gentle movement of wispy clouds into a dramatic sky.

The Ingredients

> Any camera, preferably with Bulb mode
> Sturdy tripod
> Cable release with lock
> Spare camera batteries
> Coat, gloves, and thermals
> Waterproofs
> Torch
> A friend

The Process

You can shoot two to three days either side of the full moon, depending on the amount of cloud. As a rule of thumb, if you can see the shadow cast by the moon, it's bright enough to take a picture.

Preparation

Check a detailed weather forecast before you go; there's nothing worse than driving a couple of hours to get to a location only to find that the moon has been obscured by cloud. Quite likely it is going to be cold, and depending on where you live, very cold. You'll need a good thick coat, gloves you can work in, thick socks, thermals, and more thermals. Waterproof overtrousers are useful to cut down the wind chill. Even if it's not that cold, you're not going to generate any heat standing around waiting for long exposures.

Use a sturdy tripod, and unless you have an expensive carbon-fiber model, that means a heavy one. Don't wimp out and take your lighter one because you're worried about carrying it across a few fields; you'll pay later when your pictures aren't sharp. You'll probably need a camera with a Bulb mode for exposures of over 30 seconds, and a cable release with a lock on it. If it is very cold, you'll love this for stopping your fingers freezing off. Spare camera batteries are useful if you're going to be out for a while. Long exposures eat into the power and so can the cold. Keep your spare batteries warm in a trouser pocket and their power will last for longer. Take a torch. Even if you set out in the brightest moonlight, your journey back to the car can be treacherous if clouds move in.

Alex Bamford

And finally, take a friend. As much fun as it is to sit by yourself in the middle of nowhere in the middle of the night, it is safer not to be alone. Twist an ankle in a rabbit hole when you're a couple of miles from your car and you'll be in trouble. At the very least, let someone know where you're going.

Taking the shot

For the moonlight to really have an affect on the scene, you'll need to be away from the urban sprawl. Any artificial light sources that appear in your framing are very likely to have blown highlights. It's difficult to find places where some hint of streetlighting doesn't seep into the sky, but that can be used to dramatic effect.

The lighter the subject matter in a landscape, the better it will reflect the moonlight. A white windmill or a chalk cliff will jump out of the shot. Moonlight reflected in moving water, such as the sea or a flowing river, helps suggest the passing of time.

Before shooting, allow a bit of time for your eyes to adjust to the dark, and switch your camera off while you frame your picture so that the viewfinder's LCD doesn't detract from what you are seeing.

Switch your focus to manual. For landscapes, either use the distance markings on your lens to set it to infinity or, before mounting the camera on the tripod, focus on the moon. For closer subjects, place a torch on or near the area you want sharp and use that to focus on. If you're using a zoom lens, a handy tip is to zoom right in when focusing. When you pull out again to frame your shot, the focal point will remain the same.

→ **Right:**
Defenses
Sometimes you can use street lighting to your advantage, as in this shot of a security fence shadow on a concrete sea wall. The yellow light contrasts well with the cold moonlight on the sea.

↘ **Below right:**
Pebble Beach
Though the whole scene is bathed in moonlight, it's the crashing white waves and the chalk cliffs that jump out of this shot.

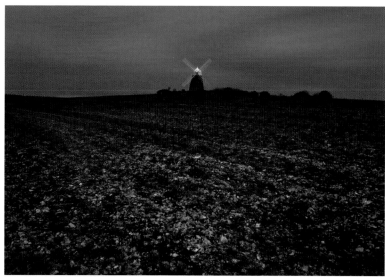

↗ Above right:

Halnaker Mill
As the white-painted cap and sails of this windmill reflect more light, they help to draw the eye into the shot.

↑ Above:

To Be Avoided
This pier was harshly lit by the port lights. I used the moonlight on this misty night to add a soft fill in the seascape behind.

→ Right:

Broken Defenses
The long exposures essential for moonlight photography can turn crashing waves into a silky-smooth blur. This contrasts well with the hard graphic lines of the sea defenses.

Switch the shutter to Bulb mode. To avoid any camera shake, use a shutter release with a lock so that you don't have to touch the camera. Exposures at ISO 100 can vary from 30 seconds to 6 minutes, depending on the brightness of the moon. Experiment to see what works for your shot at the time.

Be aware that at night, your preview screen can look a lot brighter than it really is. To counter this, when you review your pictures, use your camera's histograms to check the tonal range.

Digital cameras can suffer from random noise, resembling snow on a television. To keep this to a minimum, set the ISO as low as possible, and if your camera has a Noise Reduction mode, make sure you use it. Both of these can add to the length of time your shots take, but they will save you hours struggling with post-production afterwards.

Panoramas
A combined whole

Brighton Royal Pavilion
I couldn't have captured the entire building without making a panorama: if I had shot this any farther back, I would have been in the road.

Pier to Pier
This montage of 14 images gives a view of the beach that is more than 180°. You can see in both directions at once.

The Idea

Sometimes you'll want to shoot a wide scene, but you might not have a lens wide enough to capture it. To get around this you can take multiple photos and stitch them together on a computer to create a panoramic image. This is not as quick as taking a single image, but with a little preparation you can avoid some common pitfalls.

The Ingredients

> Any camera
> Tripod
> Hot-shoe spirit level

The Process

It is relatively simple to shoot a panoramic image–you just have to pick the spot you are going to shoot from, then take multiple photos with your camera pointing in different directions to capture a different section of the scene so that they can be stitched together later on a computer. This technique is also useful if you want to print a large-format image from a lo-res camera (like an old point-and-shoot or a camera phone): as the image is made up of multiple shots, it will have a much higher resolution than a single image.

As you turn the camera, you will notice different lighting conditions in each of the shots. If your camera is set to Auto exposure, each of your images will have a different lighting level and they will all look slightly different when viewed side by side. Because of this, it is best to shoot in Manual mode. Photoshop and other applications used to stitch images together can compensate and try to blend differently exposed images, but it is best to get it right in the first place. If the range of lighting conditions in a scene is too varied to keep the camera on one exposure setting you can change it, but do this only by 1 stop so that the exposure doesn't vary too much between adjacent shots. When you change the exposure, it's best to adjust the shutter speed: if you change the aperture from shot to shot, the depth of field, and therefore what is in focus, will also change. Turn the Auto White Balance off and select the balance that best suits your environment, otherwise your white balance will vary between shots and the images won't match.

Kevin Meredith

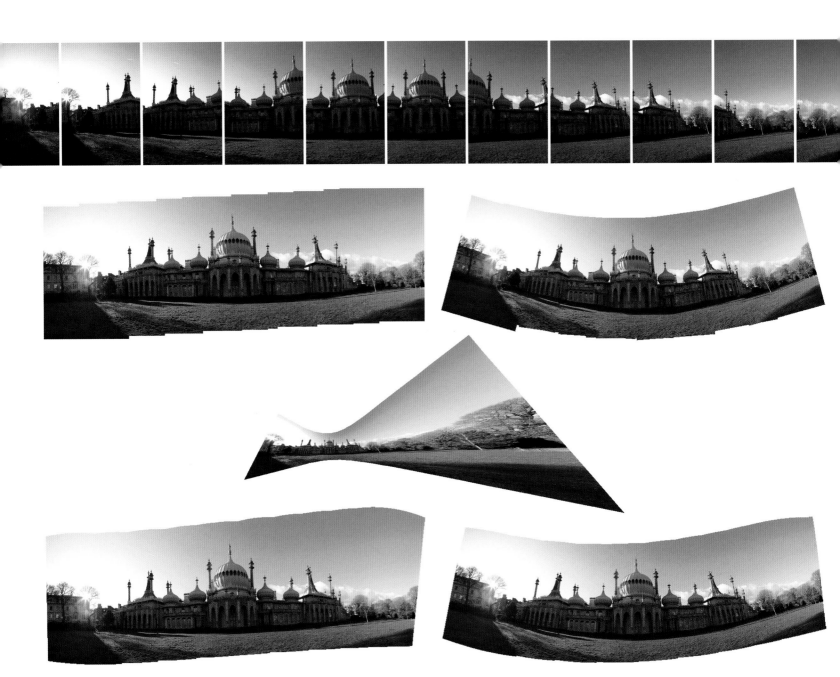

← Left:
These are the 11 individual images that I combined to make *Brighton Royal Pavilion*.

↙ Below left:
Examples of different ways images can be distorted and put together. Clockwise from left: repositioned, collaged, perspective, spherical, and cylindrical. Once you have made your panorama, you would usually crop it.

↘ Below right:
iPhone Panorama
This panorama was stitched together by AutoStich on my iPhone. It includes 21 images.

↓ Following page:
Dungeness Nuclear Power Station
Panorama images give a wonderful sense of vastness. This image of Dungeness was made up of 11 images. One of the main advantages of a panorama is the level of detail you can include. As you can see from the lighthouse detail, this image could be printed up to 80cm (c. 2½ft) wide and suffer no loss of quality.

It is best to use a tripod, as the key to success is to have the camera held in the same position when you are shooting panoramas. If you don't have a tripod, make an effort to keep the camera in the same spot—don't lean forward or backward. If you are using a tripod you need to keep the camera level as you pan. Some tripods have built-in spirit levels so you can tell when you have it set up correctly. If you have a tripod without this, you can always get a hot-shoe spirit level to fit your camera's flash hot shoe.

You can't have too much overlap. The more you have, the more your computer will have to work with when matching up images. It's best to have 25–50% of each image overlapped. If you are panning to the right, look through your viewfinder and make a mental note of what is at the right edge of the image; as you pan, you want what was at the right edge to be one-third of an image-width in from the left edge of the next image to ensure a good overlap. Make sure you have all the shots you need—it will be a frustrating waste of your time if you don't have enough images to form a complete panorama.

The focal length of your lens will determine the number of pictures you need to make your panorama. The wider the lens, the lower the number required. If you are using a zoom lens, it's best to zoom it out and have your subject appear farther away, so that you don't have to take as many pictures. You must be really careful not to change the focal length between shots because, if you do, the images won't line up properly and you will have to start shooting again.

To merge your photos using Photoshop CS4 go to File > Automate > Photomerge; if you are using Photoshop Elements 7 or 8 go to File > New > Photomerge. The same dialog box will open in both applications. You will be asked to select all the images you want to stitch together. Once you have selected them, there are a few different options you can select. Experiment with these to see what works best for you. Once you have shot the images, photomerging is the easy part.

You don't actually need a computer to stitch images together—some cameras have a Panorama mode that will do this in-camera. There is even an application for the iPhone that will stitch, and let you crop the resulting image. The best one I have found is AutoStitch.

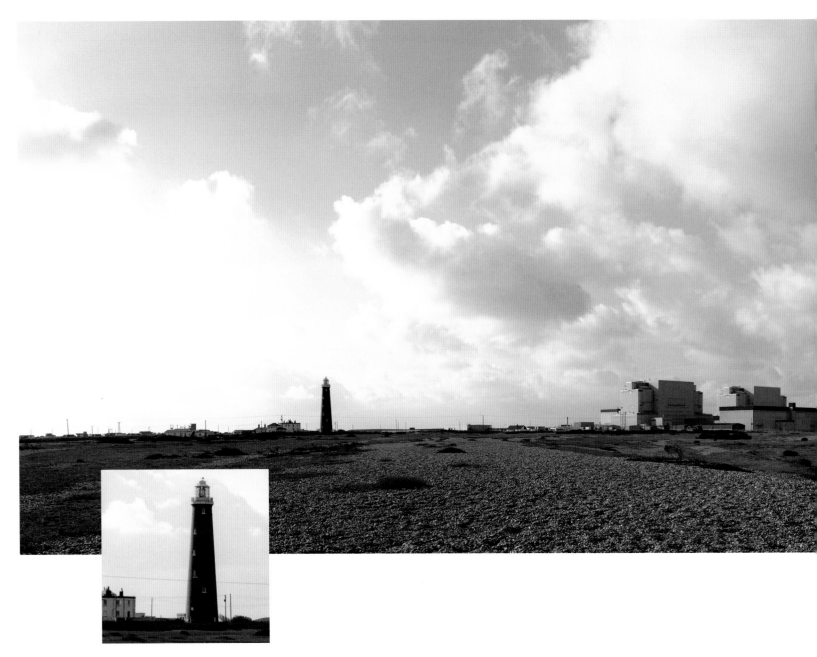

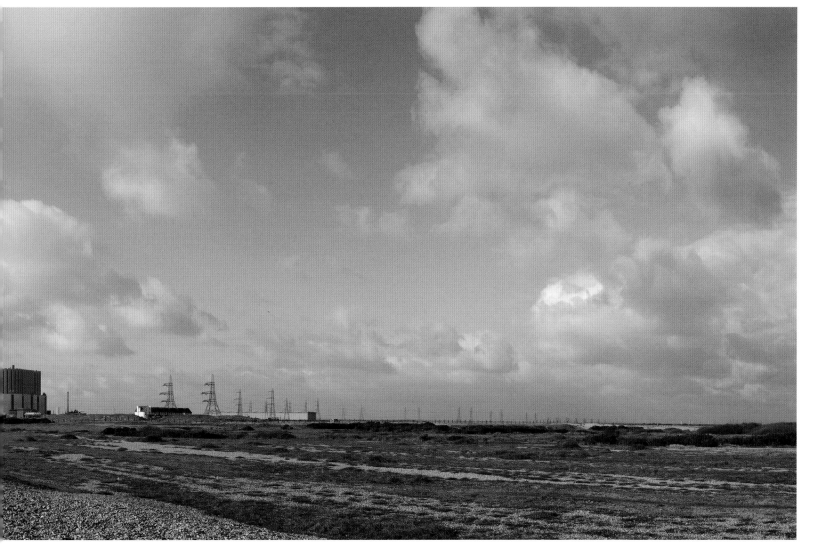

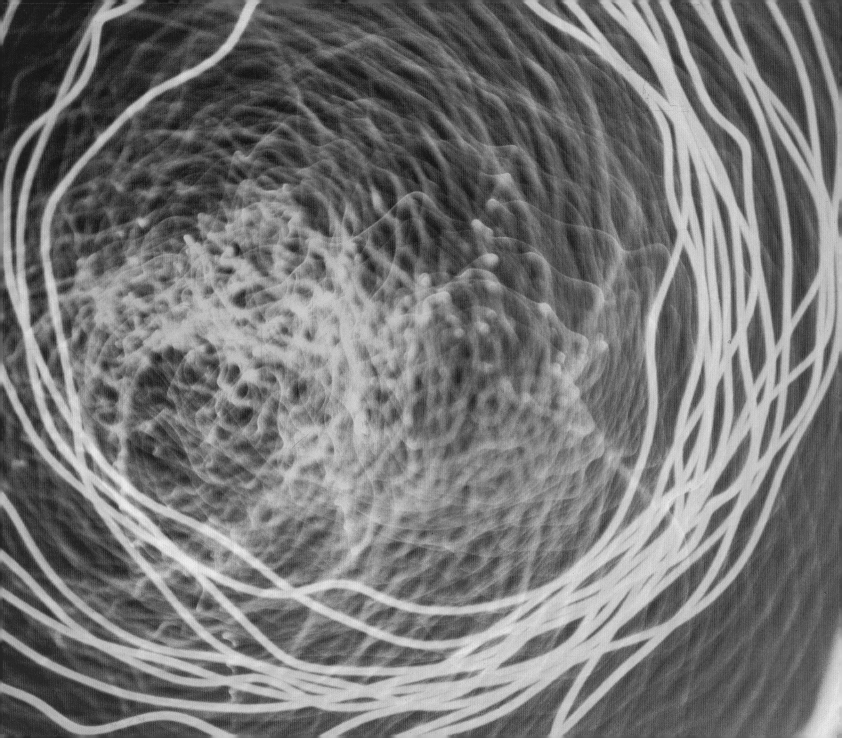

Camera tossing
Embracing camera shake

Kevin Meredith

Blue Ripples
Shot in an alleyway with a string of lights. I pointed my camera at the sky and spun for about 10 seconds while the exposure was being taken.

The Idea

A photographer will usually do their level best to keep their camera stationary while it is capturing an exposure, but with camera tossing, the idea is to never let the camera be still–to embrace camera shake and motion blur. Where camera shake sometimes gives you unwanted light trails, the idea of kinetic photography is to extend those light trails.

The Ingredients

▶ Any camera that can shoot with a shutter speed of 1/2 sec or longer

The Process

All the images in this section where shot with a shutter speed of 1 second or over: while the camera is taking the exposure it has to be moving to make trails of light like this. Because of the long exposure times needed, this type of photography is better suited to dark conditions so that you don't end up overexposing your shot, but if you want recognizable features, dusk can be a good time. If you are after light trails, a dark place with lots of small points of light is good–a dark room with fairy lights, for example.

To capture light trails, you basically need to draw with the camera. This is the opposite of light painting for which you need to keep the camera stationary and to move the light source. A low-risk technique is to spin on the spot while taking an exposure. Point the camera upward if you want to make circles and out in front of you if you want straighter lines. If you are using an SLR, set your camera to manual focus, then focus on the light source that will become your trail. Select Shutter Priority mode (TV), with an exposure of 1 second or more. It is best to start spinning before you press the shutter button.

If you are a bit of a risk taker and you want to take kinetic photography to the next level, then camera tossing is for you. As with all kinetic photography, the camera must be moving while it is taking an exposure, but with this technique you throw the camera into the air. The advantage of this is that the trails produced are really clean: if you hold the camera while spinning you will get a lot of unwanted vibration, but if you toss your camera in the air, its motion will be smooth.

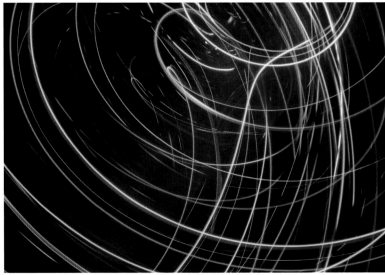

The downside is that it is quite risky. It's a good idea to attach a long strap to your camera so that there is more for you to catch if the camera slips though your fingers.

Camera tossing can be very hit-and-miss; sometimes only one in 30 shots will be any good. Because of its experimental nature, it is better suited to digital cameras, unless you have money to burn developing film! Set your shutter speed to just below how long you can keep the camera in the air. If the exposure is longer than the amount of time the camera is airborne, the picture-taking will still be in process when you catch the camera and you might spoil your smooth geometric lines. Throw the camera as high as you dare and try to put as much spin on it as possible–the more the camera spins, the better the motion lines in your image will be. I use the Self-Timer mode to make sure the exposure starts once the camera is airborne. I press the shutter, wait 2 seconds (or however long the timer mode is set for) and, just before the shutter opens, toss it into the air. It takes a bit of practice to get the timing right, but you will get the hang of it.

↑ **Above:**
Christmas-Tree Lights
The light source in these images was a set of fairy lights. I shot this with an old Canon Power Shot A 400.

↖ **Above left and left:**
Bars
Both of these images were shot on a Lomo LC-A (a film camera), in dark bars. You can see the wildly varying results you can get just by shooting in different environments.

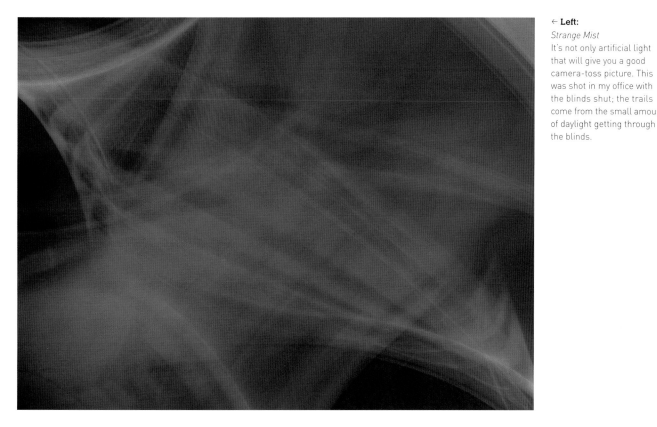

Small light sources are good for making light trails, but they tend to be one color. Tossing your camera in front of a TV can be a good way to capture a multitude of colors as a TV image is always changing. The only drawback is that it might be too bright, but you can cover part of the screen. And remember, you aren't just risking your camera; you could end up smashing your TV as well, so you must be doubly careful!

I will only toss an expensive camera indoors over a bed or something similarly soft. For general-purpose tossing I bought a secondhand Canon PowerShot A 400. It's a tough little camera. I have thrown it as high as I could and failed to catch it—it hit the stones, but carried on

working! It's a really old camera in digital terms—it's only 3 megapixels—but it has a maximum shutter speed of 1 second, and I got it really cheap on eBay. eBay has lots of old point-and-shoot cameras, but the key thing is to get one that has a shutter speed of 1 second or over, which can be quite rare with old digital compacts. Before you buy, it's best to check the spec of the camera using dpreview.com's specification database.

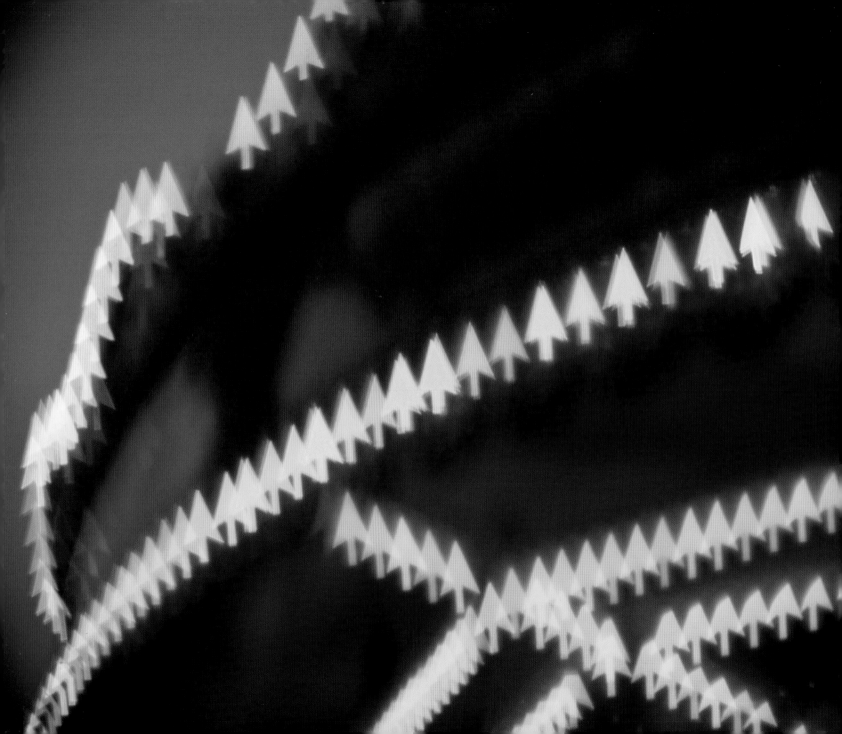

Patterned bokeh
Quality blurring

Carousel Lights
I turned the out-of-focus
lights on a carousel into
arrows by placing a cutout
of an arrow shape on the lens.

The Idea

Before you can get to grips with patterned bokeh,
you need to know what bokeh is. The term "bokeh" is
derived from the Japanese word for "blur" and is used
by photographers to refer to the out-of-focus areas
in a photograph. If a point of light is out of focus in an
image it will turn into a big circle; with patterned bokeh
you can turn these circles into any shapes you want,
without the use of image-manipulation software.

The Ingredients

> SLR and prime lens with a wide
 maximum aperture
> Black card
> Scalpel or craft knife
> Fairy lights (optional)

The Process

You may notice that if you have a small point of light
out of focus in a photo it will turn into a circle, and the
more out of focus it is, the bigger it will be. The size is
also affected by how wide your camera's aperture can
go—the wider the aperture, the bigger the circle. The
reason the out-of-focus lights appear as circles is that
the aperture inside your lens is circular. In a cheaper
lens it might be hexagonal, and then the blurred light
points will appear as hexagons. To customize your
bokeh, cut a shape out of a piece of card, then place
it over your lens so that the shape is in the middle
of the lens. Black card is best because it soaks up all
the light—if you use white, you might start to see it in
your photos. The size of the shape you should cut out
will depend entirely on what lens you are using—the
bigger the lens, the bigger your cutout has to be. For
this reason, it's best if you use an SLR as they have
bigger lenses than compacts. It is possible to use this
technique with a compact digital, but your cutout
would have to be so small it becomes impractical.
It is not well suited to film cameras because you really
need instant feedback for this technique—you would
waste too much film.

To test your cutout, set the focus on your lens to
its lowest value (the opposite of infinity), hold the
cutout over it, look through the viewfinder, and point
it at a distant light source. You should see that your
light source is now the shape of your cutout. Move
the camera around so that the light source goes to the
edge of the picture; if it disappears, you need a bigger
cutout. This process can be quite time-consuming.
Once you have the perfect-sized cutout, position it

Kevin Meredith

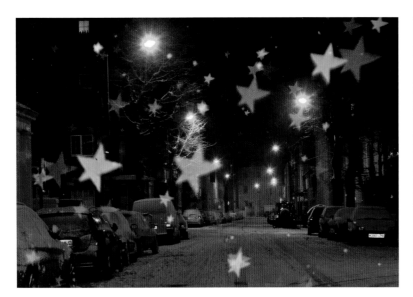

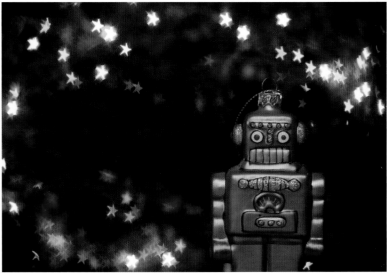

centrally over your lens, then put the camera lens on top of your card and trace around the lens. The next step is to cut this circle out, but leave some tabs, which you can use to attach the card to the lens with a rubber band.

If you aren't that crafty, you can buy kits of cutout shapes designed specifically for the purpose from bokehmasterskit.com. The kit includes shapes that would be really difficult to cut out, like stars, smiley faces, birds, and planes.

Once you have your cutout, you can start shooting. Shooting in the dark is best because this technique is all about turning points of light into shapes. Lights on their own can look great, but if you want to introduce the wow factor, it's best to incorporate something in the foreground. An easy technique, for a still life or portrait, is to use some Christmas tree lights. Set up the lights as a backdrop and position the object you want to shoot as close to you as possible so that the background will be at its most out of focus, which is what you need.

↖ **Above left:**
Snowing Stars
These stars were created by lighting up snowflakes with a flash, through a star-shaped cutout. I focused the camera on infinity.

↑ **Above:**
Robot and Stars
If you are throwing distant lights out of focus, it is possible to focus on a near object. This robot was about 40cm (c. 1ft 4in) from the lens.

← **Left:**
If you're not too handy with a scalpel, you can get the Bokeh Masters Kit from www.bokehmasterskit.com.

↗ Above right:
Love Lights
I used a heart-shaped cut-out for this image. The light sources were traffic lights and car headlights.

↑ Above:
Blurred Lights
This is blurred lights, with nothing in front of the lens.

→ Right:
Blurred Lights with Stars
The same subject as *Blurred Lights*, but this time I put a star-shaped cutout over the lens. Notice how much smaller the star is than the original circle.

You don't have to have your lights in the distance—you can blur things that are close to you by setting your focus to infinity. Water droplets on a window can be turned into bokeh shapes if there is light shining through them.

Have you ever noticed that if you take a photo with a flash while it's raining or snowing, all the droplets or snowflakes turn into bright, out-of-focus circles? You can just as easily turn them into a shape of your choosing. Next time it rains or snows at night, grab your camera and cutouts and see what you can do. It does work better with snow, so you might have to wait until you can try it.

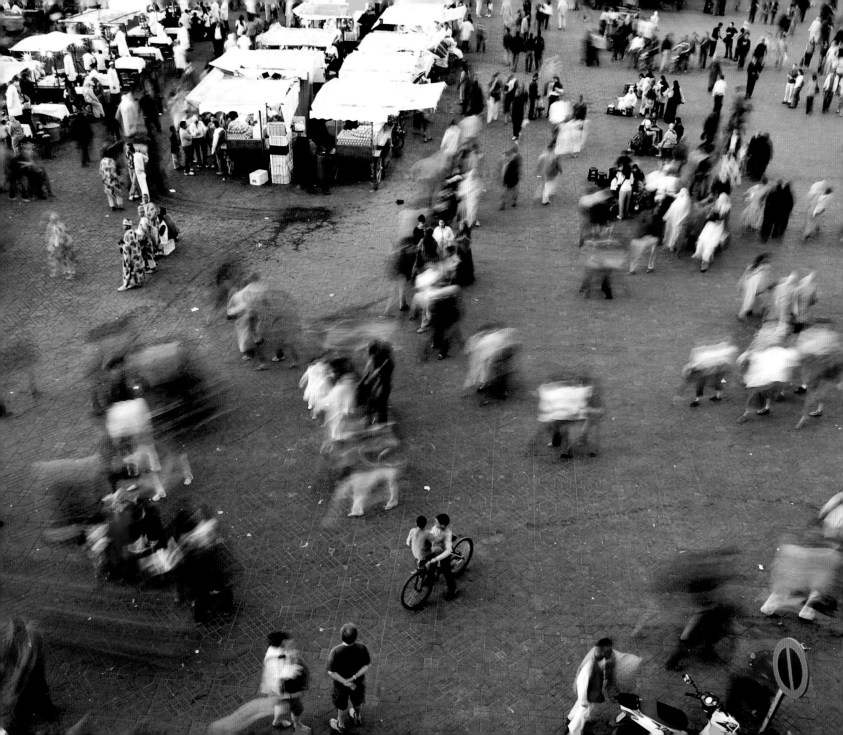

Long exposures: day
Slowing the world down

Market Square
I took this shot of a market square with an ND8 filter and a 1-second exposure. Any people who stood still for that second appear frozen in time, but anyone who was moving has become a trail of color.

The Idea

Most people associate long exposures with nighttime because the lighting conditions at night are ideal for this. But, with the right equipment, it is perfectly possible to shoot long exposures during the day and capture some stunning images.

The Ingredients

▹ Any camera
▹ Tripod
▹ Neutral density filter

The Process

To take a long exposure during the day, or under bright conditions, you will need to set the ISO on your digital camera to its lowest option or, if you are using a film camera, load a slow film (with an ISO of 50 or 100). Reducing the ISO sensitivity allows you to use the slower shutter speeds needed for long exposures. Some digital cameras have an ISO Expansion option. The lowest ISO setting on a digital camera is usually 100, but with ISO Expansion you will be able to select a setting of 50. This will allow you to shoot with a shutter speed of half what you could use were the setting ISO 100. Check your camera's manual to see if it has ISO Expansion and also for where to find it—this can be difficult as it is usually deep in Custom Functions. (Turning on ISO Expansion will also increase your camera's upper ISO limit.)

Set up your camera on a tripod so that your shots won't be affected by motion blur. This is not essential, as you can get away with resting the camera on a steady surface, but it is a help. Set the camera to Shutter Priority mode, then select your shutter speed. In Shutter Priority mode the aperture will change as you alter your shutter speed in order to give you a balanced exposure. As you slow down your shutter speed, you get to a point at which the aperture will not be able to close down anymore. You can tell when you've reached the lower limit because the aperture value will start to flash. If you slow the shutter beyond this point, your shots will be overexposed.

Kevin Meredith

To shoot with an even slower shutter speed you will need to use a neutral density (ND) filter. When I shoot a long exposure in the day, I always shoot with a range of different shutter speeds to see what looks the best; the speed to choose is down to personal preference.

An ND filter is an essential piece of kit for daylight shooting. ND filters cut out all light wavelengths equally so they darken your image. This allows you to open up your aperture and take shots with longer shutter speeds, without overexposing them. As I've mentioned before, it's good to think of ND filters as sunglasses for your camera. ND filters come in different strengths, measured in terms of stops, ranging from 2 to 13. If the lowest shutter speed you could use were 1/8 sec, a 2-stop filter (ND2) would allow you to shoot 2 stops slower, at 1/2 sec. It is possible to stack ND filters one on top of the other in order to increase their effect. If you used an ND8 and an ND4 together you would, effectively, have an ND12. Depending on your lens, focal length, and aperture, you might start to see the edges of the filters when you have them stacked; you will notice this as darkened corners in your image.

If you aren't using a DSLR or other camera onto which you can screw filters, you can hold the ND filter in front of the lens, but this doesn't work with cameras that don't take their light-meter reading through their main lens.

→ **Right:**
Old Pier
You can see that the beach and the pier are still, but as this was shot over 8 seconds, the water appears as a mist: all of its movements over that period are condensed into one moment.

↓ **Below:**
Early Morning Swimmer
I was shooting on ISO 400 film early in the morning and took this shot on 1/15 sec. This was slow enough to capture movement, and just fast enough to capture an identifiable face.

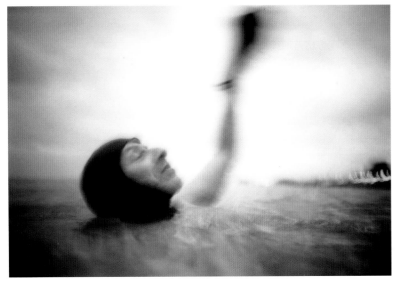

← Left:

Ghostly Walk

With long exposures, people in motion can be turned into ghosts. I shot this with the camera on the ground to avoid camera shake.

↓ Below:

Speeding Cyclist

This was taken on a rainy afternoon; cloud cover allows you to shoot at slower shutter speeds.

If you have a collection of lenses with different ring sizes you can save money by buying only the largest size filters and using a step-up ring when you want to use them with your smaller lenses. The ring size refers to the screw mount on the end of the lens. The ring size is usually displayed on the rim of the lens, but don't get it confused with the focal length—both are written in millimeters. The ring size always follows the symbol for "diameter" (a circle with a line through it). To avoid confusion, the ring size is sometimes written on the inside of lens caps. If you have money to burn you can get yourself a variable neutral density filter. With these you can adjust the amount of light cut out—between 2 and 9 stops—by rotating them.

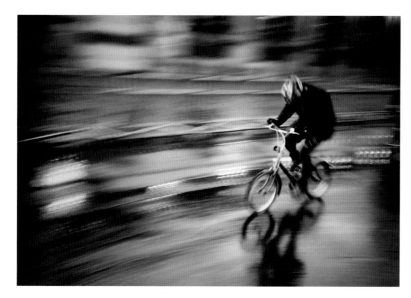

Get an audience

Share the joy

Kevin Meredith

Taking a photo is just the beginning—after shooting, there is a whole world of creativity awaiting you.

The Idea

Taking photos, and refining them on your computer, can be just the start of your photography. Once you have your images, you should get them out into the big wide world so that other people can see and enjoy your creations.

The Ingredients

› Photos
› Computer
› Internet access

The Process

Online

It used to be that if you were a budding photographer you would just show your family and friends your photos, but now, with access to the web, it's as easy to publish content as it is to view it. I post my photos to flickr.com, one of the more popular photo-sharing sites. Photo-sharing sites give you great potential for a wide audience. If you get into a certain type of photography, there will always be a corresponding flickr group, making it easy for you to show your photos to people with a similar interest, and to get tips from your peers. If you want your work seen by a lot of people, you need to make it easy to find. Make sure you add meaningful titles, descriptions, and tags to your photos so that they turn up in searches. If you are a bit shy and don't want to publish your photos publicly, facebook is good for sharing your images with family and friends.

If you want a more professional online presence for your photography, but lack the skills and/or funds to get your own website built, there are sites that offer slick, customizable portfolio templates. One such place is www.arlosites.com. You can add galleries and style your site the way you want it. In some cases this is a far cheaper option than building a site yourself as web hosting alone can cost as much.

Prints

Having your photos seen online is great, but it's always good to get physical prints. I don't own a color printer. If I want something printed, I usually get my local lab to print it because, once you have paid for a printer and ink cartridges and factored in time for cropping your prints, you can spend just as much as you would getting them printed at a lab. Once you have your photos printed, you might have a problem getting them framed. Frames can vary in price, but if you want hassle-free printing and framing, look no further than imagekind.com, which offers an online printing and framing service at a very competitive price.

Cards

Photographs are good for hanging on walls and putting in albums, but they don't take handling very well as they pick up fingerprints and kink easily. For prints that can take a little more handling I use moo.com. Moo will make you business cards, mini cards, postcards, and greetings cards from your photos. Moo's biggest strength is that it lets you have a different image on each of your cards so that, if you buy a pack of 100, you can have a different image on each.

Uploading images to websites can take a long time, but both Moo and Imagekind can grab your photos from flickr, facebook, and a number of other online services to save you time.

Books and magazines

With the advent of print on demand, anyone can have their own book printed. With traditional printing methods you have to print a minimum number of copies, which can prove costly if they are left unsold. Print on demand allows you to print just one copy, if that is what you require. Blurb (blurb.com) allows anyone to make a book, in a range of sizes, and then publish it. Blurb has its own bookmaking software called BookSmart (Mac and PC compatible), which

← Left:
The data you can add to your flickr image—including tags, people, location, and camera type—makes it much easier for you and other users to find a particular image.

→ Right:
From the Blurb website you can browse through a list of self-published books and upload your own book with the user-friendly software BookSmart.

→ Far right, top:
Moo make half- and full-size business cards from your images in packs of 50, and you can have a different image on each one.

→ Far right, bottom:
Anyone can distribute a magazine worldwide—all you need is a PDF of it.

is super easy to use and free to download. If you prefer to design your book using other software, you can upload your design to Blurb as a PDF. MagCloud (magcloud.com) do the same thing for magazines; this is really good if you have a small project you want to publish that is not quite big enough to fill a book. MagCloud, Blurb, and Imagekind also allow you to put your creations up for sale on their sites. You can sell it at cost or add a markup. It is incredible to see how print on demand has leveled the playing field when it comes to enabling people with limited resources to make their work available.

In a strange twist, big publishers are using it too. In 2009, *Life* magazine used MagCloud to reissue its 1969 Woodstock edition. Wouldn't it be cool if your magazine was on the same virtual self as *Life* magazine?

Merchandise

And it doesn't stop at that. If you want something more, check out Snapfish. Snapfish can print your photos on a huge range of products: mouse mats, T-shirts, mugs, coasters … they will even print photos onto a mini T-shirt for a teddy bear.

Camera types

While every type of camera has its own strengths and weaknesses, most can be classified according to a few basic categories: DSLR/SLR, compact digital, Micro Four Thirds (digital), toy, zone focus, and instant (Polaroid). This is not a definitive list, but it does include all the camera types covered in this book.

DSLR/SLR

DSLR (digital single lens reflex) and SLR (single lens reflex) cameras are essentially the same, the only difference being that DSLRs use a digital sensor to record an image where SLRs use film. SLRs allow you to look through the lens that takes the picture. This ensures that the picture you see through the viewfinder will be exactly the same as the picture you take. SLRs allow complete creative freedom, and with modern SLRs you can control as much or as little as you want because you can simply leave everything on Automatic. SLRs use interchangeable lenses, which means they can be used for almost any photographic task, and they don't suffer from shutter lag–the delay between the shutter button being pressed and the photo being taken. This makes them ideal for action photography, depending on how your focusing is set up. The one big drawback with SLRs is that they can be very bulky, depending on what lens you have attached. Unless you are a super-dedicated photographer, you probably won't carry your SLR with you all the time, which means you might miss some shots. SLRs are wonderful for learning about photography because you can experiment with the settings and get to understand what is happening

with the camera. Once you have this knowledge, you will have an easier time figuring out how other types of camera work.

Compact cameras

The compact digital camera is probably the most popular type of camera today because of its ease of use; most "holiday snappers" want to press the button and have a picture taken, without having to worry about what happens in between. When it comes to getting a digital compact, make sure that it offers some control over the aperture and shutter speed so that you have some creative freedom. It is also a good idea to find out how well it performs in low light without a flash: images taken with a high ISO in low light can be incredibly noisy because of the tiny sensors compact cameras use. I have never used a digital compact that didn't suffer from some degree of shutter lag, and while this lag has been reduced over the years, it is still quite difficult to capture a precise moment of action with them. The main advantage of digital compacts is that they can fit into your pocket, so you won't miss any photo opportunities. During the late 1990s, before the rise of the digital compact, film compacts were enjoying a golden age–camera companies were competing against each other in trying to make the best. Some of these cameras were very expensive, but they can now be found at reasonable prices. Classic, super-sharp film compacts worth looking out for are: Olympus μ-II, Yashica T4, Contax T2 and T3, and Nikon 35Ti.

Micro Four Thirds and hybrid

The Micro Four Thirds camera system has been about since 2008. At the time of writing, only Olympus and Panasonic make them, but other manufacturers are on board. Samsung have made a hybrid camera–the NX10–which is a similar size. Micro Four Thirds and hybrid cameras both have interchangeable lenses. These cameras don't have an optical viewfinder, which eliminates the need for a mirror box, and the digital sensor in them is smaller than those in DSLRs. These differences allow them to have a very small body, yet retain all the functionality of SLRs. Having no viewfinder isn't a huge problem as you can use video viewfinders that slide into the flash hot shoe. In fact, these give you an advantage–you can angle them upward so that you can look down into the camera. This makes taking shots at awkward angles a lot easier. The biggest advantage of this type of camera is that you have all the control of an SLR and all the choices of lens in a camera you can fit into your pocket (depending on the lens attached). My prediction is that Micro Four Thirds and hybrid cameras will become the tool of choice for hobbyist photographers.

Toy

"Toy cameras" is a collective term for a number of camera types. It is hard to pin down what a toy camera is in technical terms. For the most part, toy cameras are cheap-and-cheerful film cameras meant for a bit of fun rather than for capturing a technically perfect photo. They rebel against the super-slick digital

cameras that always push for higher resolution and greater clarity, but somehow end up losing character along the way. Most toy camera bodies are made of plastic and sometimes their lenses are plastic too, which helps keep them incredibly cheap. Despite their simple construction, some toy cameras take amazing photos—once you get to know their limitations and quirks. Toy cameras used in this book include the SuperSampler, Kalimar Action Shot 16, Holga, Lomo LC-A, and Fisheye. One of the drawbacks with toy cameras is that when a particular model becomes popular, prices can quickly jump, so if you discover the next "Holga," best keep it to yourself.

Zone focus

Zone focus refers to the focusing system used by these cameras. They have a number of fixed settings rather than a continuous focusing system. For instance, my Lomo LC-A has 0.8m (c. 21/2ft), 1.5m (c. 5ft), 3m (c. 10ft), and infinity zones of focus. You can't tell if your subject is in focus by looking through the viewfinder; you have to select the appropriate zone and just hope you have judged the distance to your subject correctly. As most zone-focus cameras were designed in an era when the electronics and mechanics required for autofocus were prohibitively expensive, they tend to have basic electronics and only one metering mode. The zone-focus cameras I use are the Lomo LC-A, Lomo LC-A+, Cosina CX-2, and Olympus XA-2.

Instant (Polaroid)

Before the advent of digital photography, the quickest way to view your image after taking a photo was to use instant cameras. With these, two minutes after you take a shot, you will have a photo in your hand. Unlike other forms of photography, with which you can reproduce an unlimited number of prints from a digital file or negative, a Polaroid image is a one-off. This makes it a very precious medium to work with. If you give someone a Polaroid it means something! It is also comparatively expensive, so it should make you really think about what you are shooting. In 2008, the production of Polaroid film ceased for a short while and it looked as though the world's Polaroid cameras would become useless, but The Impossible Project has worked hard to bring it back into production.

Photography fundamentals

Composition

Composition refers to how you place elements in your photo. As you shoot more photos you get a sense of what works and what does not. For many novices the urge is to put the subject in the center of the frame, but this often results in an uninteresting composition. The simplest way to create interesting compositions is to follow the rule of thirds. Imagine there are two horizontal lines splitting your scene into three, and the same vertically. Line up your points of interest either along these lines or where they intersect.

Focusing

Getting shots in focus is down to understanding how focus works and what the camera will try to focus on. There are three main methods of focusing: zone focus, manual focus, and autofocus. If you don't know how your camera focuses, look it up in the manual.

Zone focus

Zone focus is the simplest focusing system to explain. When you set the focus on a zone-focus camera there is nothing to tell you that anything is in focus–it is all about how well you judge distance. As the name suggests, these cameras have different "zones" of focus. For instance, on my Lomo LC-A, the different zones are 80cm (c. 2½ft), 1.5m (c. 5ft), 3m (c. 10ft), and infinity. You have to judge how far your point of focus is from you and set it to the correct zone. Some cameras don't use standard measurements at all. I have an Olympus XA2 that has a picture of two people's torsos to represent a close-up portrait, two whole people to represent a full-length portrait, and a mountain to represent infinity. This isn't that helpful when you are trying to achieve super-sharp

focusing, but if you google your camera model and "focusing distance," you can usually find what the focus zones are in centimeters.

Manual focus

Manual-focus cameras allow you to see what is in focus when you look through the viewfinder. As you turn the focusing ring you will see objects at different distances pop in and out of focus. It can sometimes be difficult to see when something is in sharp focus, so a lot of manual-focus cameras use the split-screen focusing system. With this you will see two versions of your image in the center of the viewfinder and, as you turn the focusing ring, these will move closer or farther apart from each other. When the two are lined up, you know that the image is in focus. There is also a slight variation on this in which you will see a double of everything and when the doubles are lined up, your image is in focus.

Focusing modes and their various names			
	Canon	**Nikon**	**Olympus**
Single focus	One Shot	AF S	Single AF
Continuous focus	AI servo	AF C	Continuous AF
Intelligent focus	AI focus	AF A	(N/A)

← Left:
Out of focus. If the two halves of the image in the "focusing circle" are not lined up, your image will not be in focus.

↙ Below left:
In focus. With the two halves of the image in the "focusing circle" lined up, you know your image will be in focus.

Autofocusing modes

There are three different autofocusing modes: single, continuous, and intelligent. These modes will have varying names on different on cameras, but they all do the same thing. Single-shot focus is best suited to shooting still subjects because, once focus is achieved, it will not refocus. Continuous focus does just that—it will try to refocus once it has focused. This is good for moving subjects; if someone is moving toward you, the focus will change continuously to match their position. Intelligent mode will simply choose between single-shot and continuous focus, depending on whether the subject is moving.

Most autofocus cameras have a two-step shutter button, which can be pressed halfway or fully down. As you press, you will feel resistance when the button is halfway down. At this point the camera will focus on what is in the focusing point in your frame, but it won't take the picture until you press the button the whole way down.

→ Right, top to bottom:
For this series of three photos I changed the exposure settings. The top image is underexposed, the center image is just right, and the third is overexposed.

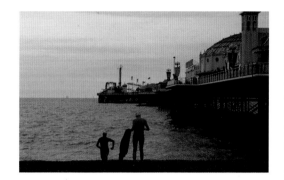
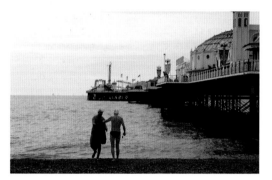
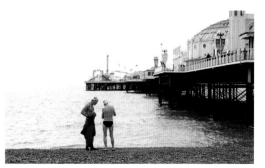

Modern autofocus cameras often have many focusing points (from 3 to over 30); old-style cameras have just one, in the middle of the frame. On a camera with many focusing points it is possible to select which one the camera uses. By default, some cameras choose the focusing point for you, depending on what is in the scene, but I prefer to set mine to the center point. If I want to focus on something that is not in the center of the focusing screen I use the focus-lock method.

Focus lock

Focus lock is especially handy if your camera only has one focus point. Aim your camera so that what you want in focus is under the focus point and press the shutter button halfway down. Once focus has been achieved you can recompose the shot while keeping the button held halfway down. When you are happy with the composition, press the shutter button fully to take the picture. If you want to take another picture you have to repeat the process. Focus lock will only work in Single-shot Autofocus mode: in Continuous-focus mode, the focus will change when you try to recompose the shot.

Exposure

If you want to get more serious about photography, you really must get to grips with exposure and the things that can affect it: shutter speed, aperture, and ISO ratings. Some people are confused by exposure, but this bathtub analogy will make everything clear! Exposure is all about exposing the recording medium in a camera, whether that is film or a digital sensor, to just the right amount of light. Too much light and your photo will be overexposed (too bright), too little and it will be underexposed (too dark).

Think of your recording medium as a bathtub and the light as water. Your aim is to fill the bathtub with just the right amount of water; if it is overexposed the bath will overflow, if it is underexposed there won't be enough water in the tub.

A camera lens has an aperture, or opening. You can change the size of this to let in more or less light. With the bathtub analogy, think of the aperture as a tap. Turning the tap on is like opening up the aperture. The faster the water flows, the quicker the tub will fill. Think of the length of time you have the tap open as your shutter speed. If you want to fill your tub slowly, you need to open the tap just enough to let a dribble of water through, but you need to leave it on long enough to let the bath fill. The idea is to get a balance between shutter speed and aperture; if you slow down the shutter speed you need to open up the aperture to keep the balance, and vice versa.

The amount of light in a scene will affect how long it takes to capture an exposure. Think of the amount of light as your water pressure. A sunny day is like having high water pressure—you won't have to open the tap (aperture) very wide to fill your bath, and you won't

have to keep it open (shutter speed) for long either. Your ISO rating is a measure of how sensitive your recording medium is. Think of the ISO as the size of your bathtub. A low ISO, like 100, would be a really big bath that requires a lot of water to fill it; a high ISO, say 1600, would be a tiny bath that needs very little water to fill. So, if a high ISO allows you to shoot quicker, why not set the ISO high all the time? It's a question of quality. Images shot at a high ISO will be noisier and less saturated (colorful). It's always better, and more effective, to scrub in a really big tub—no one likes having to wash using just a bucket.

F-stops
Every time you change either the shutter speed or the aperture, you are halving or doubling the amount of light coming into the camera. This halving/doubling is measured in f-stops. Closing the aperture by 1 stop halves the amount of light coming in to the camera; opening it by 1 stop doubles it. The same is true for shutter speed—changing the shutter speed will either half or double the time the shutter is open for. Note that some cameras now allow you to change aperture and shutter speeds by ½ stops, and sometimes even by ⅓ stop, for finely tuned exposures.

Light metering
Cameras use light meters to determine the correct exposure for a given scene. How a camera measures the light is down to the metering mode it is set to. There are three types of metering: average, spot, and center-weighted. Older film cameras tend to use average metering, which averages out the light coming from all areas to arrive at a balanced exposure. This is fine for scenes in which the light is consistent. Spot metering measures light from a small part of the scene, typically 1-5%, which allows you to set the exposure level for that specific part of the scene only. Center-weighted metering does something similar to spot metering, but takes its reading from 60-80% of the image. This mode will ensure that what is in the center of the frame is perfectly exposed, while also giving some consideration to the light at the edge of the image.

Exposure compensation
Sometimes a photo will be over- or underexposed even though the camera's light meter says you have a balanced exposure. Exposure compensation allows you to deliberately over- or underexpose a shot. This is by far the easiest way to tweak a shot's exposure level to get the result you want. If you have a film

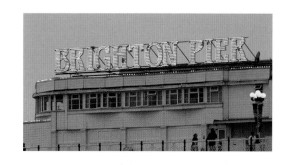

← **Left:**
The under/overexposure
scale. This has been set
to underexpose by 1 stop.

→ **Right:**
The clear image obtained
from a still camera.

↘ **Below right:**
The blurring effect caused
by camera shake.

camera that doesn't have exposure compensation, you can change the ISO setting; this will trick the camera into over- or underexposing your film. If, for instance, you have an ISO 100 film and you want to underexpose, set the camera's ISO to 200; if you want to overexpose, set it to 50. Remember to reset your exposure or ISO setting once you are done or you won't get a correct exposure for the rest of your shots.

Shutter speed

Shutter speed refers to how long a film or sensor is exposed to light and is measured in fractions of a second. If you want to freeze motion, you need a fast shutter speed–anything above 1/250 sec will freeze motion adequately. If you want motion blur, you have to slow down the shutter speed. Some cameras have a Bulb mode, which allows you to keep the shutter open for as long as you want; only when you release the shutter button will the shutter close.

Camera shake

When the shutter speed is so slow that the camera can move while the exposure is being taken, the image will be blurred. This is called camera shake. The slowest speed you can shoot at without camera shake is determined by the focal length of your lens:

your shutter speed measure cannot go below the focal length of your lens. So, if you are shooting with a 50mm lens, your shutter speed should not drop below 1/50 sec. Longer lenses require faster shutter speeds because they amplify any movement of the camera. Of course, some people have steadier hands than others, so, to see how low *you* can go, a test run is a good idea. If your camera or lens has image stabilization, this will remove some of the shake and enable you to shoot a few stops slower than normal. If you are using a tripod, it is best to turn image stabilization off: it can actually add shake if the camera is totally still.

Aperture

The aperture is an opening inside a camera lens that can get bigger or smaller to allow more or less light to enter the camera. It helps to think of the lens aperture as being like the pupil in an eye–in bright conditions both shrink to allow less light in. Aperture tends to confuse people because, as the aperture hole gets bigger, its f-number measure gets smaller: f/1.8 is a bigger hole and lets in more light then f/11. All you have to remember is that a small f-number gives a big hole that lets in more light, and a big f-number gives a small hole that lets in less light.

Depth of field

Changing the aperture will affect how much of your picture, in front of and behind what you are focusing on, is in focus. This is referred to as the depth of field. For a shallow depth of field, with little in focus, the aperture needs to be opened up (lower f number). You can use this to highlight a small portion of an image because it allows you to blur the background and foreground, making them less distracting.

Lens diffraction

There is a limit to how sharp you can get an image by closing down the aperture and increasing the depth of field because of something called "lens diffraction." This gets a bit technical and, to be honest, confuses me at times! All you have to know is that, as the aperture gets smaller, at a certain point the overall image will become less sharp. To find at what

point diffraction will affect your lens, secure your camera on a tripod, set the ISO to 100, and take the same photo with each of your f-numbers. View the images on a computer, zoomed in at 100%. As you look through you will see that the images get sharper as the f-numbers get higher up to a certain number, beyond which they become less sharp. The highest number before the image starts to blur is your lens's sweet spot. Remember it. If you are using a zoom lens, it's a good idea to repeat this on the different focal lengths.

When shooting at a small aperture on a DSLR, you might start to see more sensor dust. Dust and other particles can get into your camera when you change lenses, and this will show up on images as dark spots or lines. I would advise anyone with a DSLR to get a sensor-cleaning kit. You can save yourself a lot of time by removing dust from the sensor rather than removing it from your photos with image-editing software. Check your camera manual for details. If you are in any doubt, take it to a camera-repair shop and let a professional clean it: in most cameras the sensor is the most expensive part and you don't want to have to replace it.

Shooting mode

If you are shooting on a DSLR or SLR, you have to choose what mode to shoot in. This is also the case with some compacts. You can leave the camera in Auto or choose one of the "easy" modes like Portrait or Landscape, but if you want to take control of the camera, you will have to choose between Aperture Priority, Shutter Priority, or full Manual mode. Some photographers will tell you that any real photographer always shoots in Manual mode, but I disagree. I use Manual mode in certain situations, but most of the time I use either Aperture or Shutter Priority.

Use Aperture Priority when you want to control the depth of field—you can set the aperture and leave the camera to set the shutter speed to get a balanced exposure. Use Shutter Priority when you are trying to capture motion, either by freezing it or by recording motion blur. Shutter Priority is particularly handy in low light as you can set the shutter speed to a point where you don't get camera shake and the camera will set the aperture to get a balanced exposure.

Lens terminology

Lens names can be confusing, but it's important to understand them when you're deciding what camera or lens to buy. The focal length is described in mm. The more mm, the narrower the lens' field of view will be. A 200mm lens will allow you to shoot distant objects, but won't be much good at a party when you are close to the action. A wider lens, say a 35mm, will let you shoot closer to your subject, but the wider a lens (the shorter the focal length), the more distortion you get; horizons will be bent and people can look fatter and bulbous. Wider lenses have a greater depth of field than narrow lenses, so if you want really soft, out-of-focus backgrounds, wide-angle lenses are not for you. A zoom lens will cover a range of focal lengths. These are described in terms of their focal range, for example, 18–50mm. Lenses with a fixed focal length are referred to as prime lenses. You get a better image quality from prime lenses as they are designed for a specific job. Think of a zoom lens as a jack-of-all-trades, but a master of none.

Maximum apertures are always listed on a lens. Prime lenses are the easiest to understand. On the rim of my Canon 50mm lens is printed "50mm 1:1.4," which means the lowest f-number I can get with it is 1.4 (smaller numbers are better). There are a few more numbers on zoom lenses. On my 20–35mm is printed "20-35mm 1:3.5-4.5," which means that at 20mm, I can open up the aperture to f/3.5 and at 35mm I can open it to f/4.5. More expensive lenses will have a constant aperture. My 24–70mm lens has "24-70mm 1:2.8" on the rim, which means that it can stay at f/2.8 on any of its focal lengths. The possibility for a wider aperture is great because it means you can have shallower depth of field, and you can use it in lower lighting conditions. The one downside is that lenses with wider apertures tend to cost a lot more.

Index

Numbers in *italics* refer to illustrations; numbers in **bold** refer to main entries